LOCATION PORTRAITURE
The Story Behind the Art

First Edition 1996
Published in the United States of America by

Silver Pixel Press®
Division of The Saunders Group
21 Jet View Drive
Rochester, N.Y. 14624

Photography and Text by William S. McIntosh

Printed by Coastal Printing, Sarasota, FL 34234
Color Separations by Suncoast Color, Sarasota, FL 34236

ISBN 1-883403-37-5

Acknowledgements

I have always enjoyed sharing my experiences and techniques in location portraiture with my fellow photographers and preaching my belief in photography as an art form. I have lectured for many years in all parts of our great country as well as overseas, and several years ago published video tapes on "Environmental Portraits of Family Groups" and "Environmental Portraits of Children".

Writing a book on my photographic art had been on my mind for a long time, but somehow I was never able to accomplish it until my path crossed Paul Klingenstein's, who attended one of my slide lectures in New York City. Paul is Chairman of Mamiya America Corporation and in his young years was a portrait and wedding photographer. His enthusiasm about my photography and his strong urging to write this book was the impetus behind its creation. From the beginning, Paul has been of great help to me in every respect and his commitment to have his company place a large quantity order made this book a reality.

I would also like to thank Sharon Jegen, Sales Manager of Custom Color Lab, and her team in Kansas City, MO, my reliable photo finishing resource for many years. Sharon worked very closely with Charlene Harter, custom printer, and Dee Connell, print enhancement artist, each of whom have created master prints for my clients, my exhibition needs and for this book. Thanks are also due to Kathy Allen and Larry Staton for adding the master style canvas finish which enhances the beauty of my wall-size portraits.

My other important resource that deserves my sincere thanks is Thanhardt - Burger Corporation, LaPorte, IN, whose museum quality frames—works of art by themselves—really make my works of art complete.

I also want to express my gratitude to my many colleagues—too numerous to thank individually—here and abroad, who have helped me as volunteer assistants and who have made their lighting equipment available to me.

Finally, I should like to mention that some of the portraits in this book, and some of the articles, have been previously published in various photographic magazines, including Professional Photographer, Studio Photography, The Rangefinder, Lens, The Creative Image (British).

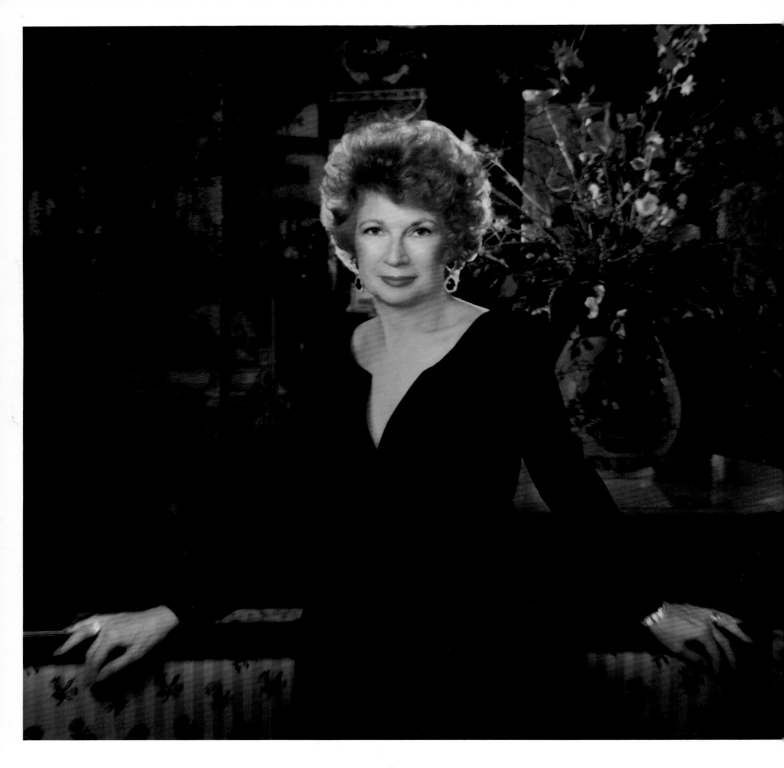

Dedication

To my wife Luci, whose love, good taste, judgment and unflagging
belief in me, have kept me on an even keel for forty years.

The wife of any successful photographer, artist, musician,
or actor, will know how much credit she deserves.

Contents

Preface

In all my 47 years as a photographer, I have never met serious portrait photographers who did not aspire to be recognized as artists. These photographers would like to feel they are contributing to the cultural life of their communities and be regarded as an equal to the area's painters, sculptors, classical musicians, and others in the arts.

There are outstanding photographers who have attained this position. Unfortunately, there are not enough. One reason, I feel, is that the education of many aspiring photographers is mainly oriented to the technical and business side of photography.

It is my belief that outstanding photographers share the same characteristics as leaders in other creative fields. They all have had excellent technical education or experience, but what makes them eminent in their fields is an inner drive to expand on their natural gifts and fundamental training. They view their work as a lifetime discipline and use the trials and errors of their life experience to pursue the highest degree of personal attainment in their art.

A portrait that can be considered a work of art must reflect the artist's predilections and style. It is the result of an agreement between the artist and subject. An artist needs to understand his subject and must be able to make his interpretation of the subject fulfill the subject's idea of how he or she wants to be perceived. But the best portraits go beyond the subject's immediate requirements and take on a life of their own. For instance, a portrait of a pianist, a painter, or a writer, should be recognized as symbolic of any pianist, painter or writer.

On the highest level of art, when the painter paints, sculptor sculpts, or photographer photographs his or her subjects, a meeting of the souls takes place. The subject is taken up with the art of the moment just as much as the artist.

Frequently, when I finish a sitting, both the subject and I are exhausted and exhilarated at the same time. We both feel that we were involved in an artistic experience.

We should not limit our vision just to making our work equal to what we see, but we should strive toward making our work more powerful than reality.

Photography as an art form, like all creative disciplines, must be learned by doing. To quote Edward Weston: "One does not think during creative work any more than one thinks while driving a car. But one has a background of years - learning, unlearning, success, failure, dreaming, thinking, experience, all this - then the moment of creation, the focusing of all into the moment. So I can make, without thought, 15 carefully considered negatives, one every 15 minutes, given material with as many possibilities. But behind this is all the eyes have seen in this life to influence me."

Alfred Stieglitz, in his essay *The Modern Way Of Picture Making* (1905) stated: "The only advice is to study the best pictures made in all media from painting to photography and to study them again and again, analyze them, steep yourself in them until they become part of your esthetic being. Then, if there be any trace of originality within you, you will intuitively adapt what you have thus made part of yourself, and tinctured by your personality you will evolve that which is called style."

The purpose of this book is to share with you my lifetime experience in pursuing portrait photography as an art form. The best instructions for making portraits are the portraits themselves. We learn by analyzing what works and what does not work. We learn the limits of the film and paper and how to use them to help us realize our vision. As much as possible, I am going to give you the ideas and concepts behind my portraits, as well as the technical information on how I created them.

I hope this record of my lifetime in photography and my unending pursuit of making portrait photography the art form I have always known it to be, will help you to join me in this ongoing quest.

How I Became a Portrait Photographer

My beginnings in photography were simple. In 1946, a year after World War II ended, I decided to leave school and join the army to see the world. I found myself at age 18 with the occupying forces in Japan, on the Imperial Palace Honor Guard in Tokyo, and with no particular plan for the future.

And then I won a raffle at the PX, and my life was to change. The prize: a Clarus 35mm camera with a 50mm f/2.8 lens.

This prompted me to go to the library and read everything I could about photography. My biggest problem was the scarcity of film in Japan. Luckily, a sergeant just in from the United States was willing to trade me a single roll of film for a souvenir.

I methodically set about making a record of everything I wanted to remember about Japan. Then, as now, all my photographs were of people. With film being so scarce, I couldn't afford to take two or three shots of anything, so I carefully posed all my subjects–a storyteller, a mother and baby, a farmer, a fisherman. I learned to control every element in the picture.

There is a moment in most photographers' lives when they are awestruck by the power of photography. This moment came for me at a small Japanese photo shop. The kind, elderly owner invited me into his darkroom to watch my very first roll of film being printed. To see my ideas, my dreams – a part of myself – come alive in that tray of developer was pure magic to me. I realized I could express myself in a way I had never dreamed possible. Photography's irresistible influence and glamorous attraction have stayed with me ever since that moment.

To this day, every time I take pictures I can hardly wait to see them finished. And I still visualize before I click the shutter, working everything out in advance. No surprises. I *make* pictures; *I don't take them.*

Soon I began selling prints to other servicemen who wanted to send pictures home. I sold 200 enlargements from that first roll of film at a dollar a print. It was more money than I had ever made before. That opened my eyes–fast!

When I returned to the United States, I went back to finish high school and inadvertently began a photography career. I became the photographer for my high school yearbook. The student advisor was a gifted teacher who wanted to produce an award-winning yearbook. She somehow convinced me that I could do a better job than the chain studio that held the contract for our senior portraits. Ours was the largest school in Virginia, with 750 seniors, and the idea scared me to death. The only qualifications I could bring to this task were the endless energy and enthusiasm of youth and a good basic knowledge of photography. I had no business experience at all.

After considering the possible careers available to me in 1949, I took the chance.

That chance paid off again and again in the years that followed. The number of high school seniors increased by approximately 20 percent every year for 20 years, and I held a virtual monopoly on all the school business in my area for 31 years. I opened three studios in area shopping malls, and I branched off into wedding and family portraiture.

In the early years, however, during the months I wasn't photographing seniors, I struggled to stay afloat. I photographed babies in a department store promotion for one cent a pound; I charged sailors one dollar for an 8x10 black-and-white print, then tried to make a profit by selling them extra prints, hand coloring, and cheap frames.

I realized very early that portrait photography in the fifties was not regarded as an art form but just a recording medium, and the average photographer shooting a wedding at an upscale reception hall had less status than a waiter.

My first long-range goal was to upgrade my portrait photography to an art form and be recognized as an artist. In 1964, an opportunity came that helped me make that transition. I had photographed the 22 top painters in Virginia, and my portraits were displayed in an exhibit, along with examples of the artists' works, at a local art gallery. The art critic of the local newspaper covered the exhibit opening and gave it an excellent review. And the Sunday arts section ran a full page of my portraits. It was the first time a portrait photographer had ever received such an honor. The museum director (of what is now the Walter Chrysler Museum) saw the write-up and, considering that other photographers, such as Richard Avedon, Yousuf Karsh, and Arnold Newman were being featured in museums at the time, decided to experiment and show my work.

The theme of that first museum exhibit, which opened in February 1968, was "The Cultural Life of Norfolk." In addition to portraits of painters, symphony principals, and ballet performers, it focused on many other of Norfolk's leading citizens, whose personalities and achievements had contributed to the cultural dynamism of the city.

The portraits set the tone of the show. There were 65 framed canvas-mounted color prints, ranging from 24"x30" to 40"x60", along with 22 black-and-white prints, some measuring an impressive 4x5 feet. This exhibit was the beginning of portrait photography becoming a respected art form in my area. And it was the first major exhibit of large photographic portraits on canvas in the United States.

With my new-found credibility, I was able to organize theme exhibits to hang in bank lobbies, libraries, schools, department stores, and, best of all, large shopping malls. A typical exhibit, for example, was titled "The Women of Hampton Roads." It consisted of 15 large, framed canvas-mounted portraits of women who had contributed to the civic and cultural betterment of the metropolitan area of Norfolk, Portsmouth, Virginia Beach, and Chesapeake (today called Hampton Roads).

In the past, civic and cultural leaders of a city were honored at dinners, had their pictures (usually unflattering ones) in the newspaper, or they may have had portraits painted of themselves to hang in public places. Founders of the city or important benefactors were honored by statues erected in public places.

Today, portrait photography makes it easy and less expensive to honor outstanding men and women. Portraits of people who never would have been recognized before can be seen by thousands of viewers at a mall, along with a newspaper article, or featured on television. My theme exhibitions are usually shown in all these media because the people selected are newsworthy or of human interest. The media needs something new every day to fill space and time; why not people who do good works instead of constantly featuring stories of war, violence, and disaster?

During my first 31 years, with the help of the very talented people on my staff, I was able to concentrate on improving my portrait work and creating a market for custom-crafted portraits. My first priority was to keep the highest quality of portraiture on display in public places as often as possible. The only way to convince the public to accept portrait photography as an art form is by continuously exposing them to it.

In 1981 I sold my portrait studios, in which about 240 people were photographed each day during the season from June through December. I had become a business executive sitting in an office all day, which was not what I really wanted to do. Don't misunderstand me. I admire successful business people and believe them to be as creative as artists; they just go about their work in a different way. But I wanted to work with people on a one-to-one basis and make the finest portraits I was capable of making.

Today I do all of my work on location. I no longer need a studio, I have no full-time employees – but plenty of "volunteer" assistants, when needed – and an answering service to handle my phone calls. I spend a lot of time with my clients and get to know them well enough to make portraits of them that deserve to be considered works of art.

In my 47 years as a photographer, I have dedicated myself to advancing portrait photography as an art form. I hope this book will further this endeavor.

The Five Tenets of my Philosophy of Photography

1. Portraits created by any other method cannot surpass the authenticity of the photographic portrait.

2. It is hard to climb to the peak of photographic quality, and it takes even more effort to maintain it when you reach it. But unless you make the journey, you are confined to the valley of mediocrity all your life.

3. You can capture a bit of someone's soul with your camera, but you have to give them a part of your soul in return.

4. There can be passion without art, but there can be no art without passion.

5. When you put your name on your work, you are telling people what you think of yourself.

Four Masters of Photography Who Inspired Me

"If I have seen farther, it is by standing on the shoulders of giants."

Sir Issac Newton, 1642-1727

There are many kinds of portrait photographers. Portraits are made by amateurs, art photographers, photojournalists, editorial photographers, fashion photographers, advertising photographers, and photographers that fit into no specific category. The subject in most of their portraits does not necessarily have to approve the selection of the pose and in many cases will have no control or decision over the finished portrait.

The photography in this book is about the portrait a person commissions for himself or herself, a loved one, or for an institution or similar use. This style of portraiture generally has to please the subject, or the photographer has not succeeded and probably will not be fully paid for his services. Its purpose is to make a flattering and optimistic statement about the subject.

Among the many great photographers who have preceded us, there are four masters who, I feel, have done the most to advance portrait photography as an art form and who have had to please their individual customers for a good part of their careers. It is the work of these masters that has had the greatest influence on me and my work. During their careers, Julia Margaret Cameron, Edward Steichen, Yousuf Karsh, and Arnold Newman have each changed portrait photography with their style. The entire history of portrait photography can be encompassed within the lifetimes of these photographers.

Julia Margaret Cameron was born in England in 1815 and is generally thought of as the finest early portrait photographer. She was noted for making pictorial portraits illustrating the poems of Alfred Lord Tennyson. Her finest works, however, were the beautiful and remarkable close-up portraits of the great Victorians, including Robert Browning, Charles Darwin, Alfred Lord Tennyson, Longfellow, and Sir John Hershel. With her insightful personality, she was able to capture their strength and character, and she made some of the most sensitive portraits ever produced.

Edward Steichen was heralded as being the most influential person on the state of the art of photography during his lifetime. He was born in Luxembourg in 1879, the same year Julia Margaret Cameron died, and moved to America at a young age. His life in photography began when the art was still in its primitive stage, and he lived to be instrumental in bringing it into the modern world.

By 1902 Steichen was beginning to be recognized as one of the finest photographers in the world. From 1923 to 1938, he was chief photographer for *Vogue* and *Vanity Fair*. Many of the world's most famous people sat in front of his camera during those years, among them his brother-in-law Carl Sandburg, Greta Garbo, Charlie Chaplin, Winston Churchill, and Franklin D. Roosevelt.

He was one of the first portrait photographers to do advertising photography for magazines. Before Steichen, most magazine illustrations were artists' drawings and paintings. Steichen put together "The Family of Man," the first major museum exhibit of photography as an art form. His biography, *My Life in Photography,* should be read by anyone seriously interested in a career in photography. He died in 1973 at the age of 94.

Yousuf Karsh was born in 1908 in Armenia and, after a difficult childhood, emigrated to Canada at the age of 16. From 1928 to 1931 he was apprenticed to photographer John Garo in Boston.

Karsh returned to Canada in 1932 and opened a studio in Ottawa, Ontario. Prime Minister W.L. Mackenzie King took a personal interest in Karsh and arranged for him to photograph Winston Churchill. Karsh zoomed to international prominence when the photograph appeared on the cover of Life magazine in December 1941.

Karsh has photographed more world leaders and celebrities than has any other portrait photographer in the entire history of photography. He is known for portraits of such illustrious people as Edward Steichen, Ernest Hemingway, John F. Kennedy, Pablo Picasso, Georgia O'Keeffe, Pablo Casals, and Queen Elizabeth II. Karsh has been setting new standards of portraiture from the end of World War II to the present day.

Arnold Newman, born in 1918, is the only one of the four photographers born in the United States. He is an entirely American artist, and his viewpoint is quite different from the rest. He defined and established the environmental, on-location portrait as it is known today. His work is prized wherever institutions collect fine photography.

Each of his portraits is unique; there is no formula or repetition to his work. Its composition is complex in its use of angles, cropping, and collages. Newman blends his subject into a design of shapes and lines that makes a powerful statement about the subject's personality and character.

Newman is unequalled in his ability to use modern design to tell a story about his subjects, which is dramatically demonstrated in his portraits of Igor Stravinsky, Edward Hopper, Aaron Copland, Piet Mondrian, and David Hockney.

Arnold Newman has brought portrait photography to its present state of the art, and his work has influenced – and continues to influence – the work being done by our best illustrative photographers today.

The Beginning of Photorealism

"How can you know where you are going unless you know where those before you have been."

The environmental or location portrait that tells a story about the subject has been with us for a long time. The Northern European painters of the early 1400s were the first to paint the realistic portrait in what we would now call photographic detail. This is especially true of the Flemish school, established by Jan van Eyck.

Flemish artists drew and painted every wrinkle in a face, every hair in a beard, and every thread in a shawl. Jan van Eyck put down on paper or panel, as exactly as possible, what his eye saw. He scrutinized the sitter and the surroundings with a desire to render everything both near and far as realistically as possible. He was one of the first, if not the first, painter to use linseed oil as a solvent of pigments. This permitted him to get greater detail in his paintings than had been possible before. His full-length painting *The Arnolfini Wedding Portrait* (1434), now at the National Gallery in London, was the first major example of this technique and is reproduced here.

Today, color photography is capable of capturing even more detail than a painting. But the limitations of optics, film, and paper prevent photography from making a portrait with the microscopic detail of the van Eyck wedding portrait. The depth of field in the painting, from the dog in the foreground to the details of the back wall of the room reflected in the convex mirror, would be beyond the capability of a lens to keep both in focus. Color film and paper can achieve a tonal scale of only some 16 to 19 tones from light to dark; a painter, though, can achieve an almost infinite number of tones from dark to light. The painter is limited only by his skill, or more correctly, his lack of skill.

The advantage of the photographic portrait is its accuracy and its instant rendering of the detail it would take hours for a master artist to paint. Consider, for example, the chandelier in van Eyck's wedding portrait. A top artist told me that it must have taken him days to paint it. A painting can add tones to the human complexion that do not exist; a color photograph is capable of recording all the tones in a face that do exist. In addition, a photographer can provide the subject with a variety of poses and expressions to choose from; a painter usually gives only one.

A portrait painting and a portrait photograph are two different things. A painting cannot match the detail, realism, authenticity, and the immediacy of a moment in time that a photograph can, and a photographer cannot match the rich color scale, tonal scale, mystery, and total immersion of the master painter's self in his work.

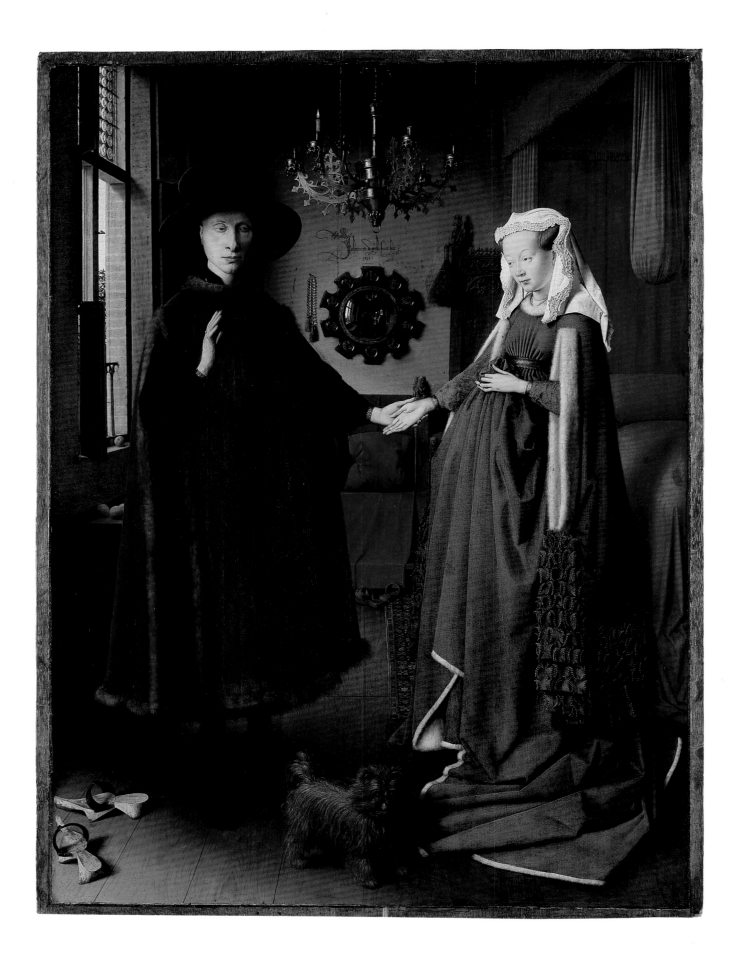

The Classic Portrait

The term "classic" brings up several questions. What is a "classic portrait"? Why is one portrait considered a classic while others are not? Is a classic portrait a work of art?

"Classic" implies timelessness. There are three elements that elevate a portrait from one that is merely a pictorial record, to one that has a timeless quality: *Design, Pose* and *Color Harmony.*

1. *Design* is your concept or idea of where the portrait is going to be made, the space or background you will use to reflect the lifestyle or preference of the subject. Composition is part of design and defines how you will arrange the subject and other elements in that space to form a complete visual statement.

2. *Pose* considers how and why and where you position your subject after you have decided on the location.

3. *Color Harmony* is the blending of the colors of clothes, furniture, plants, artifacts and background together, to make a pleasing picture.

Is a classic portrait a work of art? Art means different things to different people and, like beauty, often is in the eye of the beholder. But a work of art is something that stands the test of time. I would say that a fine classic portrait is definitely a work of art.

The Future of The Art of Portrait Photography

Several years ago I made a portrait of the retiring music director at a church in Norfolk, VA. At a reception after the unveiling of the portrait, an elderly gentleman approached me, took my hand in both of his, and said that twenty years ago I had photographed his wife. He told me that she had died two years ago, and the portrait I had made of her was his most treasured possession. I saw his emotion, and I, too, was moved by his feelings. What greater reward could a portrait photographer enjoy than to have captured an image of loved ones that would continue to remind the family and friends of the love and influence they had on their lives?

The gentleman was thanking me for capturing the part of his wife's personality that he loved and was familiar with. It may have been only a twinkle in her smile, or a pensive or reflective look, but he has a portrait of his wife the way he remembers her.

It would seem that everyone would want photographic portraits of their loved ones, and fortunately for photographers, most people do. However, many people are perfectly satisfied with a tiny snapshot, glossy 5x7, or "huge" (to them) 8x10, perhaps made for business purposes. Often the frame costs many times more than the photograph.

Rarely does one see a photographic portrait on a wall in upper class homes. Perhaps the reason for this is that the quality of most photographic portraits has been inferior to painted portraits. There have not been many photographic artists making custom portraits for the affluent market, and the vast majority of the public has not been exposed to the finest portraits available.

But portrait photography as an art form is coming into its own. Museums are displaying the work of portrait photographers on a regular basis. There are photographic portraits by Karsh of Margaret Thatcher and John Major hanging prominently in the National Portrait Gallery in London. More and more official portraits of executives are the work of photographers. I photographed Admiral Frank Kelso, the retiring Chief of Naval Operations, for his official portrait. It hangs in the Pentagon next to paintings of all the previous chiefs. It's the first time that a photograph was used, instead of a painting, for an official portrait of a CNO.

I can predict with some confidence that this trend will continue, and more and more of our government, military, and business leaders will move away from paintings and toward photographic portraits.

There will always be formula-produced portraits made in discount stores. There will always be portraits made in studios and outdoors for a moderate price. But the day is coming when custom color portraits that take as much as a day to plan and photograph – not to mention the considerable art work involved in finishing the prints that are enlarged to 16x20, 24x30, or more, mounted on canvas, and dressed up in an attractive custom-made frame – will be seen on the walls of homes and featured in upscale architecture and design magazines. It will not be uncommon to see photographic portraits on the walls of million dollar homes next to museum-quality paintings.

Great portraits will sell for many thousands of dollars and the frame will be a substantial part of the cost. But they will still be a bargain because a painted portrait would cost many times more.

In some areas it is happening now. The trend can only expand and grow, because this is the era of portrait photography as an art form.

My Tools and Techniques

While the painter needs only brushes, colors, canvas, and an easel, the modern photographic artist requires extensive equipment, which, if it is to serve its purpose, must grow on him and practically become part of him. I certainly could not achieve my desired results without the hardware that has become available only during the past few decades.

Camera

In the early days of my career, my camera of choice was an 8x10 wooden studio camera with a 5x7 reducing back and a 3½x5 split feature. To get the finest quality black-and-white results, the 8x10 was necessary. Full 5x7 was almost as good, but 3½x5 was good only to an 11x14 enlargement.

The films of that era were great for reproducing a full range of tones from the deepest black to the brightest white, but they were in no way as fine grained or sharp as today's films.

Portraits in color began to appear in studios in the late fifties and throughout the sixties, but they did not overtake black and white and hand-colored portraits until the early seventies. The great improvements in color-negative film, pioneered by Eastman Kodak, and the introduction of the Mamiya RB67 medium-format SLR camera in 1970, paved the way.

For me, this camera was love at first sight. It uses 120 and 220 film and its 6x7cm negatives enlarge to the standard 8x10 inch format without cropping. The image is large enough to be analyzed without a magnifier and looks good on Polaroid proofs. Its bellows and convenient rack and pinion focusing, with focus lock, work just like on my view camera. Bellows focusing permits use of lenses from extreme wide angle to telephoto and allows close-up photography without accessories. This also keeps lens prices lower because it eliminates the need for a helical focusing mount on each lens. The camera also has a revolving back, so I can compose horizontally or vertically, without moving the body.

In the early eighties, the electronic Mamiya RZ67 came on the market and I switched to it because its additional features are important to me. Its accessory power winder, which recocks the shutter and advances the film, and its radio remote control, permit me to leave the camera and to direct my subjects, especially children, in close proximity and then step to the side and shoot away. No long cable release or air hoses are in the way, and there is no need to return to the camera after every exposure.

I also love the AE Prism Finder with its through-the-lens metering, in both the average or spot metering modes. It serves me well for my outdoor photography. I particularly appreciate that an ISO film-speed dial is part of every film magazine and Polaroid Back. I set the film speed when I load film and never have to worry about it again.

A flip-up magnifier with diopter adjustment that attaches to the prism finder is most useful for critical focusing, especially when I shoot with the Mamiya 150mm f/4 variable soft-focus lens.

Lenses

As you have noticed, I own and use an arsenal of Mamiya lenses. That's because different focal-length lenses control the angle of view, perspective, sense of proportion, vista, and an outlook on your subject that expands your visual horizons. Human beings are the most complicated, enigmatic, and mysterious subject matter you will ever encounter with your camera. Why should we limit ourselves to only one or two points of view of our subjects? Imagine playing golf, needing a four-iron for a shot, but you only have a seven-iron!

A professional photographer should know what equipment will help create any style portrait he may wish to make, and he should have it available when he needs it.

The portraits in this book were made with the Mamiya fisheye 37mm f/4.5 lens; 50mm and 65mm wide-angle lenses; 90mm and 110mm normal lenses as well as 140mm macro, 150mm variable soft focus, 150mm standard, 180mm, and the 210mm APO. Each lens has different characteristics and helps me create the exact type of portrait best suited to my subject.

I frequently use wide-angle lenses in my portraiture and particularly the 65mm lens. Wide angle lenses are necessary if you want to create a portrait with an interesting background that tells a story about the subject. It requires skill and practice to take advantage of the great depth of field which these lenses offer, without being troubled by distortion. Care must be taken to place the subject in the center of the image and to keep hands and feet in the same plane as, or even behind, the face in order not to have them appear too big. The portraits on pages 79, 205, 207, and 209 are typical examples. Note how I placed the hands.

Another one of my favorite lenses is the 150mm f/4 Variable Soft Focus. Its optical design produces images of varying softness between f/4 and f/8. Stopped down beyond f/8, its sharpness equals a normal lens. It comes supplied with three interchangeable discs, which are placed into the lens barrel and which permit further modulation of the image. The results this lens can produce are unique and most appealing for certain subjects and lighting conditions. Pictures taken with this lens have a certain ethereal quality that cannot be equalled with diffusion filters placed in front of or behind the lens. (Because there are no wide angle lenses of this type available, I must use diffusion filters with such lenses if conditions require it.) Another great advantage of the variable softness lens is that it eliminates a great deal of retouching.

Lens Shades

All Mamiya lenses come with factory supplied rubber lens shades, but I prefer the Mamiya G3 Bellows lens hood. It features side struts which expand and contract by means of a geared drive knob and thus needs no base or side rail which might interfere with wide angle lenses. It accepts 3" square filters and vignetters (which I don't use). Its square shape and 7" long bellows allows me to extend the G3 beyond the range of standard shades and thus block out more of the ambient side and back light that I frequently use.

Exposure Meter

There are many good universal exposure meters on the market which measure both flash and ambient light. I use a Minolta III, because I am comfortable with it, even though newer models are available.

Polaroid Proofing Back

My portraits are designed to make a statement about my subjects. This requires a setting or a background with many elements in it. While an exposure meter is essential, I could not fine tune my lighting and composition without first making a Polaroid check. That's why I am presenting a typical example of how Polaroid serves me on page 158 (The Artist and the Model).

Film Magazines

I never go on an assignment without at least two loaded 220 magazines and one loaded 120 magazine. Considering all other expenses that go into creating a superior portrait, film is cheap and there is safety in making many exposures.

Tripods

A sturdy, heavy-duty tripod is a must. Equally important is how high it can be raised. One of my tripods is ten feet tall, and sometimes this is still not sufficient when I need a high

camera angle. A tall tripod requires a matching ladder. I use Arca-Swiss Monoball heads on my tripods. They are really precision made and their aspheric ball and socket permit easy and rock-steady camera positioning.

Lighting Equipment

My lighting equipment cases hold eight flash units, and one battery powered model that I need for fill-flash outdoors. Sometimes I have to borrow or rent additional ones.

Last but not least....

All the hardware listed is required to produce my best possible color negatives. However, I would be remiss if I did not give credit to my friends at companies, who take over after I have completed a sitting. They contribute an important part to my success, and they have served me reliably and efficiently for many, many years.

Custom Color Corporation, Kansas City, MO (800-821-5623)

Established in 1959, this lab offers all the services a demanding professional could want. They process my film, make my 24x30 inch (and up) enlargements, transfer them to canvas backing, and mount them on Masonite boards, ready for framing. In spite of my striving for perfection in lighting and composition, it is sometimes necessary to airbrush a certain section of a print to tone it down, to add clouds to a plain sky, or to do some other retouching. They also have electronic-imaging facilities, which I occasionally need to solve otherwise impossible problems. (For a typical situation, see page 194)

Thanhardt-Burger Corporation, LaPorte, IN (800-826-4375)

The source of the beautiful frames which make my portraits sparkle. They deserve the special chapter, starting on page 212.

Special Notes

In describing my lighting techniques in this book, I frequently state the placement of my flash units at certain angles to the subject, expressed in degrees. For this purpose I visualize a horizontal clock with the subject positioned at 6 o'clock. If the flash is at 9 o'clock I call it a 90 degree angle to the subject's left; at 10:30 o'clock a 135 degree angle to the left, etc.

When I talk about the right or left of the subject or a room, I mean the right or left of the reader when he looks at the pictures.

When I state long exposure times, like for instance 2 seconds, it is always a situation where I want to capture details in the background, illuminated by ambient light, whereas the subject itself is only lighted by the flash exposure of typically 1/1000 sec. In such situations, I always turn the modeling lights in the main light and fill light off, in order not to overexpose the subject's face.

In books like this, lighting plans are frequently shown in diagrams. I prefer describing them in words, because I feel the graphics of the lighting plan on the left page interfere with the the study and contemplation of the portrait on the right page.

Outdoor Portraits

The most popular portraits I create for my clients are made outdoors in private yards, public gardens, at the beach, near a lake, or in a state park. Almost every city has some public green space that can make an excellent location for photography. So do the attractive, lovingly tended gardens around many homes.

The best time for outdoor photography is in the early morning or late afternoon. It's best to avoid the hours between 11 AM and 2 PM because in the middle of the day, the sun is so high in the sky and its rays so harsh, that it is hard to use it as a backlight. In most other positions it might cause your subjects to squint. I frequently like to use backlight plus fill-flash, because it gives brilliance to the portrait, separating the subject from the background.

My fill-flash routine consists of using a bare bulb flash to light the face and front of my subject when the sun is backlighting it. I aim my meter towards the camera from the face of my subject and get an incident light reading and set the camera and lens accordingly. Then I set the fill-in flash output for one stop less exposure. For example, when the incident reading for the face is f/8, I would set the fill-in flash for f/5.6. This gives me a 2:1 lighting ratio to make my subject's face stand out without overbalancing the backlight effect.

Just before sunset or after sunrise are my favorite times to make portraits if there is enough open space around the subject. The problem is that gardens and parks often have many trees that can block the sun in the late afternoon or early morning, so you must plan your location carefully.

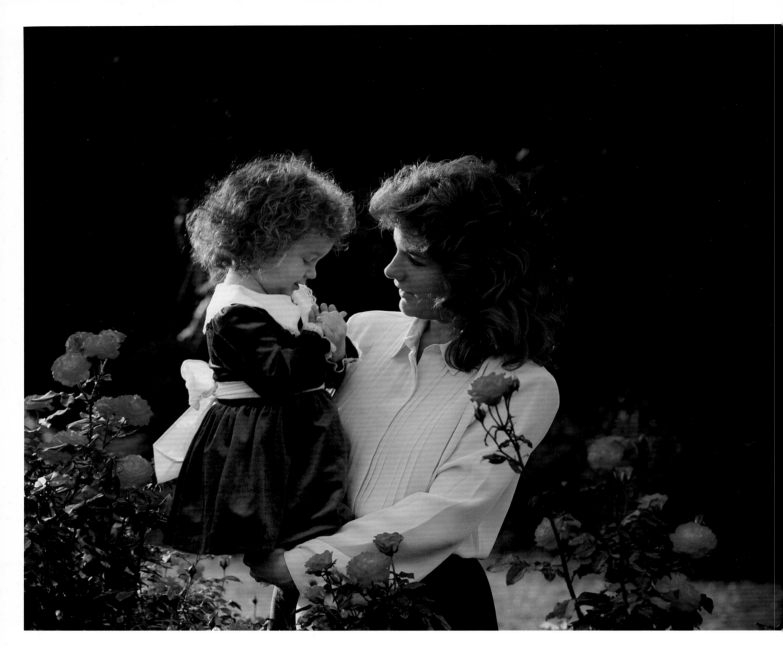

Kala and Ashlynn DiCiero

Kala is having a mother/daughter talk with Ashlynn. This type of portrait is pure serendipity; it cannot be planned. I noticed Ashlynn asking her mother what was going on, with the bright flash light going off and the noise of the camera winder advancing the film. Kala was explaining that I was taking their picture. I decided to be quiet and just expose film. Fortunately, we both got what we were looking for.

I used the 180mm lens to bring the background closer to the subjects. A normal 110mm lens would have included some of the sky and too many trees. The bare bulb strobe was set to light the faces.

Camera:	Mamiya RZ67
Lens:	Mamiya Sekor 180mm f/4.5
Exposure:	1/60 sec at f/11
Lighting:	Natural outdoor lighting in late afternoon. Bare bulb fill-flash set for f/8
Film:	Kodak Vericolor III ISO 160 exposed at ISO 100

Natalie Jackson Watering her Flowers

Natalie is three years old and she really does not care if I get a picture of her or not. She is an adorable little girl who wants to please, as long as it is fun. My job is to make it fun.

I gave Natalie the watering can and told her I wanted her to water the flowers just like the little girl in the nursery rhyme "Mary, Mary, quite contrary, how does your garden grow. . ." She walked up to it and dumped the whole can of water on the flower at once, watering the flower and her shoes at the same time. Her mother wiped off the shoes and we decided to try it again, but without the water. I got down on my knees and whispered that if she walked very slowly over to the flower and touched it with the spout of the can, something magic would happen. She did, and something wonderful did happen: I got the picture.

Camera:	Mamiya RZ67
Lens:	RB 150mm f/4 variable soft-focus with f/4.5 disc
Exposure:	1/125 sec at f/4.5
Lighting:	Natural outdoor lighting in late afternoon. Bare-bulb fill flash set for f/2.8.
	I positioned Natalie so the late afternoon sun would rim her with a strong backlight. A gobo on a stand blocked the light from shining into the lens.
Film:	Fuji Reala 100

\triangleright

Mrs. Michelle Bowling and Jeffery, Jr.

On one of my many scouting trips looking for backgrounds, I found this lovely spot with oleanders brilliantly lighted from the back. Michelle was interested in an outdoor portrait, and I thought this would be a perfect background for her and her little boy.

When working with a mother and child, I first try to get a good pose of them looking at the camera. Then I let them do something together to get an interplay. Usually, this makes the better portrait.

Camera:	Mamiya RZ67
Lens:	Mamiya Sekor 110mm f/2.8
Exposure:	1/30 sec at f/11
Lighting:	Bare bulb strobe main light set for f/8
Film:	Fuji Reala ISO 100

\triangleright

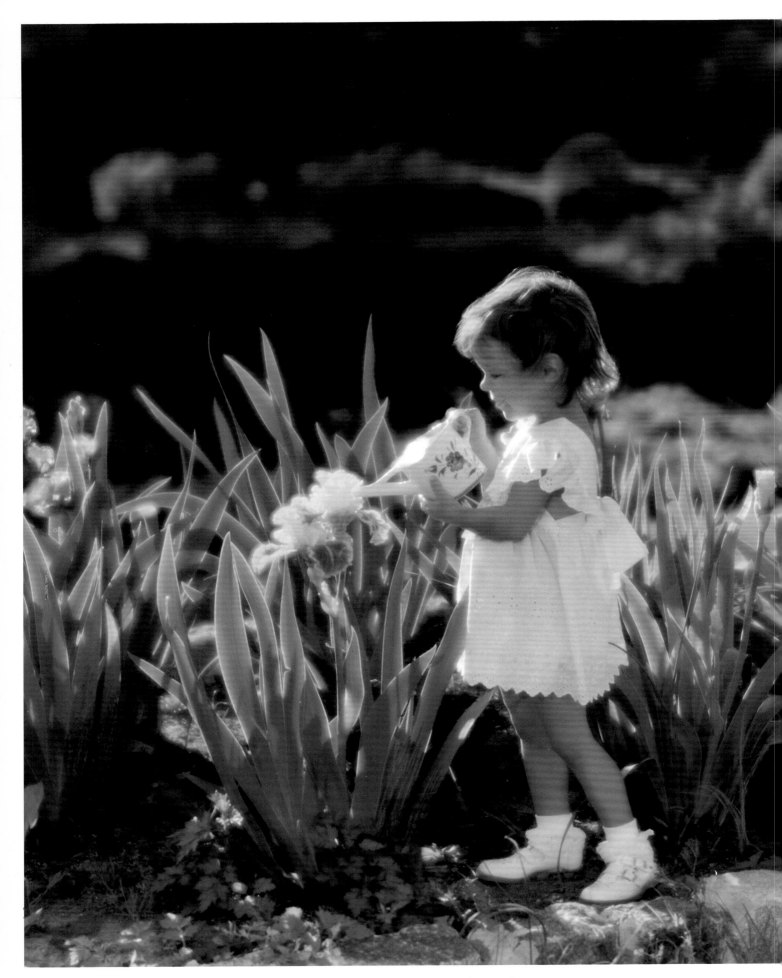

Natalie Jackson Watering her Flowers

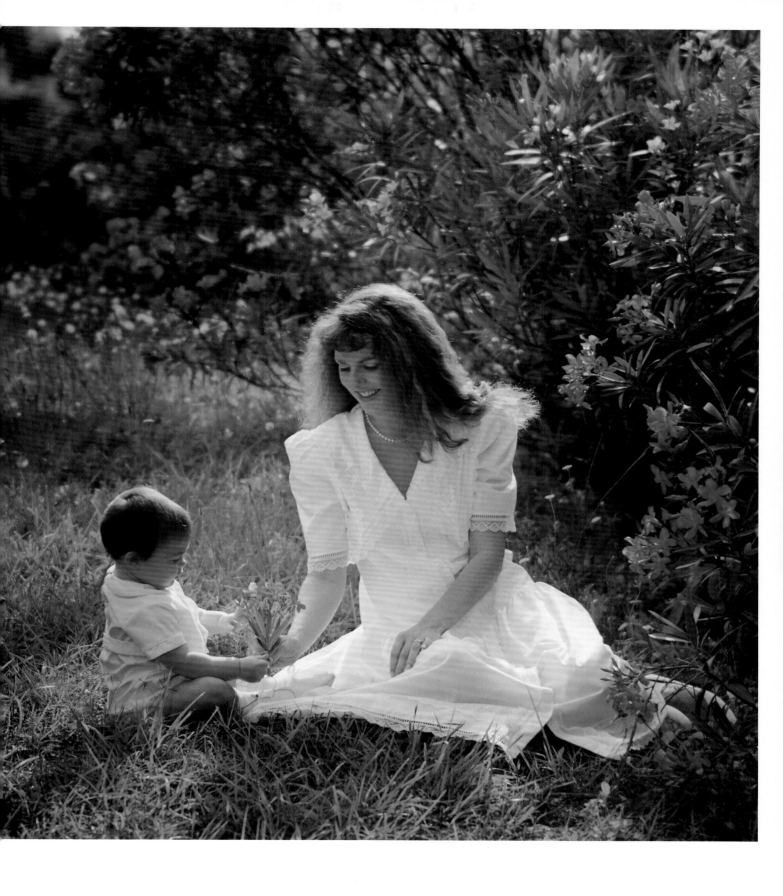

Mrs. Michelle Bowling and Jeffery, Jr.

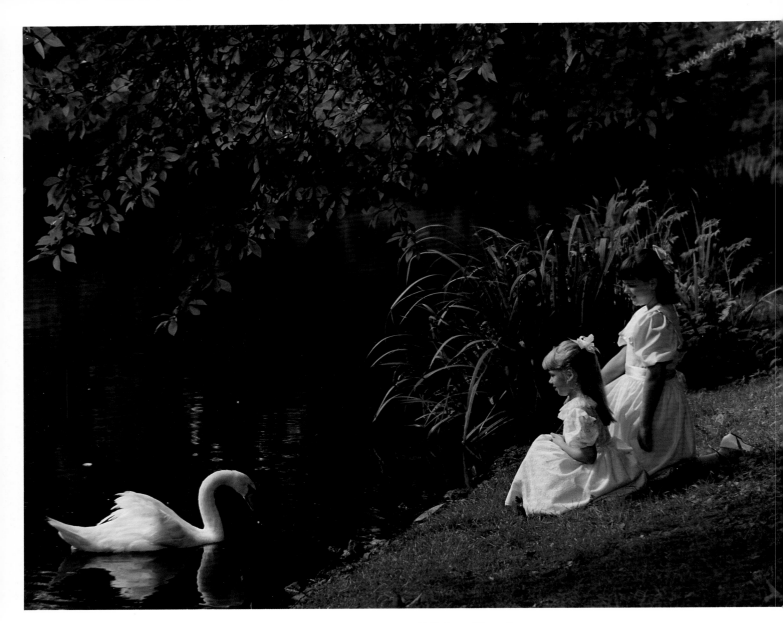

Jamie Lynn and Lisa Braban

I photographed the Braban sisters in the gardens of the Governor's Palace in Williamsburg, Virginia, for a local PBS television program on how a portraitist photographs children outdoors. The television station arranged for us to use the gardens early in the morning, before they opened to the public. Normally, they are not available for professional portraits.

I always plan my portrait sessions in advance. I had visited these gardens previously and knew to come prepared with bread for the swan and small stones to toss near the multitude of ducks to keep them out of the picture. The pose, background, and time of day were set; I only had to worry about the girls and the swan. I need not have worried – all came through beautifully.

Camera:	Mamiya RZ67
Lens:	Mamiya Sekor RB 150mm f/4 variable soft-focus without disc
Exposure:	1/125 sec at f/6.3
Lighting:	Natural outdoor lighting in early morning. Bare bulb fill-flash set for f/4.5, just enough to fill in dark shadows.
Film:	Kodak Vericolor III ISO 160 exposed at ISO 100

Brittany Swan

Brittany is eight years old. I told her that she had to pose just right because I was going to put her portrait on display and someone from Hollywood might see it and she would be "discovered." She really didn't believe me, but she posed anyway.

I asked Brittany's mother to have her wear a pretty white dress, and I placed her behind the trellis so the roses and trellis formed a frame around her. We made the photograph at sunset, just before the sun dropped below the horizon. Because the light was soft, I used a sharp lens to give more contrast and sharpness.

Camera:	Mamiya RZ67
Lens:	Mamiya Sekor Macro 140mm f/4.5
Exposure:	1/15 sec at f/5.6
Lighting:	Natural outdoor lighting at sunset
Film:	Fuji NPS ISO 160

Carissa, Book and Roses

I photographed Carissa one hour before sunset. I placed her so the sun was to the left and behind her, backlighting the roses and making her stand out from the grass. Her white dress was specially selected for this shooting session. I used a bare-bulb flash, set for one stop less exposure than the backlight, so as not to overpower it.

Camera:	Mamiya RZ67
Lens:	Mamiya Sekor RB 150mm f/4 variable soft-focus lens without disc
Exposure:	1/250 sec at f/6.3
Lighting:	Natural outdoor lighting before sunset. Bare bulb fill-flash set for f/4.5
Film:	Fuji NPS ISO 160

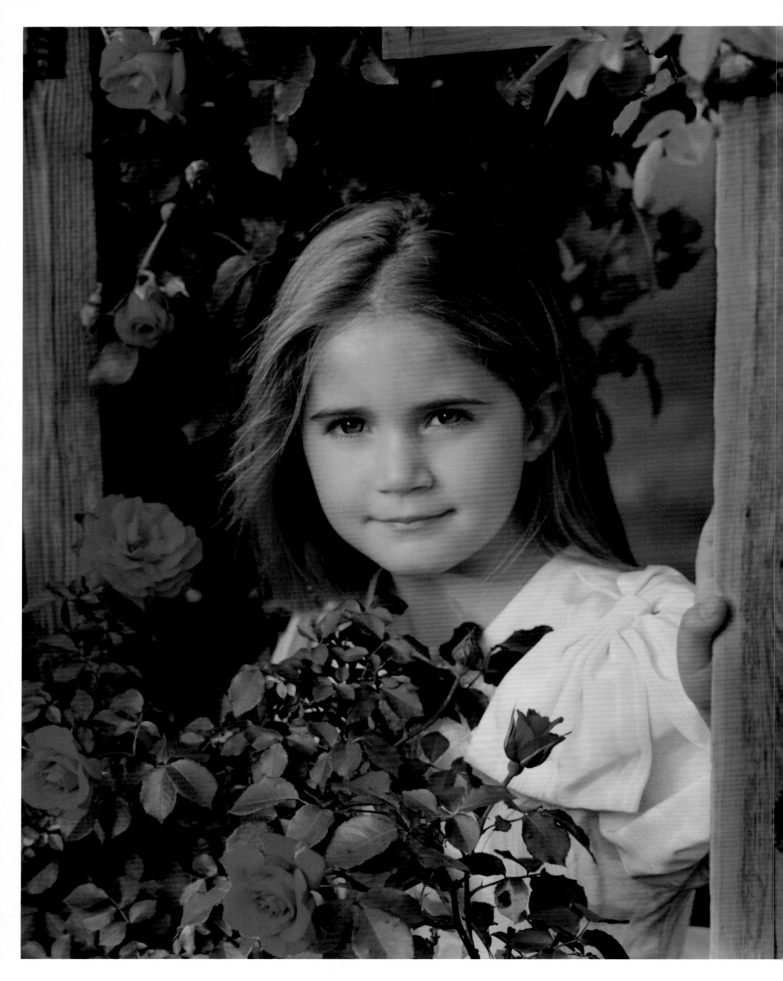

Brittany Swan

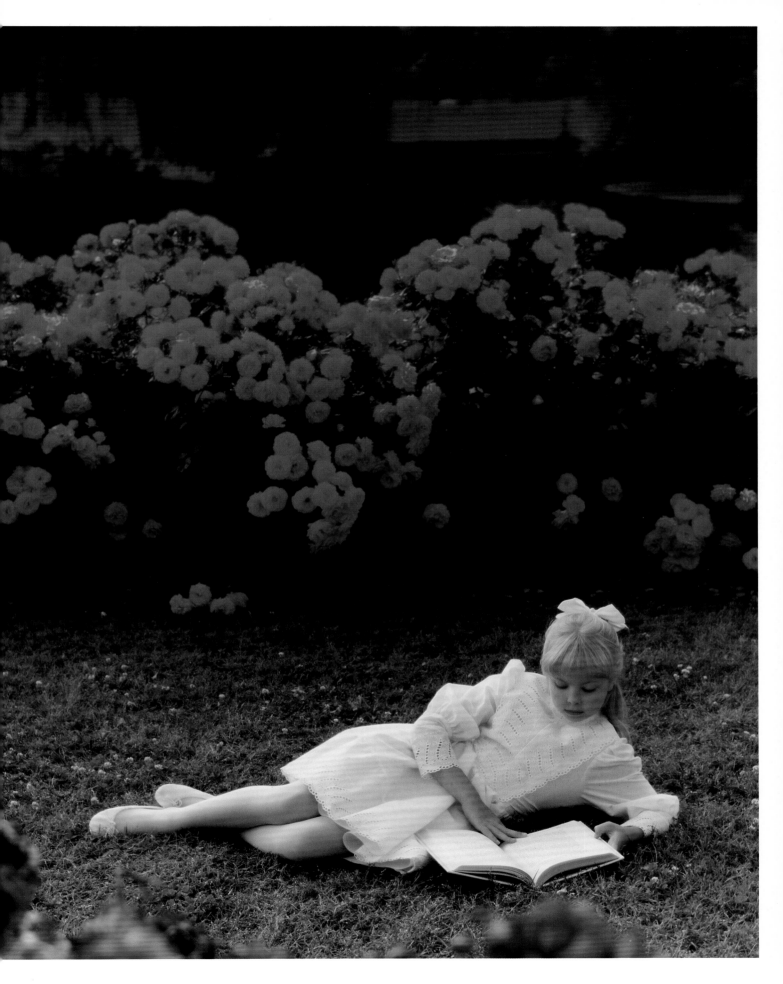

Carissa, Book and Roses

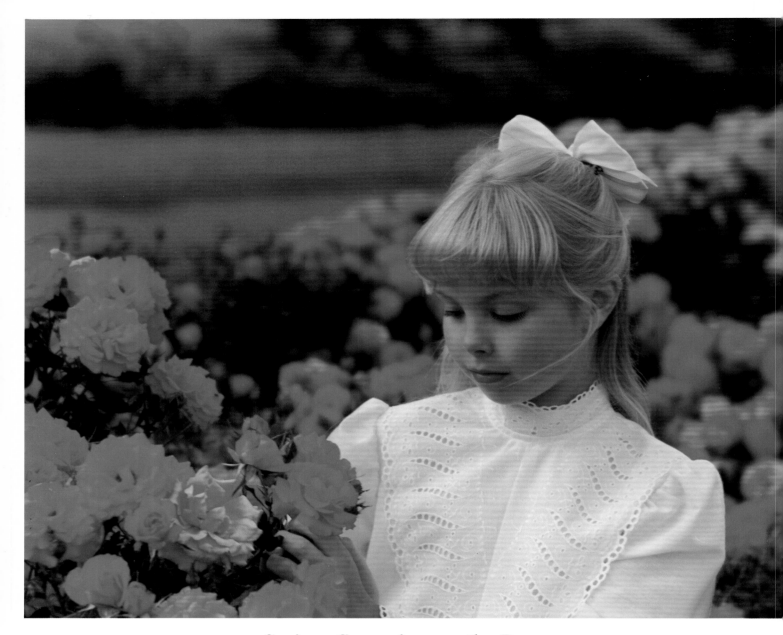

Carissa Graza Among the Roses

I have been photographing Carissa Graza since she was five years old. She always has been easy to photograph, but now at ten years old, she has an active imagination and I can talk with her about Snow White, Alice in Wonderland, and other fascinating things.

Photographing her among the roses, I wanted her to have a serene, reflective look. I asked her to think about how Alice would look if she were dreaming about roses and going to a magic place full of beautiful flowers that were even prettier than the garden she was in now. Young girls over the age of seven or so like to talk, so I engage them in a conversation and keep taking pictures until I get the result I want.

Camera:	Mamiya RZ67
Lens:	Mamiya Sekor RB150mm f/4 variable soft focus, without disc
Exposure:	1/30 sec at f/6.3
Lighting:	Natural outdoor lighting in late afternoon
Film:	Fuji NPS ISO 160
Comments:	I used the soft-focus lens without a disc. The results are slightly soft, but not as soft as they would have been with a disc. Also, this avoids the halo a disc produces.

Jennifer Power on the Garden Wall

I have made portraits of Jennifer every year since she was two years old. For this one, I wanted a rather formal pose, similar in style to those used by Gainsborough when he painted the children of the English nobility in the 1700s. Jennifer's mother and I decided the frilly white dress and hat would be just right. The background, wall, white dress, and backlighting would make Jennifer stand out beautifully.

The choice of soft focus versus sharp lenses for my outdoor portraits of children depends on the instinctive feel I have about the child and the background. The lighting on Jennifer was bright and contrasty, but I wanted a soft effect. The soft-focus lens is ideally suited to produce this result since it tends to lower the contrast at wider lens openings.

Camera:	Mamiya RZ67
Lens:	Mamiya Sekor RB 150mm f/4 variable soft-focus without disc
Exposure:	1/125 sec at f/5.6
Lighting:	Natural outdoor lighting in late afternoon
Film:	Kodak Vericolor III, exposed at ISO 100

Travis Allen Fuentes

Travis is four years old. A four-year-old will last only as long as his interest in the game you have concocted – which is about four minutes – if you are lucky!

When Travis arrived with his father, my camera was already set up on a seven-foot-high tripod, looking down at the forest of trees in the background. I was on a ladder behind the camera with a concealed toy monkey. I told the young man that I had a monkey that would play in the tree with him if he did exactly what I asked him to do. His dad boosted him into the fork of the tree, which was about four feet off the ground. I told Travis how I wanted him to pose, and he did it – just long enough for me to get one exposure.

Camera:	Mamiya RZ 67
Lens:	Mamiya Sekor 65mm f/4
Exposure:	1/60 sec at f/8
Lighting:	Cloudy day. Bare bulb fill-flash set for f/6.3
Film:	Fuji NHG ISO 400

Jennifer Power on the Garden Wall

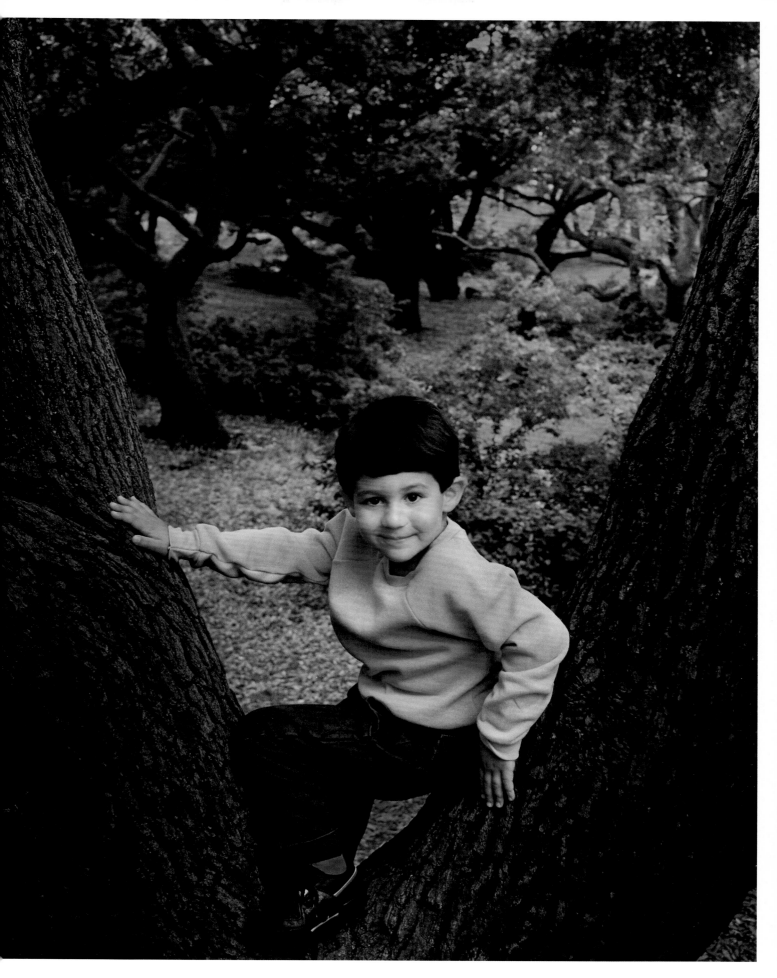

Travis Allen Fuentes

The Family Group Outdoors

Just think, the whole outdoors is yours for making a family group portrait. It sounds so easy. Just go outside to the backyard, to the beach, to a park, or by a lake; have everyone dress casually, and take the picture. For the most part, this is all you are going to get: a picture.

An outdoor portrait that can be considered a work of art requires considerable planning and control. The outdoors is visual chaos that must be controlled to make any meaningful portrait, especially of a family group.

In any open area, such as a beach or field on a sunny day, the time of day is critical. If the sun is too bright, the subjects will squint. However, a fill-in flash lets you use a park, wooded area, or a backyard with some shade at almost any time of day. An experienced photographer will continually scout out areas to find new backgrounds that will enhance his subjects.

Clothes are 75 to 80 percent of the portrait, and what the subjects wear is an essential consideration. Their clothes should be coordinated for color, tone, and style. Otherwise the portrait will be nothing more than just a record. If, for example, some people have short sleeves, some long; some wear light pants and skirts, others dark; some have brown shoes, others white; and each person wears a different color and pattern, the result is going to be unattractive and will draw attention to the clothing rather than to the faces.

There are no absolutes in photography or any art. It is all a matter of taste. There are, however, some guidelines that always work.

White clothes are fine if the subjects are of average weight or slender. If not, the light will bounce off the white shirt or blouse and make the person's neck and jowls look larger. If the subject is of average weight, the photographer can correct for this; if not, he can do a little, but not enough. Wear white or pastel, you gain ten pounds; wear dark or medium shades, you lose ten.

Solid-color clothes, in cool or neutral shades, with long sleeves, always look good. Cool colors, such as blue and green recede, and warm colors, such as red, orange, and yellow, advance. Cool colors or neutral colors (such as black, white, and gray) will emphasize the faces and make them appear warmer and more pleasing in the photographs.

The Stephen Michaels Family

I met with the Michaels family on the beach on a warm day in late winter. The sun is more subdued in the winter, so you can usually work without worrying about your subject's squinting. The great thing about the ocean front as a background is that it changes every day, and the change is even more dramatic in the winter. I also like the warm color of the sea grass.

The composition of my group is an asymmetrical inverted triangle. If you split the picture in half, the part with the mother and son is about equal in visual weight to the larger and heaver weight of dad and the dog. The inclined fence (just barely visible) helped me position the group in a natural pose.

The afternoon sun to the left of the subject was a bit harsh, so I filled in the shadow side of the faces with a bare-bulb flash.

Camera:	Mamiya RZ67
Lens:	Mamiya Sekor 110mm f/2.8
Exposure:	1/125 sec at f/8
Lighting:	Natural outdoor lighting in late afternoon with sun to left of subjects. Bare bulb fill-flash set for f/5.6
Film:	Fuji Reala 100

The Edward Stein Family

I have been photographing the Stein family for 30 years. This portrait was made in 1976, and I've included it in this book because it still stands up as a timeless portrait. It has all the elements necessary to make it an art form.

The portrait was made in the fall, on a waterfront lot that Edward had bought to build his home on. I liked the tall sea grass and decided to make a vertical print, even though the pose is horizontal. I feel it captures a very casual, natural look, and the space above the group gives it a free, outdoorsy feeling. After all, if you have the whole outdoors to work with, why not use it?

Camera:	Mamiya RB67
Lens:	Mamiya Sekor 90mm F/3.5
Exposure:	1/30 sec at f/11
Lighting:	Late afternoon sun. No fill-flash needed.
Film:	Kodak Vericolor II exposed at ISO 100

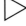

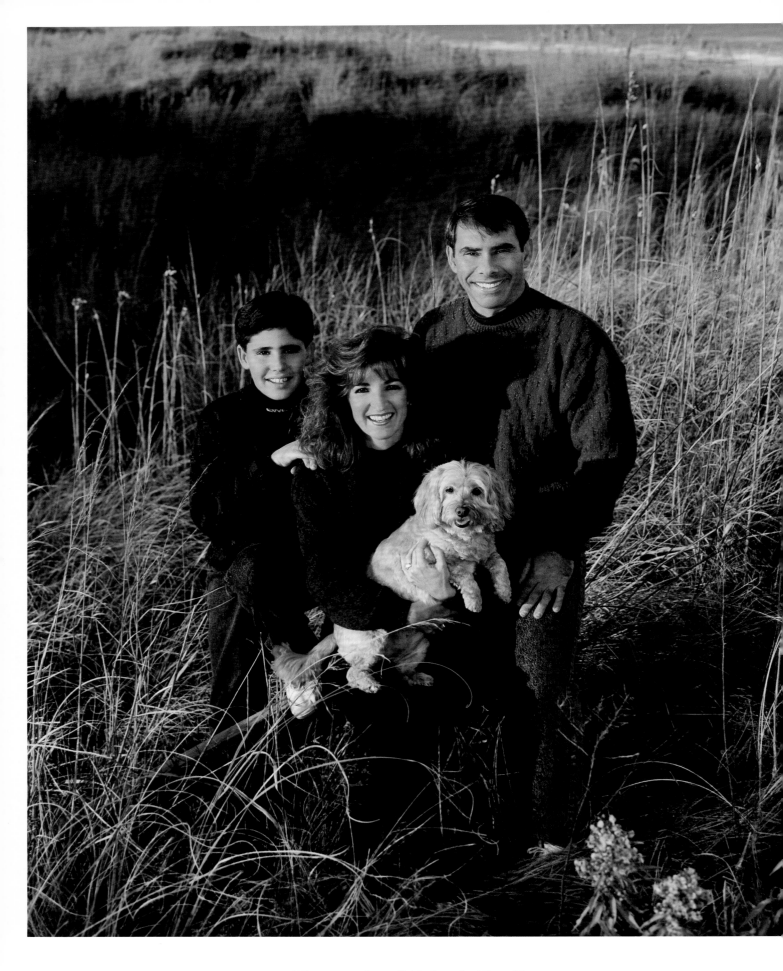

The Stephen Michaels Family

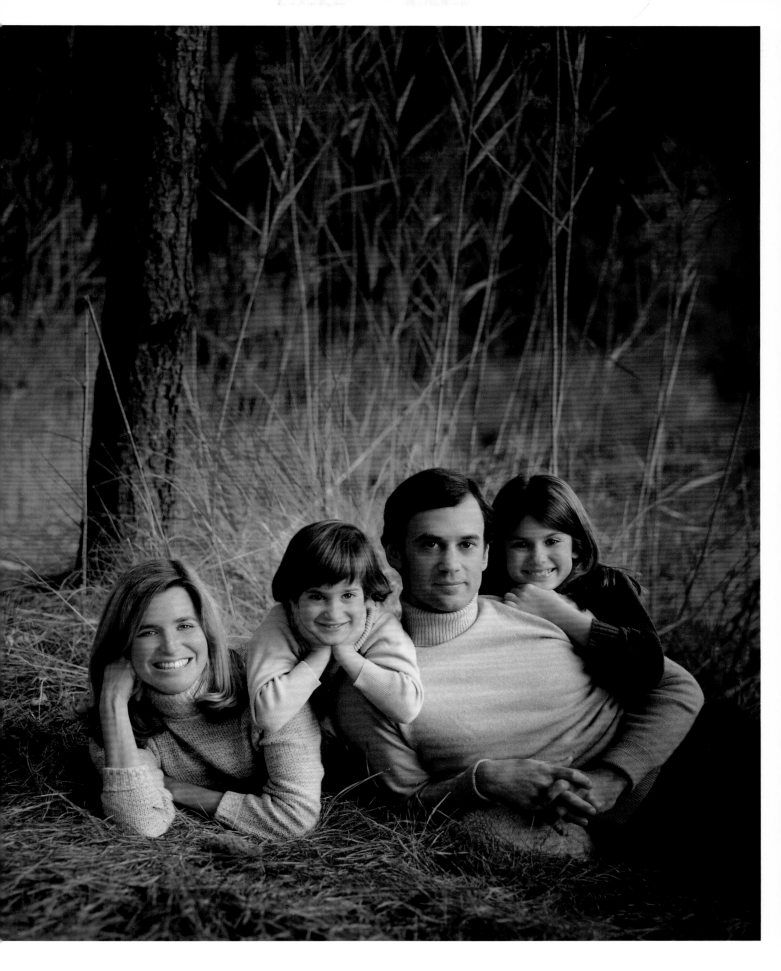

The Edward Stein Family

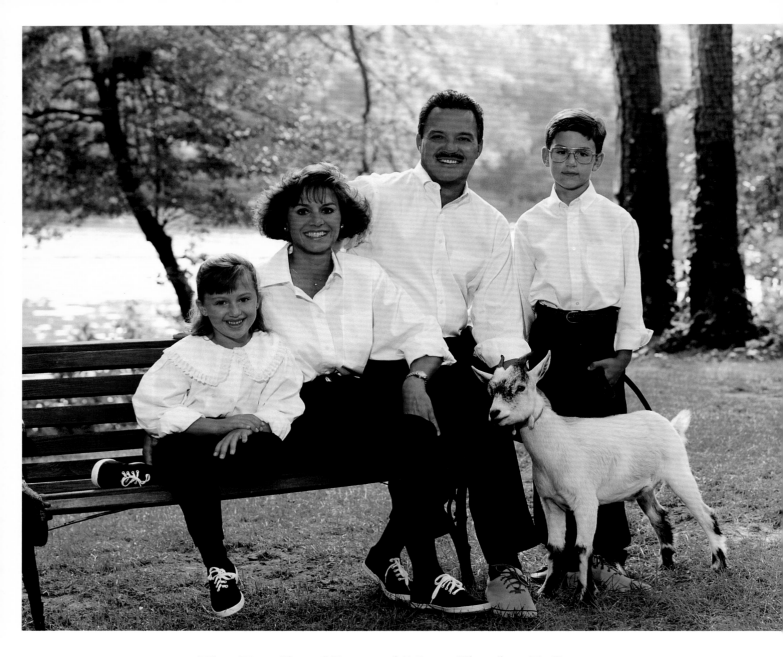

The Family of Dr. and Mrs. Charles F. Stange

When visiting the Stanges, I was taken by their pet goat. It is always a good idea to include family pets whenever possible. They help make a good portrait better.

Families that live on the waterfront like to show it in their portrait. However, the lighting can be difficult. Trees frequently surround lakes, and their branches and leaves cast uneven shadows. I chose the late afternoon sun to backlight the group, and I used a bare-bulb strobe to light them.

The black-and-white clothes were chosen to match the black-and-white fur of the goat. White clothes should only be used on people who are thin or of normal weight. White makes a person's face appear larger because the reflection from the shirt or blouse fills in the natural shadow under the chin, which emphasizes the separation between chin and neck.

Camera:	Mamiya RZ67
Lens:	Mamiya Sekor 110mm f/2.8
Exposure:	1/60 sec at f/8
Lighting:	Ambient light. Bare bulb strobe set for f/5.6
Film:	Fuji Reala, ISO 100

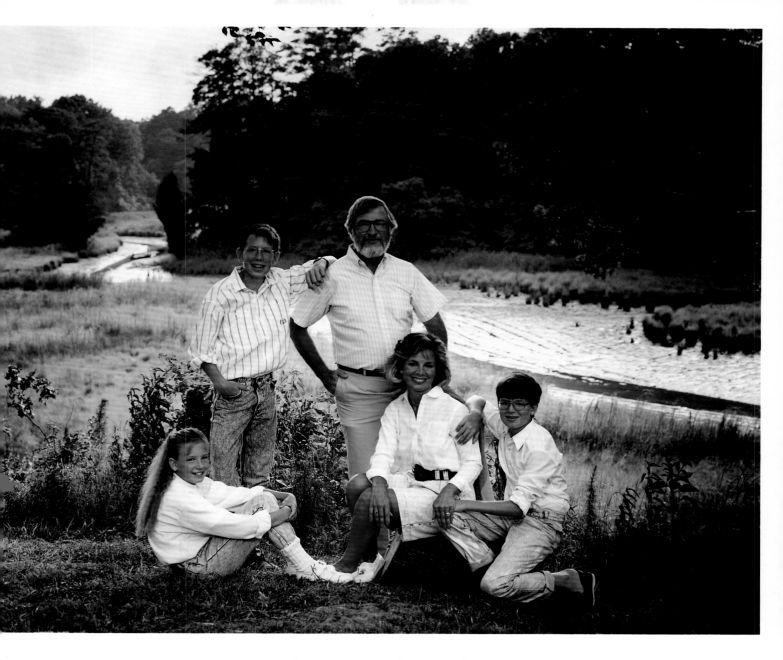

The Ron Pack Family

Ron and Christine Pack's backyard reminds me of some of the backgrounds in Renaissance paintings. The cool green trees and winding stream behind the subjects bring out the rich, warm tones in their faces.

The pose is an unstructured asymmetrical triangle. Dad holds down the middle, mother and youngest son on the right balanced by the oldest son and daughter on the left. There is a hierarchy in posing any group. In this portrait, dad and mother are in in the middle, the most important position, with the oldest son highest and closest to the middle. The next oldest child is the son next to his mother. He is taller than the youngest child, the daughter, who is the lowest and sitting on the ground. Imagine how it would look if the youngest son were standing next to dad and the oldest son were next to his mother or on the ground, where the daughter is.

The late afternoon sun was our backlight, with the sun directly behind the group. A gobo kept the sun off the lens.

Camera:	Mamiya RZ67
Lens:	Mamiya Sekor 110mm f/2.8
Exposure:	1/400 sec at f/8
Lighting:	200 Ws Bare bulb flash set for f/5.6
Film:	Fuji Reala, ISO 100

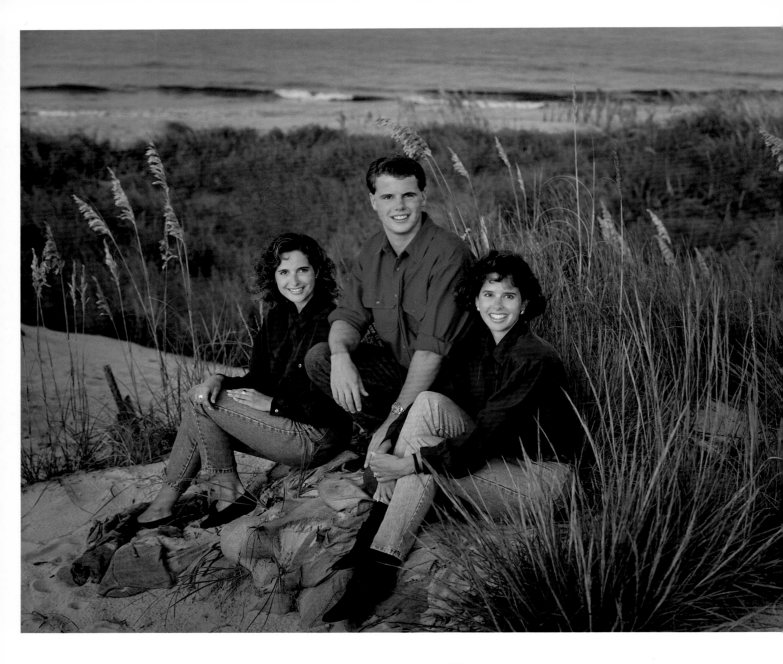

Megan, John and Kelly Dobson

The portrait of the Dobson children was made as a gift for their parents. Usually I recommend against using red in clothing for a group portrait because it draws too much attention to the person wearing it. In this case, however, the red is not too bright but is a dark, subtle shade, and John, being the only man and in the middle, does not detract from his sisters. Imagine what it would look like if one of the sisters had on a red blouse. It would throw the portrait completely out of balance.

The setting was the ocean front, about five minutes before the sun went below the horizon.

Camera: Mamiya RZ67
Lens: Mamiya Sekor 110mm f/2.8
Exposure: 1/30 sec at f/8
Lighting: Natural outdoor lighting. No flash needed.
Film: Fuji NPS ISO 100

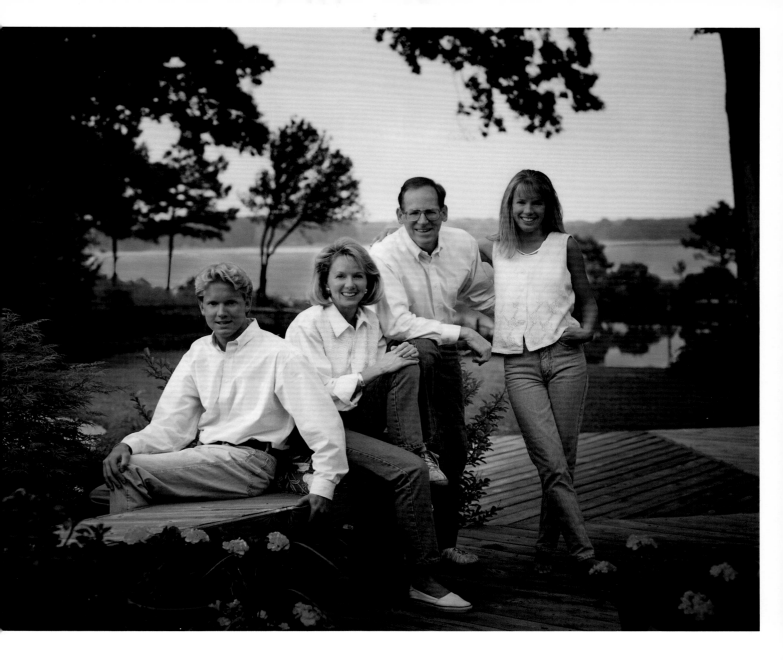

The Family of Dr. and Mrs. Stanley H. Legum

When I visited the Legums to check their yard for the best time of day to photograph them, I saw that all I had to do was show up about 30 minutes before the sun went down and the light would be just right.

Design and composition centers the group by framing them with a tree trunk on the right, heavy foliage on the left, and a canopy of tree branches overhead. We placed some potted plants in the foreground to keep the eye in the frame and to add a little color. Plain white shirts and blue jeans with white shoes are always in style and do not detract from the subjects.

I like to place the parents in the middle of a group and the children on each end. The pose is casual and is in an asymmetrical triangle. It is balanced by size, line, and weight.

Camera:	Mamiya RZ67
Lens:	110mm f/2.8
Exposure:	1/30 sec at f/8
Lighting:	Natural outdoor lighting in late afternoon. No flash used. Sun was 45 degrees to the left of the camera.
Film:	Fuji Reala ISO 100

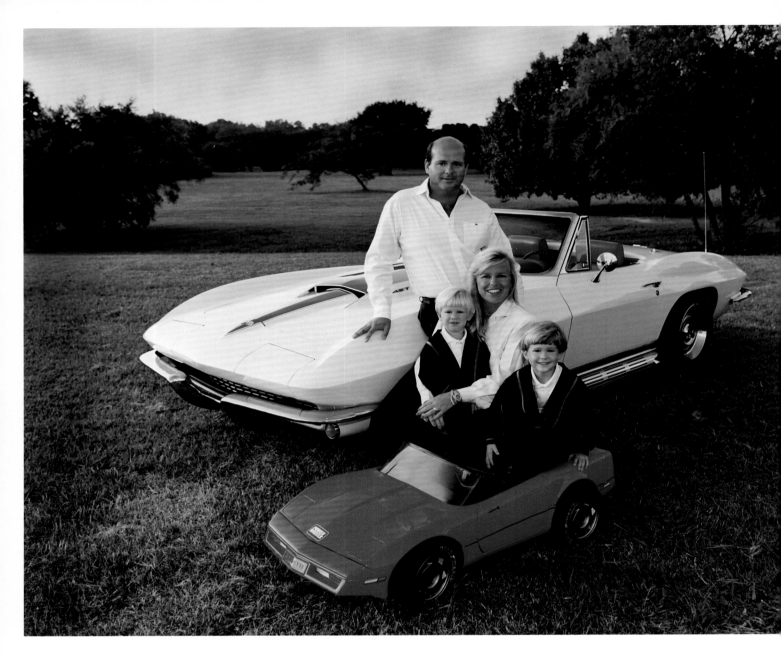

Eddie Falk Family with Corvettes

The Falk family is heavily involved in selling automobiles, from $1,000,000 classic cars to $6,000 subcompacts. When photographing the eldest son and his family, I thought it very appropriate to include his 1966 classic Corvette and his boys' toy Corvette.

The clothes were selected to coordinate with the colors of the automobiles. I chose a background that would emphasize the subjects and give a perception of space and depth. To emphasize the length and sleekness of the cars, I used a wide-angle lens. Since that could have distorted the boys and made them too large in relation to their parents and the car, I elevated the camera on a 10-foot tripod.

Camera:	Mamiya RZ67
Lens:	Mamiya Sekor 65mm f/4
Exposure:	1/30 sec at f/11
Lighting:	Ambient light. Bare bulb flash set for f/8 to light the face.
Film:	Fuji Reala ISO 100

The Grandchildren of Mary Jane Dull Hoffman

When my wife, Luci, and I were visiting friends near Charlottesville, Virginia, we ended up in Mary Jane's historic 19th century farmhouse. Knowing of my interest in photography, Mary Jane showed me a picture of her mother and three siblings sitting on a horse, in farm clothes. The picture was taken in the early 1900s.

I said I would like to make a photograph just like it. Mary Jane said she had four beautiful grandchildren, and they would all be there for the Thanksgiving weekend. She also said she could get a horse, so we immediately set up an appointment.

The idea was to do two sessions in two different locations, one at sunset and one at sunrise. Because of the logistics of putting this shoot together, we did not want to take a chance on not getting a unique and wonderful portrait.

The first session was at sunset with the farmhouse in the background. It was okay, but not exceptional. The next morning the sun, the background, the horse, and the children all came together for an attractive portrait.

I attached a monopod with C-clamps to a 6-foot ladder to elevate the camera to about 10 feet. I waited for the morning sun to be bright enough to backlight the fall foliage and the children. The children and horse were facing the foliage under a tree so they were looking into the shade. I had to use a bare-bulb strobe as the main light for their faces. The exposure for the background was between f/8 and f/11.

Camera:	Mamiya RZ67
Lens:	Mamiya Sekor 65mm f/4
Exposure:	1/125 sec between f/8 and f/11
Lighting:	Bare bulb at f/8
Film:	Fuji NHG ISO 400

\triangleright

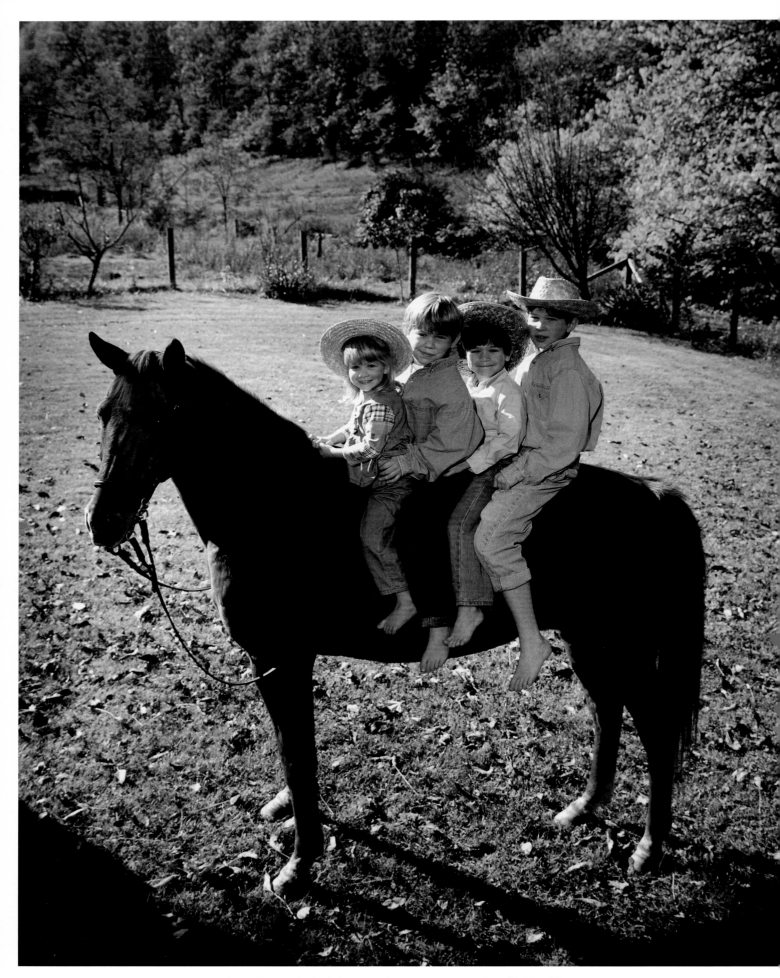

The Grandchildren of Mary Jane Dull Hoffman

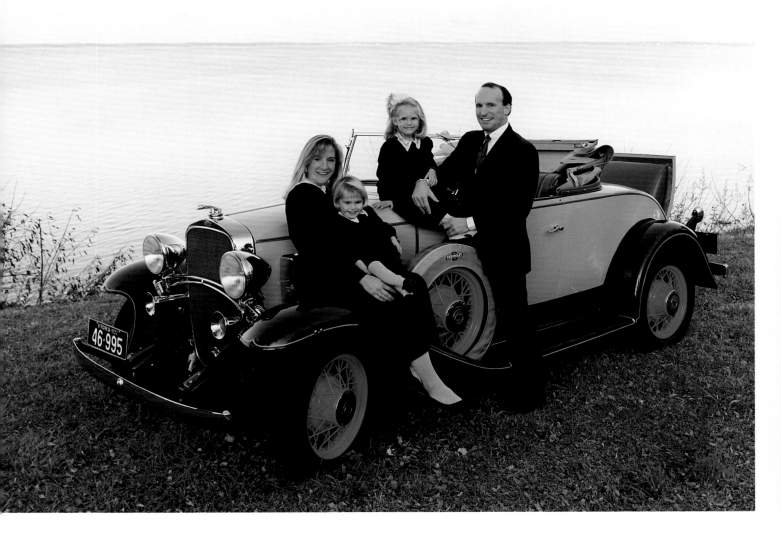

The Bradley Hiltz Family

Brad and Cindy Hiltz, with daughters Elizabeth and Kaitlyn, were photographed with this beautiful 1932 Chevrolet Roadster for a photo exhibit featuring classic cars and their owners. The choice of location and the very late afternoon sun enhances the color and body sculpture of this wonderful old auto. Notice the complete lack of reflections in the car body.

I placed the camera on a 10-foot tripod so the skyline would not bisect the portrait, and I shot with a wide-angle lens to lengthen the car and keep it from looking squatty.

Camera:	Mamiya RZ67
Lens:	Mamiya Sekor 110 mm f/2.8
Exposure:	1/30 sec at f/11
Lighting:	Natural outdoor lighting in late afternoon
Film:	Fuji NHG ISO 100

Andrew Swift and his Fire Truck

Following the success of the Falk family portrait, I pursued other ideas for child portraits with toy trucks and cars in front of real ones.

My long-time friends Don and Marsha Swift and I were able to persuade the local fire department to park a fire truck across the street as background for this portrait of Andrew.

I later grouped the firemen around their truck, took their picture, and gave each of them an 8x10 print.

Camera:	Mamiya RZ67
Lens:	Mamiya Sekor 65mm f/4
Exposure:	65mm at f/11
Lighting:	Natural outdoor lighting. Bare bulb flash set for f/8 to light the face.
Film:	Fuji Reala ISO 100
Comments:	The camera was on a 6 foot tripod.

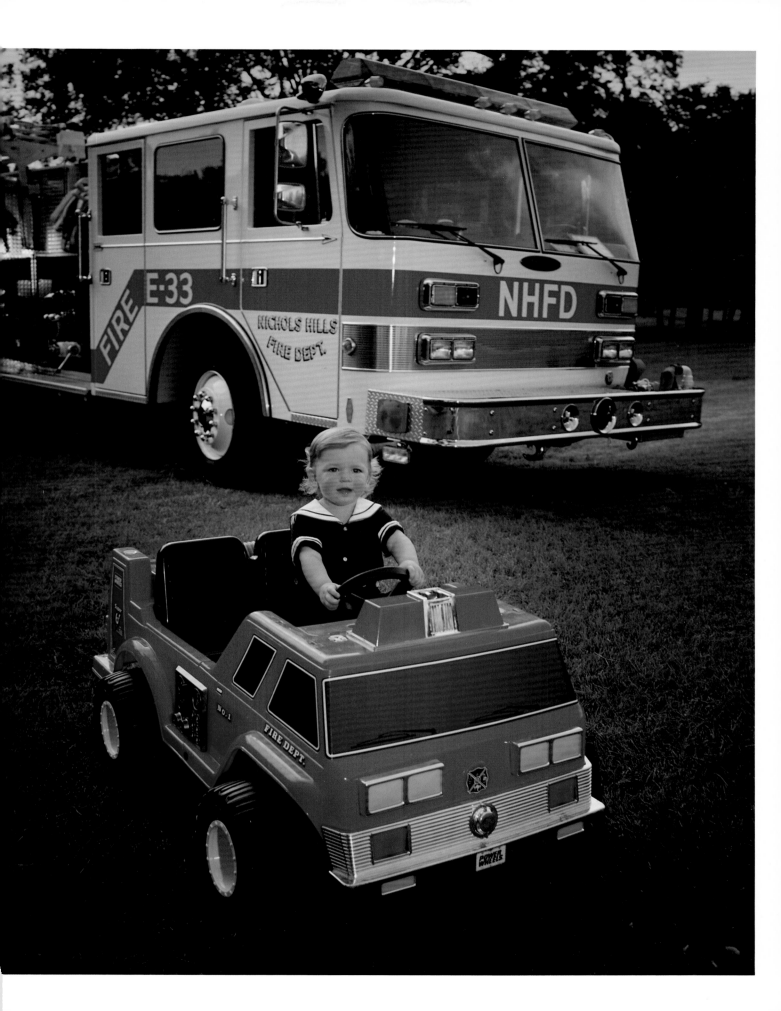

Mr. and Mrs. Charles Robert Jackson "Paint the Town Red"

I made this portrait to illustrate the theme of the annual fund-raising party for the Dallas Museum. Linda Jackson was in charge of the event, called "Paint the Town Red." She wore red for a year and drove a new red Mercedes 560 SL to help publicize the event.

I selected the entrance to the Dallas shopping and entertainment center as the background, to emphasize Dallas, a red-hot city where things were happening. Since this was a night shot, we had to use several lights. The main light was a 1,200 Ws Speedotron with a 54-inch umbrella placed at a 45 degree angle to the left of the camera.

The fill light was a 400 Ws in a 48-inch umbrella at the camera.

Two 200 Ws units with 7-inch silver reflectors and barn doors, one on each side, were directed to the back of the car and the couple, separating them from the dark building.

Camera: Mamiya RZ67
Lens: Mamiya Sekor 65mm f/4
Exposure: 1 sec between f/8 and f/11
Lighting: 4 Flash units
Film: Kodak Vericolor VPH ISO 400

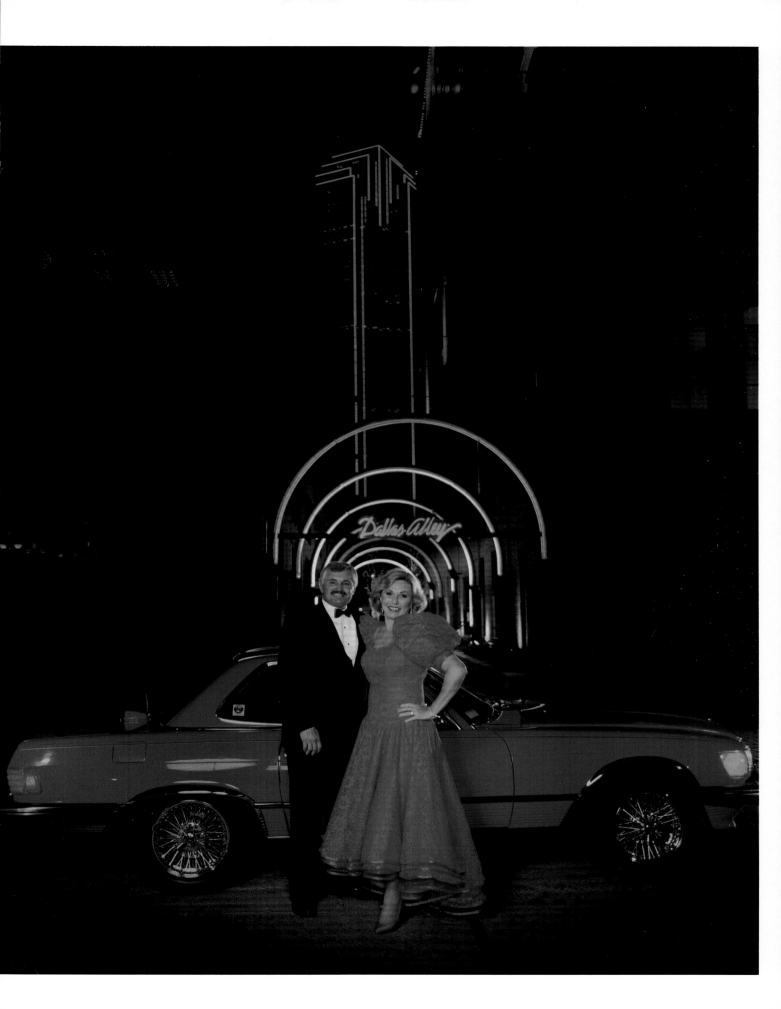

Sunrise and Sunset

Two periods in the day are ideal for making outdoor portraits, even though there is considerable variation in the light from day to day and from season to season. I am talking mostly about late spring, summer, and early fall. In the morning, the best time is about 15 minutes before the sun comes up to 30 minutes thereafter. In the evening, I like to shoot from about 30 minutes before the sun sets to almost 30 minutes after the sun goes down. The light is soft and flattering during these periods and can be very dramatic.

The light at sunrise does not last as long as it does at sunset. It is weak before it comes up. It quickly can become too bright – within about 30 to 40 minutes – and cause your subject's eyes to squint.

Tamara Pastore

I selected the background for this portrait of Tamara because of the long expanse of sea grass and the much taller sea oats. The best light was about 30 minutes after the sun came up. The sun backlighted the sea oats and turned them into a warm amber color that, I believed, would make a pleasing background for a lovely young woman.

I am constantly searching for portrait locations with attractive scenery that will provide good backgrounds. Whenever I find one, I jot it in a notebook as a reminder for a future portrait site.

The sea oats are taller than Tamara, and I wanted to include more of the space behind her. I stacked two milk crates and had Tamara stand on them. This elevated her about 30 inches. I was on a ladder with a tall tripod, extended to about seven feet, looking slightly down on her. This high viewpoint eliminated the horizon line and surrounded Tamara with a sea of grass and sea oats.

Camera:	Mamiya RZ67
Lens:	Mamiya Sekor RB 150 mm variable soft focus with the f/6.3 disc.
Exposure:	1/100 sec at f/6.3
Lighting:	Natural outdoor lighting at sunrise. Bare bulb flash set for f/4 to light face. Backlight exposure metered at f/5.6
Film:	Fuji Reala ISO 100

\triangleright

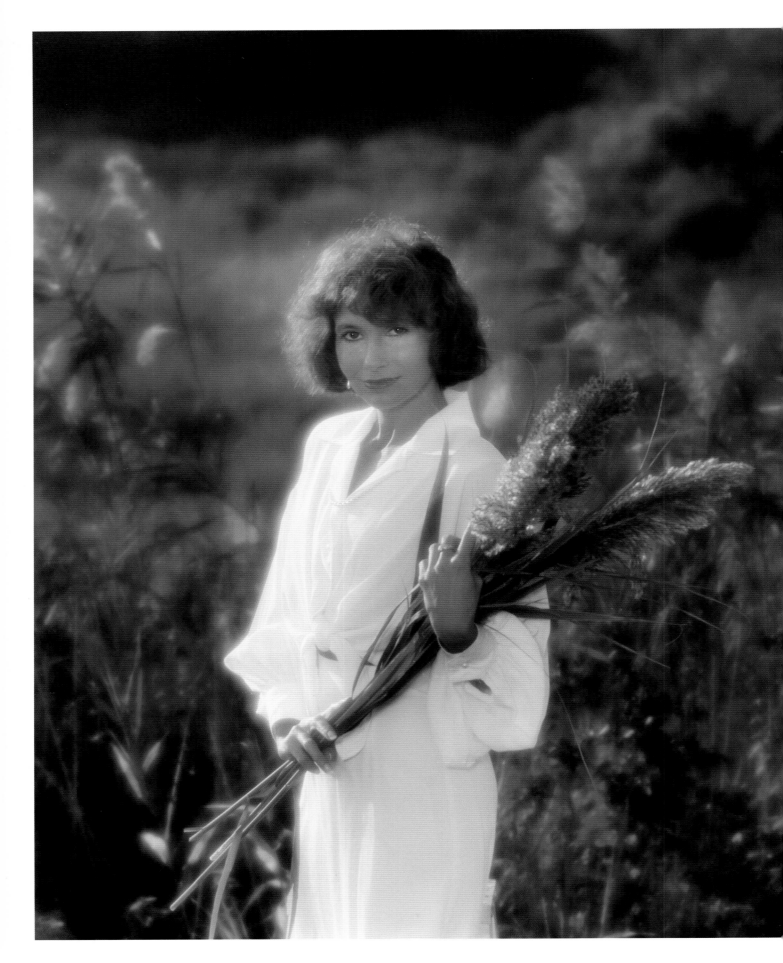

Tamara Pastore

Amery Thurman Photographed as "Pinkie"

The October sunsets on the Atlantic Ocean frequently have this purple/pinkish color. I had photographed Amery previously, with her brother, and she had worn this dress and hat with its pink ribbon. The idea of photographing her as a modern Pinkie occurred to me. "Pinkie" is the famous painting by Sir Thomas Lawrence of Sarah Barrett Moulton, in the Huntington Museum in Pasadena, California.

I called Amery's mother and we planned the portrait. She bought the scarf to match the dress, and we waited for a day when the wind would blow the scarf and ribbon.

Camera:	Mamiya RZ67
Lens:	Mamiya Sekor Macro 140mm f/4.5
Exposure:	1/30 sec at f/4.5
Lighting:	Natural outdoor lighting just before sunset. Bare bulb flash set for f/4
Film:	Fuji Reala ISO 100

▷

Cindy and Bill Minton

The Mintons were photographed an hour before sunset. The sun was behind them and the wind was blowing just enough to make Cindy's hair and the fur of Alydar, their beautiful collie, stand out.

The rolling sand dunes, aided by the fence, lead the eye to the white shirted couple and compensate for their being placed just off center.

Camera:	Mamiya RZ67
Lens:	Mamiya Sekor 140mm f/4.5 Macro
Exposure:	1/60 sec at f/8
Lighting:	Natural outdoor light with 100 Ws bare bulb flash set for f/5.6
Film:	Fuji NPS ISO 160
Comments:	I chose the the slightly longer than normal 140mm lens to bring the background closer, at a wider lens opening, without throwing it too much out of focus, which a longer lens like the 180mm might.

▷

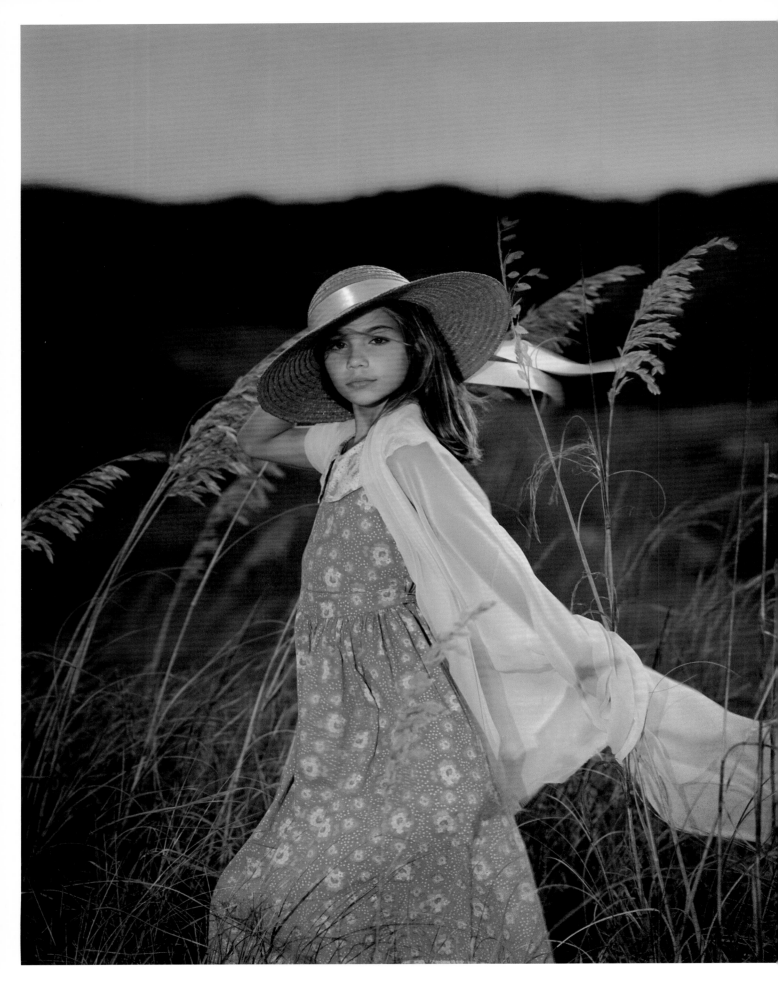

Amery Thurman Photographed as "Pinkie"

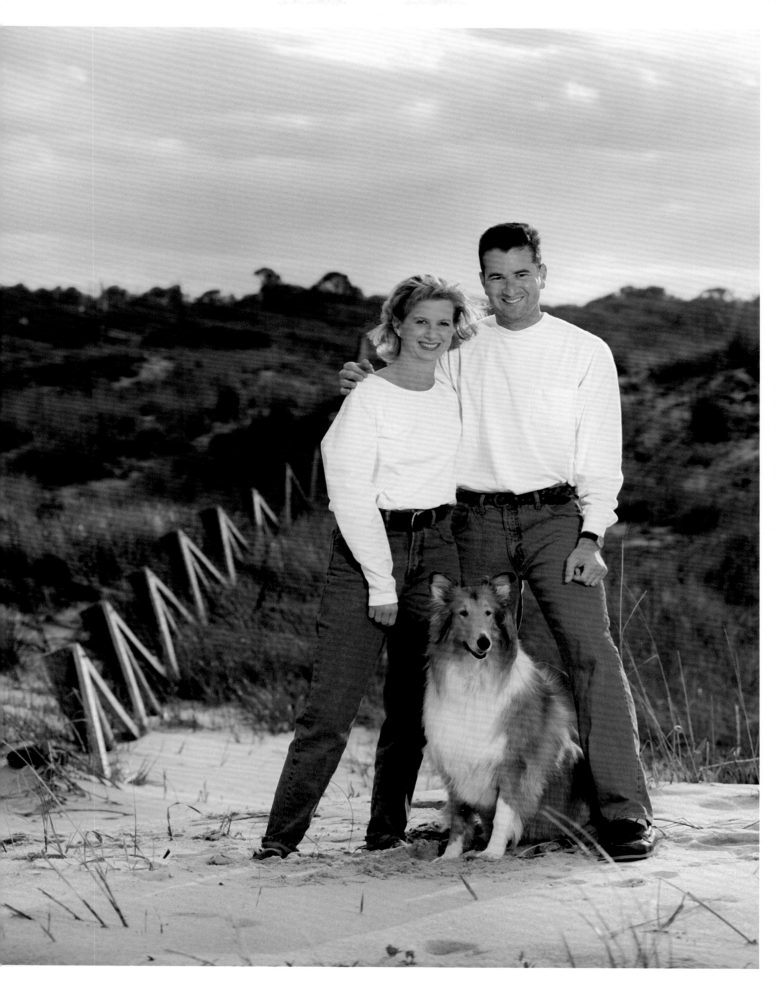

Cindy and Bill Minton

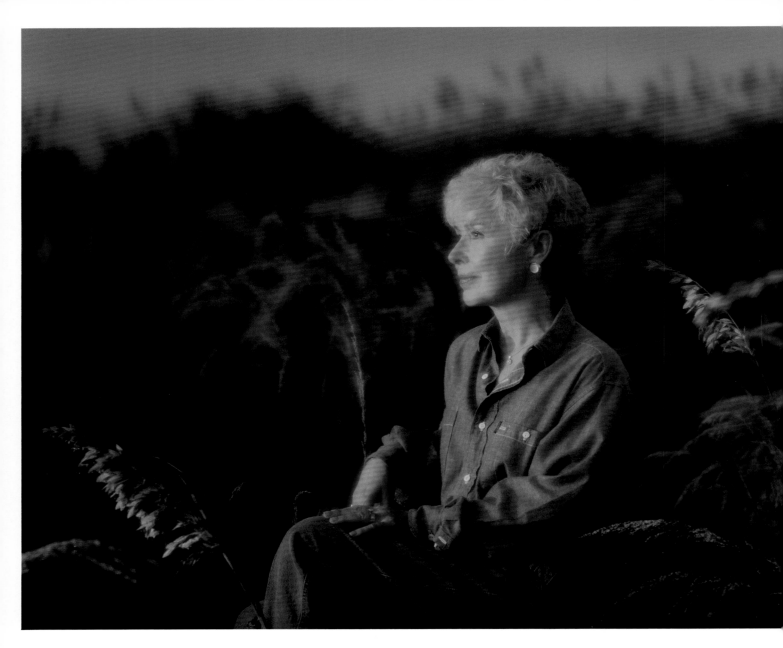

Norma Jean Slaughter

Photographing a mature woman outdoors can turn out to be a beautiful, aesthetic adventure or an unflattering document. My photography is devoted to making a positive, optimistic statement about my subjects. I look for the beauty and love that is within them, so I can create an image their families will enjoy for years to come.

Norma Jean wanted an outdoor portrait of herself. During our consultation, I recommended that she wear a blue long-sleeve shirt and jeans. The portrait would be made at sunset in the dunes, just before the sun went down.

Camera:	Mamiya RZ67
Lens:	Mamiya Sekor RB 150mm f/4.5 variable soft focus with f/5.6 disc.
Exposure:	1/60 sec at f/5.6
Lighting:	Natural outdoor lighting with the sun 90 degrees to the left of the subject, just before sunset. No flash or reflector was needed.
Film:	Fuji Reala ISO 100

Cherie Smith

I photographed Cherie Smith in exactly the same location and time as Norma Jean Slaughter. It might seem that using the same spot to make a portrait would produce a lot of similar images and would eventually be boring to look at, but "it ain't necessarily so."

I did use the same exposure, but that's where the similarity ended. The light is different every day, and in photographing Cherie, I used a normal focal-length lens to include more of the background. Cherie's portrait is in sharp focus, Norma Jean's is soft focus; Cherie is facing the camera, Norma Jean is in profile; Cherie's white outfit sets off against the background, Norma Jean's almost blends into the background.

The portraits are similar in a way, yet each is very different. Each version does justice to the subject.

Camera:	Mamiya RZ67
Lens:	Mamiya Sekor 110mm f/2.8
Exposure:	1/60sec at f/5.6
Lighting:	Natural outdoor lighting just before sunset. No flash or reflector was needed.
Film:	Fuji Reala ISO 100

▷

Jay and David Flynn

David Flynn, who is a bank vice president, works in the tall building on the left, and Jay Flynn, the branch manager of a computer service company, works in the building on the right. The portrait was a present for their parents. In my consultation with Jay, the older brother, I recommended that we use the downtown cityscape as a background to tell a story about two successful young executives whose parents are justifiably proud of them.

We made the portrait on a pier across the river from downtown Norfolk, Virginia, at sunset. There is a window of opportunity starting at about 15 minutes before the sun goes down until the sun actually drops below the horizon. During that time you can make exposures in the direct sun without it causing the subjects to squint. This is the magic time when the finest portraits can be made.

I exposed 20 negatives on a 220 roll of film and obtained several good expressions to choose from.

Camera:	Mamiya RZ67
Lens:	Mamiya Sekor 110mm f/2.5
Exposure:	1/30 sec at f/8
Lighting:	Natural outdoor lighting just before the sun set.
Film:	Fuji NHG ISO 400

▷

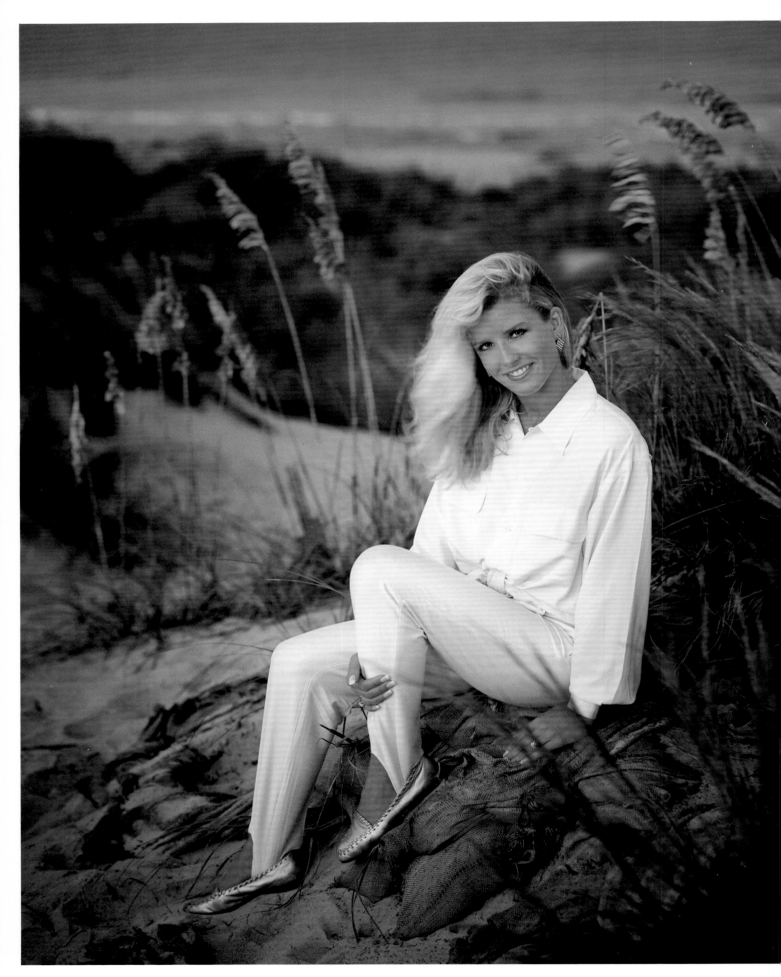

Cherie Smith

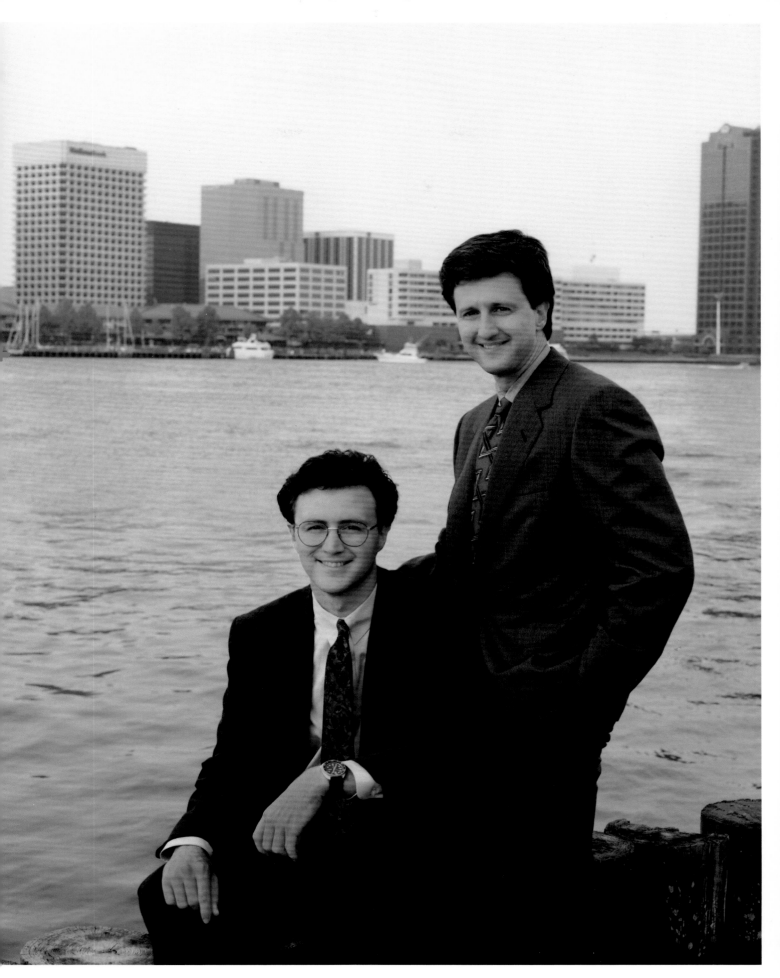

David and Jay Flynn

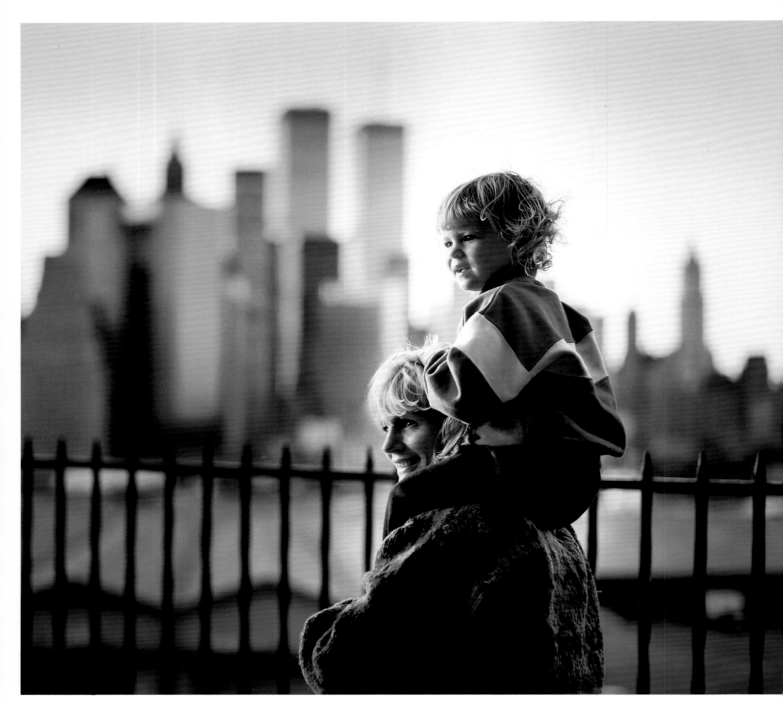

Astrid Loftus and Kellyn

Astrid is a stockbroker, so the view of New York's Wall Street skyscrapers were an appropriate background. I made the portrait, just before sunset, from the Brooklyn Heights Promenade, across the river from Manhattan. The pose is very natural and believable, and we chose the clothes to complement the colors in the cityscape.

I placed my tripod-mounted camera at almost 90 degrees to Astrid and Kellyn, and I began amusing Kellyn with a toy monkey sitting on my shoulder. By working with the RZ radio remote control and the camera's auto winder, I made ten quick exposures and got the expression I wanted.

Camera: Mamiya RZ67
Lens: Mamiya Sekor 110mm f/2.8
Exposure: 1/30 sec at f/4
Lighting: Natural outdoor lighting just before sunset.
Film: Fuji Reala ISO 100

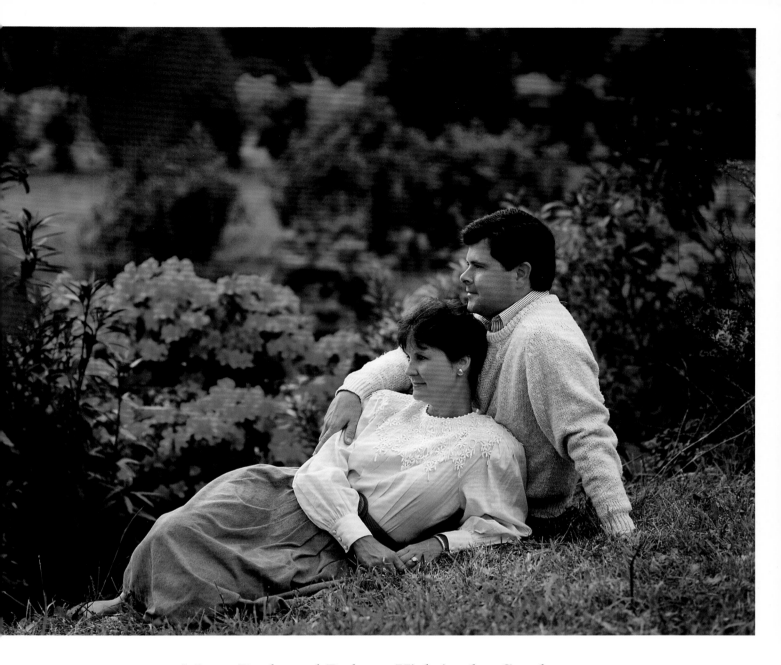

Mary Beth and Robert Kirk in the Garden

I photographed Mary Beth and Robert in the Botanical Gardens when the spring azaleas were at the peak of their bloom. The flowers' beauty lasts only about ten days to two weeks, and I try to schedule at least one sitting a day during that time.

My subjects are relaxing on the bank of a canal (not visible) that runs through the gardens. The azaleas add color to the picture and lead the viewer's eye into the subject. The photograph has a foreground, middle ground just behind the subjects, and background of azaleas behind the greenery, which gives the portrait color harmony, depth, and design.

Camera:	Mamiya RZ67
Lens:	Mamiya Sekor 110mm f/2.8
Exposure:	1/125 sec at f/8
Lighting:	Natural outdoor lighting, two hours before sunset. Bare bulb fill-flash set for f/5.6 to fill in the shadows.
Film:	Kodak Vericolor III ISO 160 exposed at ISO 100

The Art of Photographing the Child

Some of the most beautiful statues, paintings, and portrait photographs ever created were made of children. People who have very little knowledge or interest in art have heard of the paintings "Pinkie," by Sir Thomas Lawrence, and "Blue Boy," by Sir Joshua Reynolds. Photography, however, has not had time to bring the great photographic portraits of children to the public's attention.

There are two classic photographers of children every photographer should be aware of an English woman, Julia Margaret Cameron (1815-1879), who photographed her nieces in fairy-tale costumes, and an American woman, Gertrude Kaesebier (1852-1934), whose portrait "Blessed Art Thou Among Women" is generally acknowledged to be one of the finest portraits of a child and mother ever made.

Successful portraits of children can give the viewer a feeling of uninhibited love, innocence, spontaneity, the past, the present, and the future. Children are our future.

An artistic portrait of a child will have several attributes an ordinary photograph will lack: The *location* for the portrait will have been carefully chosen to complement the child; the style and color of the *clothes* will be compatible with the background while making the child stand out from it; the *pose* and the design and concept of how the subject will look in the surrounding space will be clear in the photographer's mind before he makes the portrait.

Some studio portraits can be considered art, but most are merely record portraits. They usually have a good pose, good expression, very basic lighting, and a flat background – either a wall, seamless paper, or canvas. Sometimes generic props are added. The studio is a good place to start, but don't stop there. Go into the home and outdoors and expand your talent and art.

It is not difficult to get a good expression from a child if it does not take too long. A child is like a small universe with suns exploding continuously. Children do not like to sit still very long unless they are learning something or are being entertained. I allow one minute for every year of a child's age as the prime time to get a good expression. The younger they are, the quicker they get bored with you.

The present-day potential for portraits of children as an art form is greater than it has ever been. With the introduction of high-speed, fine-grain, color negative film, we can make images before sunrise, after sunset, and in other low-light situations that were not possible a few years ago.

Ann Robinson

Ann Robinson is the five-year-old daughter of Mr. and Mrs. Thomas Robinson. We chose the dining room for her portrait because I loved the beautiful black Chinoiserie china armoire, decorated with a gold-leaf design. I brought in an end table from another room and put a tall green plant on it to balance the plant hanging from the top of the armoire. I borrowed the chair from still another room and put the teacup and saucer on the table to balance the design. We chose the pastel green dress to make Ann stand out in the portrait.

Keep in mind that an unretouched print of this portrait would not be perfect, in spite of my careful lighting, because the background would be much too busy and bright. I had my lab airbrush and use light oil colors to tone down the wall, armoire, chair, carpet, teacup, and saucer.

Camera:	Mamiya RZ67
Lens:	Mamiya Sekor 65mm f/4
Exposure:	1/125 sec at f/11
Lighting:	5 Flash units
Film:	Fuji Reala ISO 100

Lighting Plan:

Main light: 200 Ws flash in 31" umbrella placed 45 degrees to left of subject.

Fill light: similar to main, but behind camera and farther away from subject.

Background light: 50 Ws flash in 7" reflector, with barndoors, in right rear of room directed on right rear wall; similar flash in left rear of room directed on left rear wall.

Back light: 50 Ws flash in 7" reflector, with barndoors, in right rear of room, aimed at subject to separate her from background.

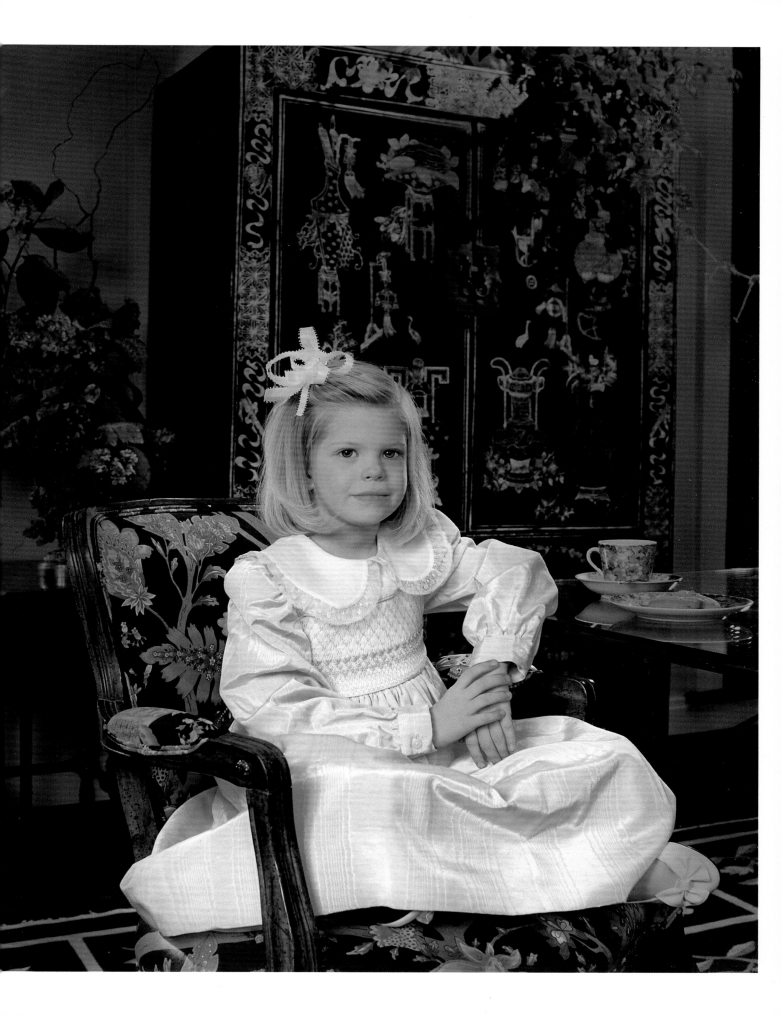

Carissa Graza and her Dolls

This idea of a portrait of Carissa, one of my favorite child models, surrounded by dolls, came from a friend who owns a doll shop. I thought such a portrait would be striking. I frequently borrow dolls and doll furniture from my friend when I want to photograph some of my customers' daughters.

When Fuji Film engaged me to make several portraits for advertising the new NHG ISO 400 film, I immediately called Carissa's mother, to see if Carissa had a pretty ruffled dress. She did. With nearly all the dolls in the doll shop, I was ready to make the picture I had dreamed about.

The Victoria House Museum in Norfolk, Virginia, graciously allowed me to use one of their rooms for a morning. It took me, Jo Ann, her friend Ann Dyer (who also lent us some dolls from her collection), and an assistant about 2½ hours to set up the dolls, lights, and camera for the shoot, but only 15 minutes to make the portrait.

Camera:	Mamiya RZ67
Lens:	Mamiya Sekor 65mm f/4
Exposure:	1/125 sec at f/22
Lighting:	6 Flash units
Film:	Fuji NHG ISO 400

Lighting Plan:

Main light: 100 Ws, in a 7" reflector with barndoors was placed 90 degrees to the left of the subject.

Fill light: 200 Ws, with a 31" reflector behind the camera.

Back light: Two 50 Ws units in 7" reflectors with barndoors located in the rear of the room, one on each side, at about 135 degrees from the left and the right, just outside the picture area and directed at the subject, to make her stand out from the background.

Background light: Two additional 50 Ws units were placed left, just outside the picture area, between the subject and the background. One was directed to the left wall and one to the right. Barndoors were used to blend the light and make it even over the background.

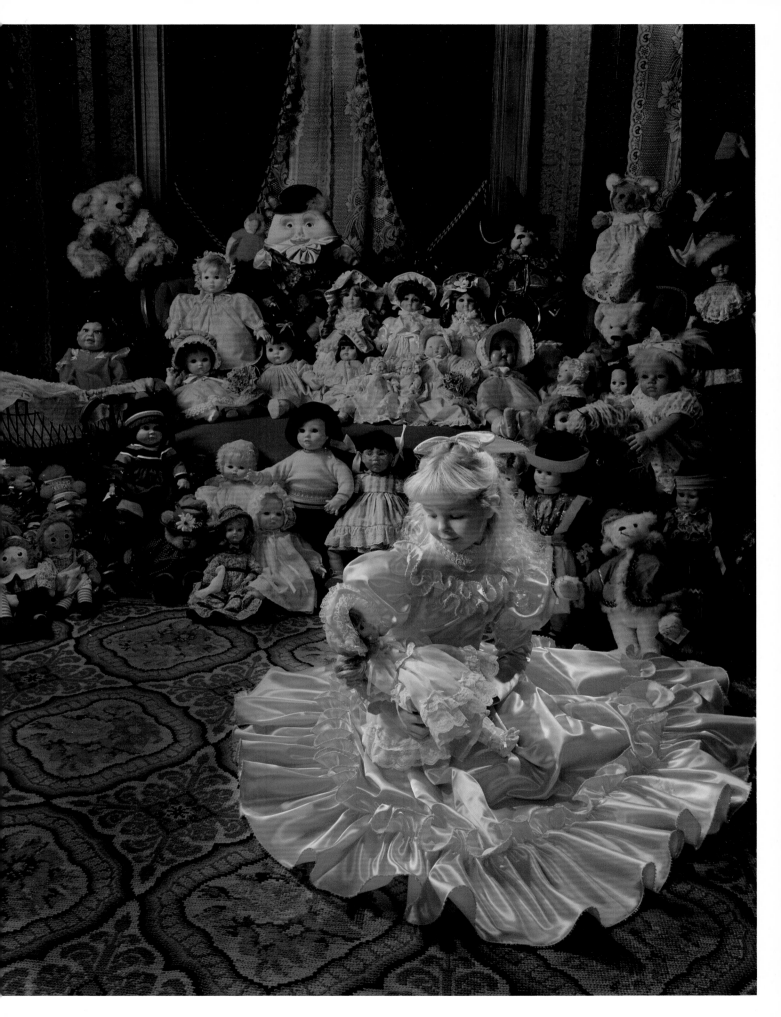

Amery and Carissa Reading Book

The living room of this beautiful old home was selected for its rich, warm background. It was a perfect setting for the elegant portrait of these two lovely young girls reading a book. The painting over the fireplace echoes the color in their dresses. The books on the shelves behind them also aid the theme of the portrait. The clothes they wore and the flower arrangement were purchased to harmonize with the tone and colors in the room.

Camera:	Mamiya RZ67
Lens:	Mamiya Sekor 65mm f/4
Exposure:	1/125 sec at f/11
Lighting:	6 Flash units
Film:	Fuji NPS ISO 160

Lighting Plan:

Main light: 200 Ws in a 31" umbrella, set for f/8-11, placed at 45 degrees to the left of the camera.

Fill light: Similar unit, set for f/5.6, behind the camera.

Skim lights: Two 200 Ws with 7" reflectors and barndoors were placed 135 degrees to the right rear and left rear of the room, directed at the girls.

Background lights: One 200 Ws in 7" reflector, with barndoors, set for f/8, was placed at 45 degrees to the left rear of the room to light the fireplace and wall. Another similar unit with 3" honeycomb, set for f/8, placed at about 90 degrees to the fireplace, was directed at the flower arrangement.

Katherine Kelley Gunst

Katherine is 12 years old. It has always been a mystery to me that a young girl can become a self-assured young woman in only 12 years or less. Would it not be a shame if she did not have a portrait of herself to look at when she is a grown woman of 40 or so?

I photographed Katherine in this tastefully decorated dining room. I liked the handsome mirror with its reflection of the paintings on the opposite wall giving the portrait a greater depth. I look for every opportunity to create depth in my work, as it makes the portrait more interesting and adds dimension to an otherwise flat surface. I often utilize mirrors to accomplish this, which necessitates placing the camera and lights very carefully so they won't be reflected in the mirror.

Camera:	Mamiya RZ67
Lens:	Mamiya Sekor 65mm f/4
Exposure:	1/8 sec at f/11
Lighting:	6 Flash units
Film:	Kodak Vericolor III ISO 160, exposed at ISO 100

Lighting Plan:

Main light: 200 Ws in 31" umbrella, placed 45 degrees to the left of the subject.

Fill light: Similar to main, but behind camera and further away from the subject.

Back light: 50 Ws with 3" honey comb and snoot, placed about 2 feet behind subject's head to light her hair.

Background Light:Two 50 Ws in 7" reflectors with barndoors, in the left rear of the room to light left rear wall and one directed at the wall reflected in the mirror.

Mark Bramlett

When I entered the foyer of this lavish home, I introduced myself to my 15-year-old subject, Mark. I told him I thought his house was much like an F. Scott Fitzgerald-type setting and that I'd like to photograph him in a Fitzgerald-type outfit.

He agreed, and we went up to his bedroom and looked over his wardrobe. We found the perfect jacket to go with the marble in the two-story foyer, a pink shirt to match the wall in the background, and a dark green tie to pick up the greenery on the table in the far room. I added a small table with a plant in the lower right to balance the design. Together, we produced what I think is one of my nicest portraits.

Camera:	Mamiya RZ67
Lens:	Mamiya Sekor 65mm f/4
Exposure:	1/5 sec at f/11
Lighting:	6 Flash units
Film:	Kodak Vericolor III, exposed at ISO 100

Lighting Plan:

Main light: 200 Ws in 31" umbrella at 45 degrees to the left of subject.

Fill light: Similar to main, behind camera and further away from subject.

Skim light: 100 Ws in 7" reflector with barndoors, directed at subject from the left rear.

Background lights: One 100 Ws in 7" reflector with barndoors upstairs to light staircase; similar unit behind the column on ground floor to light left area. A 50Ws unit with 3" honeycomb, just out of the picture area, is lighting the silver bowl with plant.

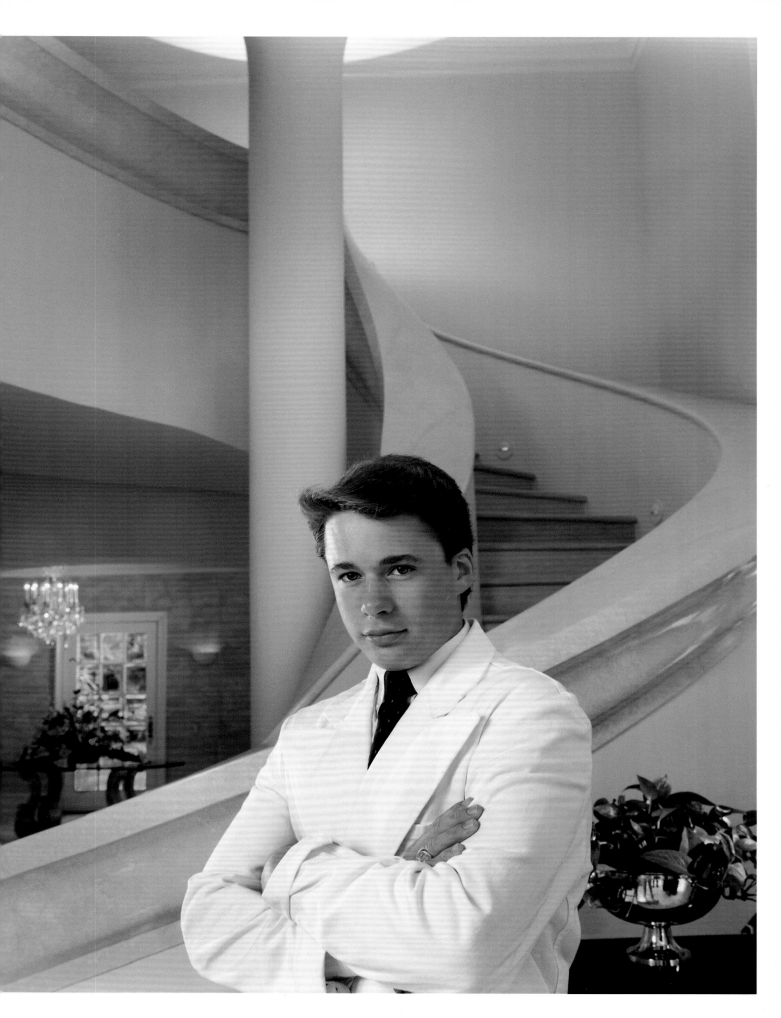

Amery Thurman: Young Girl on a Merry-Go-Round

Interesting and unique portraits do not just happen; they are planned. I had seen this merry-go-round many times in the mall and thought it would make a great background for a portrait. I approached the carousel manager and he agreed to let me use it on a Sunday morning, when no shoppers were around. Since I have an exhibit of my work in this mall every spring and fall, the manager would get the benefit of extra advertising when I displayed the portrait. I would have to pay the carousel operator, however.

I used the soft-focus lens to give the dreamy effect I wanted.

Camera:	Mamiya RZ67
Lens:	Mamiya Sekor 150mm f/4 variable soft focus
Exposure:	1/30 sec at f/6.3 without disc
Lighting:	4 Flash units
Film:	Fuji NPS ISO 160

Lighting Plan:

Main light: 50Ws with 7" silver reflector and barndoors, 45 degrees to right of camera.

Fill light: 100 Ws with 31" umbrella, directly behind the camera.

Skim light: 50Ws with 7" reflector and barndoors, behind the subject and 135 degrees to her right, directed toward the subject.

Background light: 50Ws with 7" reflector and barndoors, 90 degrees to right of camera, directed on carousel wall.

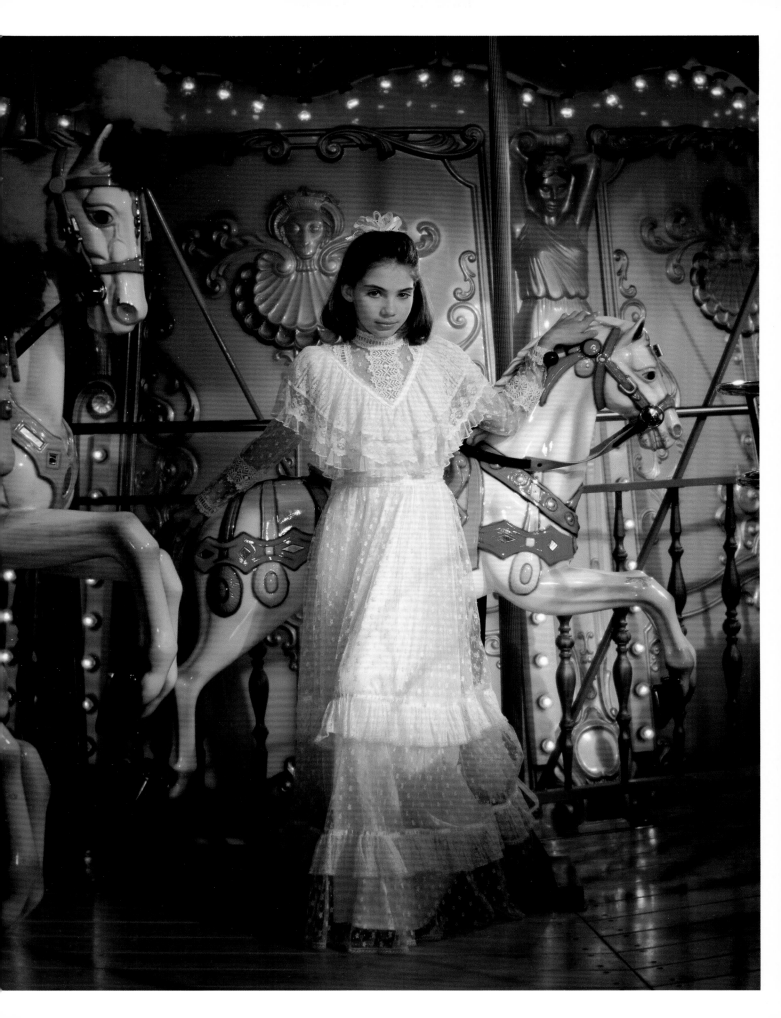

Abigail McCutchin

I visited Abigail's home to discuss her portrait with her parents. Abigail is a cute four year old and has a fluffy little dog that follows her around. In looking for ideas, I felt we should have that dog in the picture.

My choice of rooms was one that had a fireplace and blue walls. It had a light blue carpet, but I knew a darker oriental carpet in another room would make a better setting.

I asked that Abigail's parents buy her a dark blue velvet dress with a white collar. I told the McCutchins that my plan was for my assistant and me to move some of the furniture out of the room and replace the rug with the oriental one. Then I would pose Abigail on the rug with her dog and make a wonderful portrait.

When I explain to parents that I am not just taking a photograph, but creating an art form, and I paint a visual picture with words, it is not too hard to convince them to go along with my suggestions.

My assistant and I returned for the appointment and spent a little over one hour preparing the room and setting up my equipment. I photographed Abigail and her dog in about ten minutes and created an award-winning portrait.

Camera:	Mamiya RZ67
Lens:	Mamiya Sekor 65mm f/4
Exposure:	1/60 sec at f/11
Lighting:	4 Flash units
Film:	Kodak Vericolor III, exposed at ISO 100

Lighting Plan:

Main light: One 200 Ws in 31" umbrella, placed 50 degrees to the left of the subject.

Fill light: Similar to main light but behind camera and further away from subject.

Background lights: One 50 Ws unit in 7" reflector with barndoors to the left rear of the room, just outside of picture area, directed at right rear wall. Another, similar unit, to the right rear of the room directed to illuminate the left rear wall.

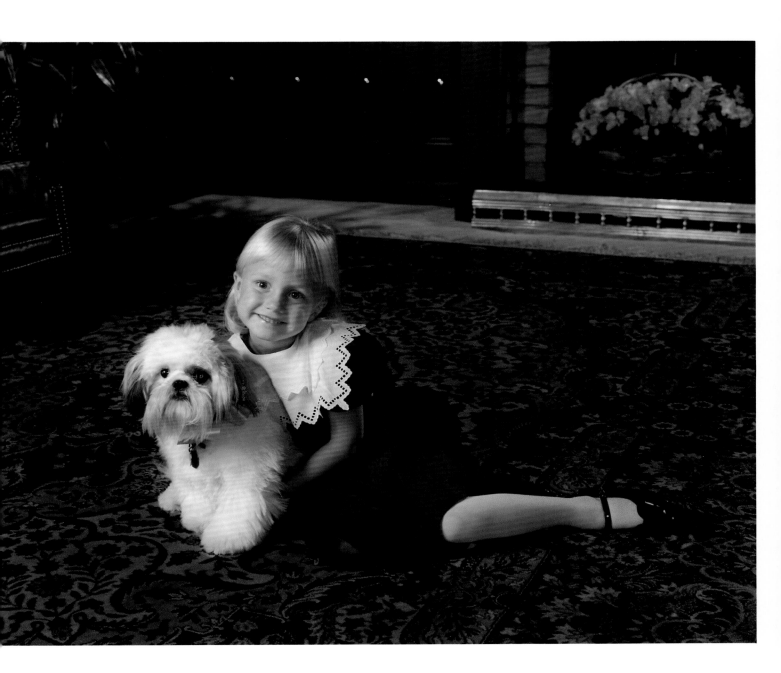

The Classic Portrait in the Home

Portraits of families in their homes have been with us long before photography was invented. Some of the finest early examples were by English painters in the late 1700s, such as Thomas Gainsborough and Sir Joshua Reynolds. The father of the modern environmental portrait and one of the greatest portrait painters of all time is John Singer Sargent. He was born in 1856, the year the negative/positive system of photography came into common use. Sargent created some of the most beautiful family group portraits ever done in any medium. His portraits of the families of the Duke of Marboro (1905) and Sir Orbert Sitwell (1900) are prime examples of his style.

It is only in recent years, with the continuous improvement of cameras, lenses, color films and papers, that photography has come close to competing with a fine portrait painting. Photographers now have the capability to produce exquisite family portraits that are lifelike and can capture the vitality and exuberance of the subjects. Portraits can show the fine detail and texture of their surroundings, which would be impossible for the finest artist to duplicate in so short a time.

With all these advantages, today's portrait photographer can still learn a great deal from John Singer Sargent. His work was always innovative. He never repeated his poses, but created a new pose and design for each group. He carefully selected the space in which he placed his subjects. The color and style of clothing of his group was always in harmony with the background, and the artifacts included in his portraits helped fill the space to make a complete composition. Most of his portraits depicted his subjects in some natural activity. Even when looking at the artist, his subjects seem to be enjoying themselves in some game or other pleasant activity, only stopping momentarily to join in a conversation.

Mr. and Mrs. Barron A. Cass III

Darlene and Barron Cass were hosts at a huge lawn party for the Dallas Cattle Barons Ball. The ball was held to raise money for charity, and the portrait was made to honor the couple's many contributions to local causes.

I find that the foyer of a stately home is frequently the most impressive place to make a portrait. Here, the two-story height of the ceiling, the art work on the stairway walls, the clock, the Henry Moore statue, and the room in the background all added visual excitement to the portrait.

The only thing I had to move was the statue. We turned it around to use as a base for the pose. Since Barron was wearing a tuxedo, we only had to consider what Darlene should wear. I thought the gown she chose blended beautifully with the whole design.

I used a very wide angle 50mm lens to be able to include as much of the foyer as possible. This lens covers an angle of 84 degrees, compared to the 65mm lens, which covers 68 degrees. When using the 50mm lens, the subject must be right in the middle of the picture and there should be some object at the bottom of the frame; otherwise the subject will appear distorted.

Camera: Mamiya RZ67
Lens: Mamiya Sekor 50mm f/4.5
Exposure: 1/30 sec at f/16
Lighting: 5 Flash units
Film: Kodak Vericolor III ISO 160 exposed at ISO 100
Lighting Plan:

Main Light: 200 Ws with 7" reflector and barndoors, at 45 degrees to the left of the subjects set for f/11-16.

Skim Light: Similar unit placed at 135 degrees to the left rear of the subjects.

Background Light: Another similar unit, set for f/8, to light the area below the staircase.

Another similar unit, set for f/8, was placed on the balcony upstairs to light the wall.

Still another similar unit, set for f/11 was lighting the paneled room. It required more light because the paneling was darker.

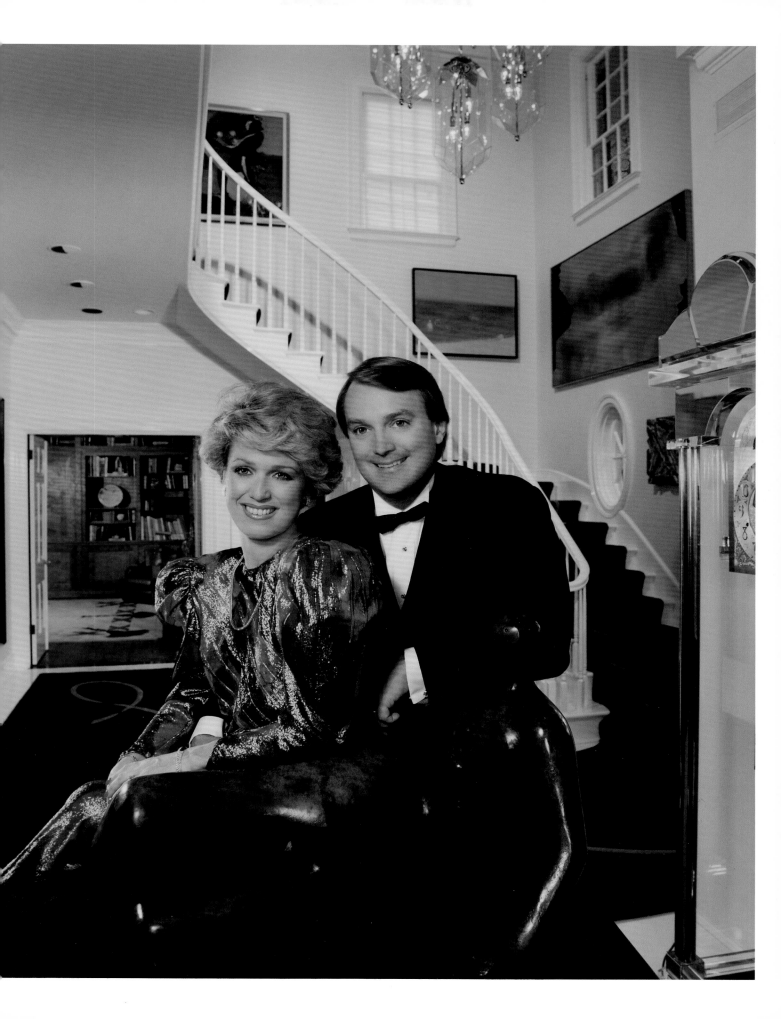

Admiral USN (Ret.) and Mrs. Leon Edney

Admiral and Mrs. Edney's former home, the Missouri House, is one of the historic houses on the Norfolk Naval Base and was built for the Jamestown Exposition in 1907. It would be a shame to live in a house like this and not take advantage of its beautiful lobby for a portrait.

I had to back my camera up to the front door so I could include as much of the room as possible. The chair, table, and flower arrangement were already in the room; I just moved them around to create the design for a pleasing portrait.

Occasionally, someone says that my moving furniture and accessories around is not an accurate portrayal of the way a family lives in their home; they feel that I am distorting the picture. I counter that I am not a documentary photographer, telling things as they are. My job is to make the subjects and their environment look the very best I am capable of. People do not decorate and position their furniture to have their portraits made; they do it to live in. I have to rearrange the furnishings to make the best use of them for a story-telling portrait.

Camera:	Mamiya RZ67
Lens:	Mamiya Sekor 65mm f/4
Exposure:	1/8 sec between f/11 and f/16
Lighting:	8 Flash units
Film:	Fuji Reala ISO 100

Lighting Plan:

Main Light: 200 Ws with 31" umbrella at 45 degrees to the left of the subjects, set at fill.

Fill Light: Similar to main light, set for f/8, placed behind camera.

Skim Lights: 100 Ws with 3" honeycomb and snoot, set for f/11, behind Mrs. Edney to light her hair.

Similar unit to light flower arrangement on table.

Background Lights: Six 200 Ws with 7" reflectors and barndoors, all set for f/8 to light the expansive background and balcony.

The Family of the Honorable and Mrs. Robert G. Doumar

Bob and I grew up together, and I have been photographing him and his family for many years. This portrait was made about 1974. The point I want to make is that it could have been made yesterday, because it has all the elements of a classic portrait.

The design of the group fits the space in the room. The subjects are prominent and the artifacts and furniture add visual interest. The pose is casual and informal. Having the subjects engaged in an activity makes a much more interesting picture than if they were just looking at the camera. However, it is always a good idea to also make a photograph where everyone looks at the camera, to give the client a choice.

The blue color in their clothes harmonizes with the blue objects in the background. The neckties have a little red, which echoes the red in the painting and the cushions on the chairs.

Camera:	Mamiya RB67
Lens:	Mamiya Sekor 65mm f/4
Exposure:	1/15 sec at f/11
Lighting:	5 Flash units
Film:	Kodak Vericolor I, ISO 100

Lighting Plan:

Main light: 200 Ws with a 31" white umbrella, set for f/8 - 11, positioned 45 degrees to the left of camera

Fill light: 200 Ws with 31" white umbrella, set for f/5.6 - 8, placed behind the camera

Background light: Two 100 Ws with 7" silver reflectors and barndoors positioned near the left back wall . One was aimed at the wall on the right and one was aimed at the back wall, both set for f/5.6 - 8.

Back light: 100 Ws with a 7" silver reflector and barndoors ,set for f/11, directed on the family from the left rear.

Grandmother's Estate Planning

This portrait was made for the Clark and Stant law firm as an illustration for their new brochure. The attorney, Jo Ann Blair Sheppard, is helping her client to asses her estate.

It is a very complicated composition, designed to show a room full of art and artifacts and still make the two main subjects stand out. Portrait was made in the Hermitage Foundation Museum.

Camera: Mamiya RZ67
Lens: Mamiya Sekor 65mm f/4
Exposure: 1/5 sec at f/22
Lighting: 6 Flash units
Film: Fuji NHG ISO 400, for greater depth of field

Lighting Plan:

Main lights: 100 Ws with 7" reflector and barndoors, just out of picture area, to the right at 135 degree angle, directed on grandmother's face.

A similar light, out of the picture area, to the left at a 135 degree angle, and directed on grandmother's face. Both were set at f/16 - 22.

Fill light: 400 Ws with 31" umbrella, set for f/11, behind camera.

Background lights: Two 100 Ws , one on the right directed at the left wall and one on the left directed at the right wall.

Accent light: 100 Ws with barndoors, placed 90 degrees to the right of the camera directed on the painting and the decorative clock Jo Ann is pointing at.

The Family of William J. Vaughan, Jr.

Like many of my long-time customers, Bill Vaughan has been photographed by me since he was a little boy. This portrait was one of several family groups I made in 1990 for a PBS television program, to be shown on The Learning Channel, titled "Techniques of the Masters," sponsored by the Eastman Kodak Company. The program selected several photographers in different fields, such as portraiture, photojournalism, advertising, and fashion. The television crew spent a day with each of us, videotaping us at work and interviewing us to show the public how photographers work and create.

I made the Vaughan portrait on their sun porch, where the furniture was already color coordinated. All I had to do was recommend the clothes to harmonize with the room. We moved the furniture into the middle of the room, and I positioned the group to produce an asymmetrical design. The size and visual weight of mother and dad offset and balanced the combined weight and size of daughters and dog.

There is no absolute formula for this pose: Do it until it looks right!

Camera:	Mamiya RZ67
Lens:	Mamiya Sekor 65mm f/4
Exposure:	1/30 sec at f/11
Lighting:	4 Flash units
Film:	Kodak Vericolor III ISO 160, exposed at ISO 100

Lighting Plan

Main light: 200 Ws in 31" umbrella, set for f/8 - 11, placed 45 degrees to the left of the subjects.

Fill light: Similar unit behind the camera set for f/5.6 - 8.

Skim light: 200 Ws with 3" honeycomb and snoot behind mother's head to light hair.

Background light: 200 Ws in a 7" reflector, set for f/8 placed in left rear.

Elegant Women in Their Homes

Most of the photographs published, or exhibited at photographers' conventions, are of beautiful young women. It is true that they constitute a good portion of the portrait market, and I have always enjoyed photographing them. However, most of the orders for large and expensive custom portraits are of women over the age of 40.

It's actually easier to create different portraits of this age group. They have lived long enough to have acquired a distinctive look and a style uniquely their own. And they can afford to pay more for a portrait that displays their taste and individuality in a positive and optimistic way.

The challenge of photographing elegant women in their homes is not only making fine portraits of them, but also choosing as background the most impressive room in their homes, without it detracting from them. *Architectural Digest* shows photographs of homes and their owners all the time. The result, however, is usually a compromise between the subject and the decor. Most *Architectural Digest* photographers are not portrait photographers and frequently lack the skills necessary to make flattering portraits of their owners. There is no reason why we portrait photographers cannot excel in making both the owners and the homes shine.

This type of imaginative portraiture requires more lights to illuminate the background. And we must use wide angle lenses – with a minimum of distortion – from the 37mm fisheye, to the 50mm, 65mm, and the shift 75mm for the 2¼"x 2¾" format of the Mamiya RZ67. It also takes more time to plan and arrange the setting. But the end result is worth the effort and will convince your client that you are a photographic artist and worth your price.

Mrs. Ruth Tinney

Mrs. Ruth Tinney owns the beautiful Bellevue mansion Newport, Rhode Island. I photographed Mrs. Tinney and her family when I was in Newport for a lecture on portrait photography. The surroundings in this impressive mansion were lavish. My challenge was to get a nice portrait of Mrs. Tinney and include as much of the interior as possible. The cooperation and gracious hospitality of the Tinney family made this assignment a pleasure.

Before I can arrange the lights in a complicated location like this, I have to make decisions based on the ambient light in the room. I knew I needed an aperture of at least f/16 to get maximum depth of field. The exposure reading for the ambient light at f/16 was 1 sec with ISO 400 film.

I set up my flash units to light Mrs. Tinney's stand-in, setting the lighting for f/22. I wanted Mrs. Tinney to be one stop brighter than the room so she would stand out from the background. I balanced and lighted the areas not covered by the room lights, and made many Polaroid proof prints until I had a good exposure. I made 20 exposures of Mrs. Tinney on 220 film in about 20 minutes, and I got the picture I was looking for.

Camera: Mamiya RZ67

Lens: Mamiya Sekor 65mm f/4

Exposure: 1 sec at f/22

Lighting: 9 Flash units

Film: Kodak Vericolor III ISO 160 exposed at ISO 100

Lighting Plan

> Main light: 200 Ws with 7" reflector and barndoors, 45 degrees to the right of the subject set for f/16 - 22.
>
> Fill light: 200 Ws in 31" umbrella, set for f/11 - 16.
>
> Skim light: 200 Ws with 7" reflector with barndoors, 135 degrees to the right of the subject, set for f/22.
>
> Background light: Two 200 Ws with 7" reflectors in the far back rooms, each set for f/16; two similar lights were placed behind and to the left of the subject, directed to the right front and rear of the great hall and two more similarly placed on the right rear of the subject, to light the left front and rear. All four lights were set at f/16. Without these six lights to subtly boost the lighting of the chandeliers, the walls of the room would have been too dark to see any detail.

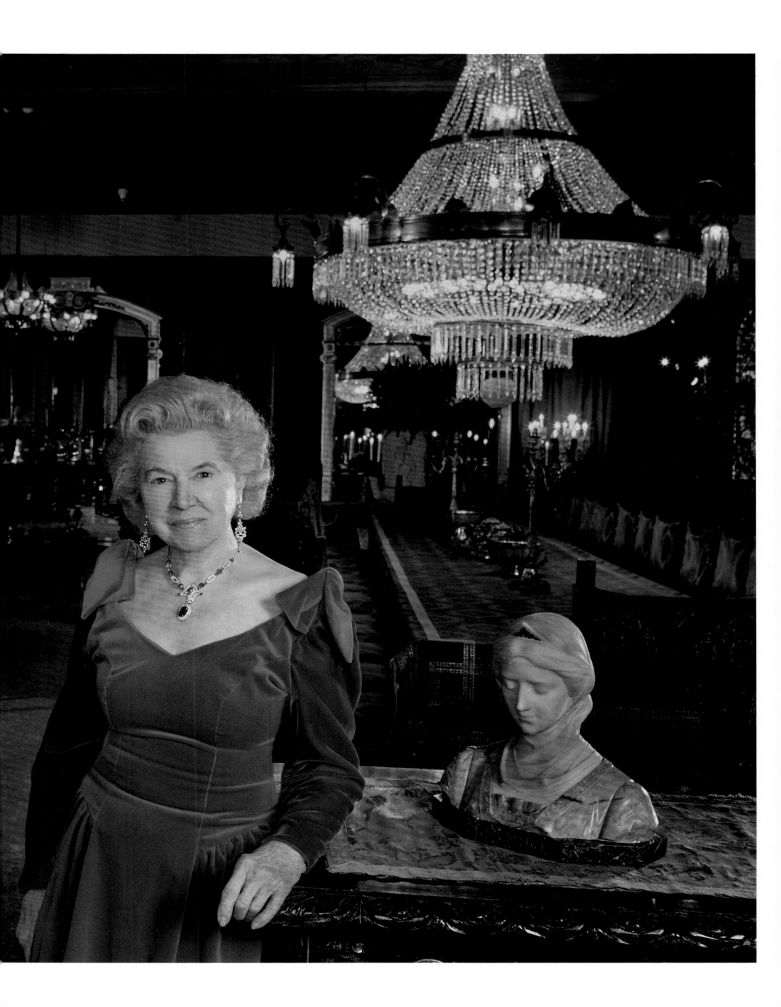

Mrs. Paul David Miller

Becky Miller is the wife of Admiral Paul David Miller. At the time this portrait was made, they resided in Virginia House on the Naval Base at Norfolk, Virginia. This beautiful old mansion was built in 1907 for the Jamestown Exposition, celebrating the 300th anniversary of Jamestown, Virginia.

The entrance hall of this turn-of-the-century mansion was enormous. I placed the plant on the left and the table and bowl on the right of my subject. The table provided a good prop for Becky to rest on. It also helped draw attention to the subject.

I used the 65mm wide angle lens to include much of the beauty of the room and balcony.

Camera: Mamiya RZ67
Lens: Mamiya Sekor 65mm f/4 wide angle
Exposure: 1/15 sec at f/11,to pick up room's ambient light
Lighting: 5 Flash units
Film: Fuji Reala ISO 100

Lighting Plan:

Main light: 200 Ws in 31" umbrella, placed at 45 degrees to left of subject.

Fill light: Same unit but twice the distance from subject and behind the camera.

Back light: One 100 WS with 3" honeycomb and snoot.

Background lights: Two 100 Ws with 7" reflectors, placed about 10 ft behind, on each side of the subject, to light the opposite wall. Another two similar units were lighting the upstairs walls. Each was set at 200 Ws. Background exposure was f/8, one stop less than light on subject to make her stand out from background.

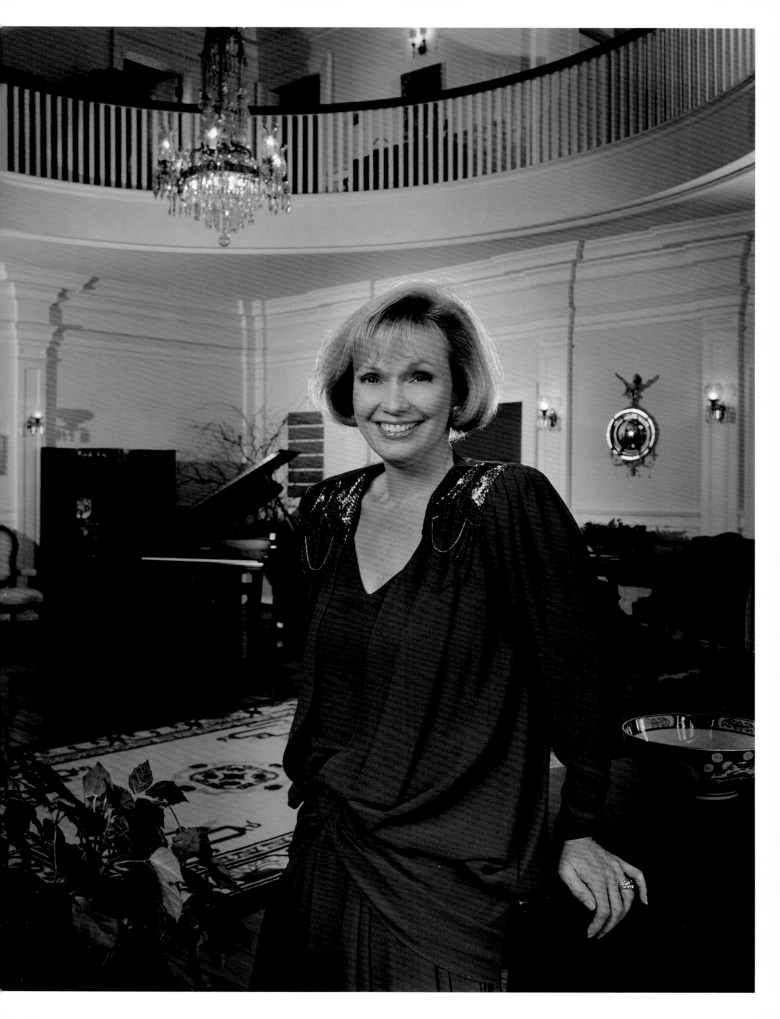

Kathrine Treherne, M.D.

Dr. Treherne, chairman of dermatology of the National Medical Association, was photographed in her Portsmouth, Virginia home. I preferred to create an image of an elegant, warm woman in a comfortable background, rather than one of a physician in a white coat, within a sterile office environment.

Dr. Treherne also happens to be my dermatologist, so it was not difficult for me to get a pleasant smile from her!

This portrait is another good example of how I move furniture and accessories to design the space around the subject. The sofa was positioned so that Kathrine would be framed by the cabinet mirror in the background. I added the the flowering plant to match the design and color of the sofa. The lamp was placed on the opposite wall to reflect in the mirror and give depth to the portrait.

Camera: Mamiya RZ67
Lens: Mamiya Sekor 65mm f/4 wide angle
Exposure: 1/8 sec at f/11 to pick up lamp reflected in the mirror.
Lighting: 6 Flash units
Film: Fuji NPS ISO 160

Lighting Plan:

Main light: 200 Ws in 31" umbrella, placed 45 degrees to the subject's left, set for f/8 - 11.

Fill light: Same as main, placed directly behind the camera and set for f/6.3.

Skim light: 200 Ws in a 7" reflector with barndoors, at 135 degrees to the left and set at f/11, directed at the subject.

Background light: The wall reflected in the mirror was illuminated by a 200Ws flash with 7" reflector and barndoors. Two similar units, set at f/8, were used to light the right and left cabinets.

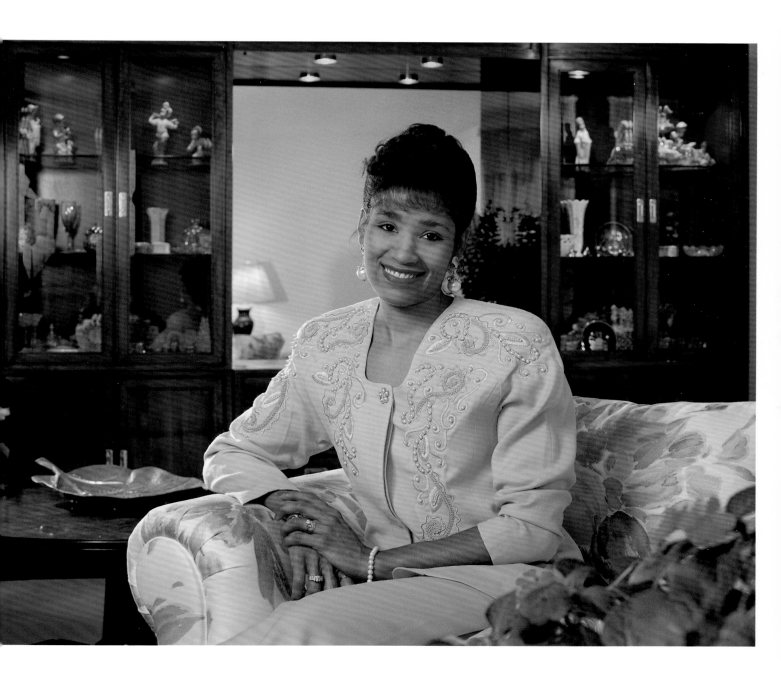

Mrs. Olan Mills II

Norma Mills was one of four ladies I was commissioned to photograph for the Chattanooga Fashion Hall of Fame. The portrait was made in her exquisite home, decorated with beautiful antiques.

The wall-size tapestry, Russian samovar and antique cabinet formed a refined background for a refined lady. We selected her blue silk blouse to match the blue shades in the chair and tapestry.

Camera: Mamiya RZ67
Lens: Mamiya Sekor 65mm f/4 with B+W #2 soft focus filter
Exposure: 1/60 sec, f/8 - 11
Lighting: 6 Flash units
Film: Kodak Vericolor III ISO 160, exposed at ISO 100

Lighting Plan

Main light: 200 Ws with 31" umbrella, set for f/8

Fill light: Similar unit set for f/4.5

Skim light: Two 100 Ws with 7" reflectors and barndoors, directed at the subject from the right and left of the room.

Background light: Two similar units were directed on the wall tapestry and table from each side of the rear of the room.

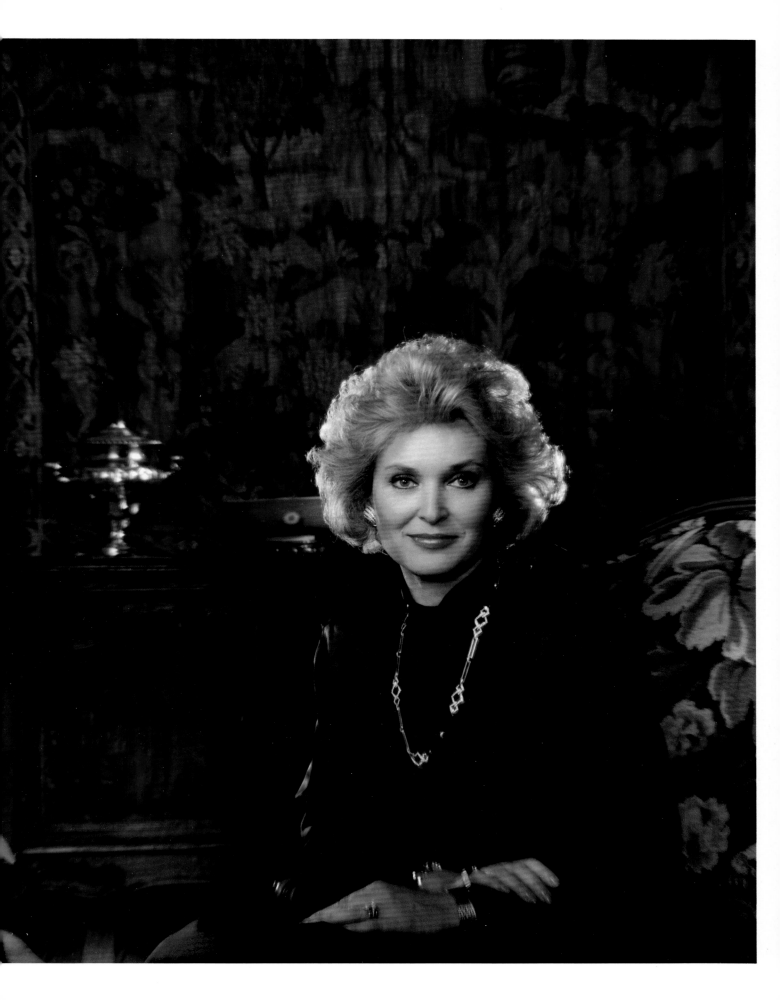

Mrs. Chloe C. Mundy

Mrs. Mundy is the mother of Dorothy Doumar. I have been photographing the Doumar family for forty-five years and this portrait was made for her two daughters. One of the great rewards of being a portrait photographer is to establish friendships with your clients and to be able to serve them for generation after generation.

Camera: Mamiya RZ 67
Lens: Mamiya Sekor 150mm f/4 variable soft focus with 5.6 disc
Exposure: 1/15 sec at f/5.6
Lighting: 4 Flash units
Film: Kodak Vericolor III ISO 160 exposed at ISO 100

Lighting Plan

Main light: 100 Ws in 7" reflector with barndoors and diffuser, set for f/5, at 45 degrees to the left of the camera.

Fill light: 100 Ws in 31" umbrella, set for f/2.8 behind camera.

Back light: 100 Ws with 3" honeycomb and snoot, set for f/5.6 to light hair.

Background light: 100 Ws with barndoors, set for f/4.

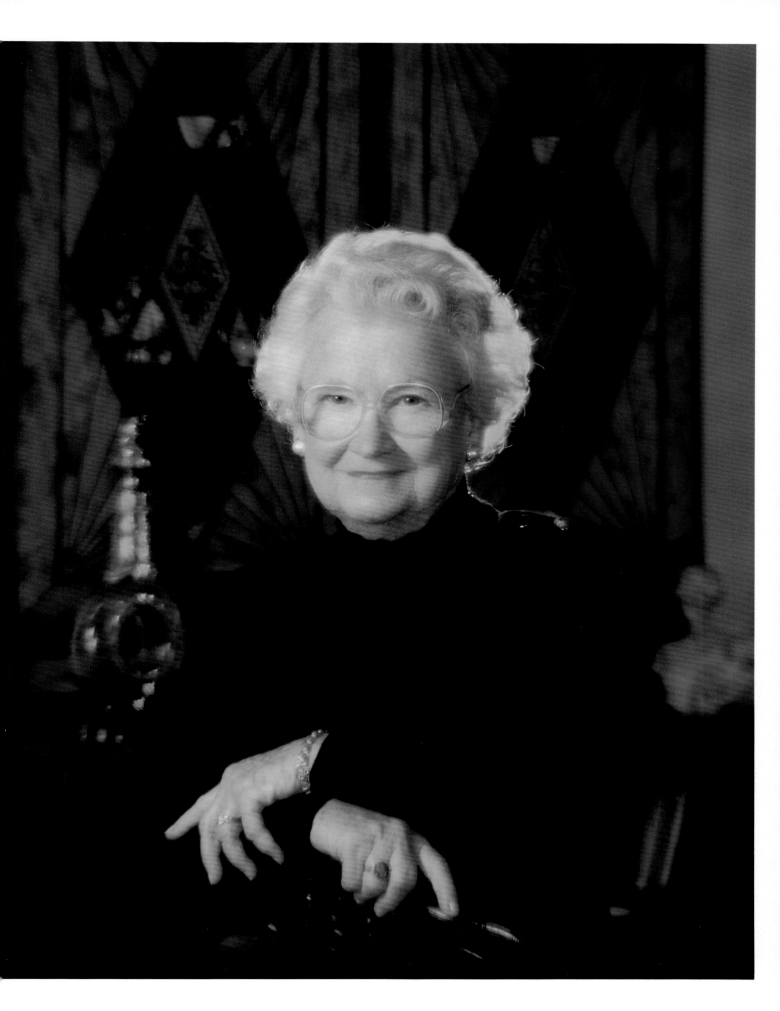

Mrs. Lee Smith Conduff

When I started my career in photography in 1948, Lee owned the neighborhood hair styling salon. (They called it a beauty parlor then). I photographed her in her salon and charged her $1.00 for an 8x10 black-and-white picture. (It was not a "portrait" then, it was just a picture.)

Now, decades later, I photographed her again, to celebrate her 80th birthday. I think Lee could have been a movie star. She can assume poses some young girls would have trouble with. As is routine for most of my home portraits, tables, artifacts and lamps were moved to give a more pleasing design to the picture.

I believe it is my job to make pleasing portraits of my clients. This requires selecting the right clothing, accessories and pose. Obviously, Lee Smith at 80 does have wrinkles. Yet the structure of her face, her jaw line and her hair, look the same to me as in 1948. The soft focus lens, a little retouching and the three quarter pose, with ample space around her, contribute to the image her friends and I see of her: An elegant, beautiful lady with lots of vitality.

Camera: Mamiya RZ67
Lens: Mamiya Sekor 150mm f/4 variable soft focus with no disc
Exposure: 1/15 sec at f/4
Lighting: 4 Flash units
Film: Fuji NPS ISO 100

Lighting Plan
 Main light: 100 Ws in 7" reflector with barndoors and diffuser to reduce light output, set for f/3.5, at 45 degrees to the right of subject.
 Skim light: 100 Ws in 7" reflector with barndoors, set for f/4.
 Background light: Similar unit placed in left rear.

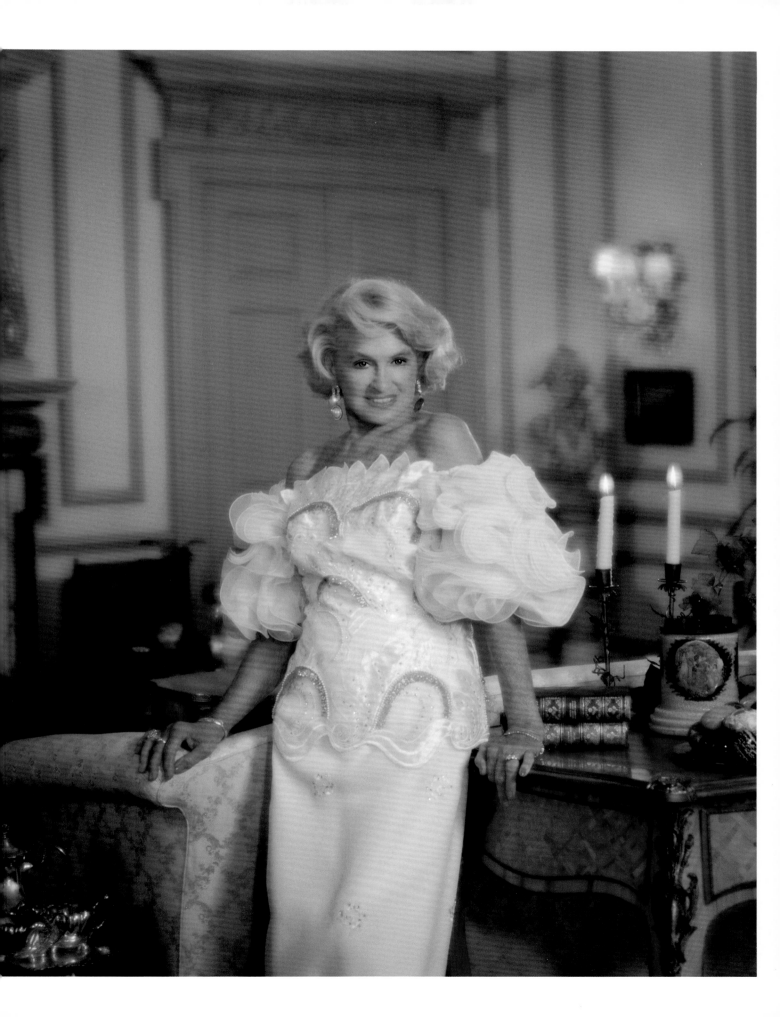

Mary Kay

In 1985, Dallas honored the city's five outstanding women at a special luncheon sponsored by the Chamber of Commerce. I was selected to photograph these ladies and Mary Kay – of cosmetics fame – was my first subject.

Mary Kay, my wife Luci, and I spent an entire morning together. I set up the equipment while Luci talked to her about cosmetics. In discussing her clothing, I suggested she wear the very fashionable black dress instead of an equally striking pink one. Black would make her show up better against the white sofa and carpet.

Throughout the morning session, we learned each other's life stories. I found Mary Kay one of the most charming people I have ever met. It is easy to understand why she has had such an incredible career.

Camera:	Mamiya RZ67
Lens:	Mamiya Sekor 50mm f/4.5 with a B+W #2 soft focus filter
Exposure:	1/15 sec at f11
Lighting:	11 Flash units
Film:	Kodak Vericolor III ISO 160, exposed at ISO 100

Lighting Plan

Main light: 200 Ws in 7" reflector with barndoors, placed 45 degrees to the subject's right, set at f/8 - 11.

Fill light: 200 Ws in 31" umbrella, directly behind camera and set at f/6.3.

Back light: 100 Ws with honeycomb and snoot set for f/5.6 behind her head lighting her hair.

Background light: Four 200 Ws with 7" reflectors and barndoors. Four additional units, placed in the rear of the room, were used to light the 30 ft. ceiling, upper part of the wall and the left middle of the picture.

Comments: The very wide angle 50mm lens was needed to cover the magnificent expanse of the 30 ft ceiling. This lens, through controlled distortion, also made Mary Kay appear taller.

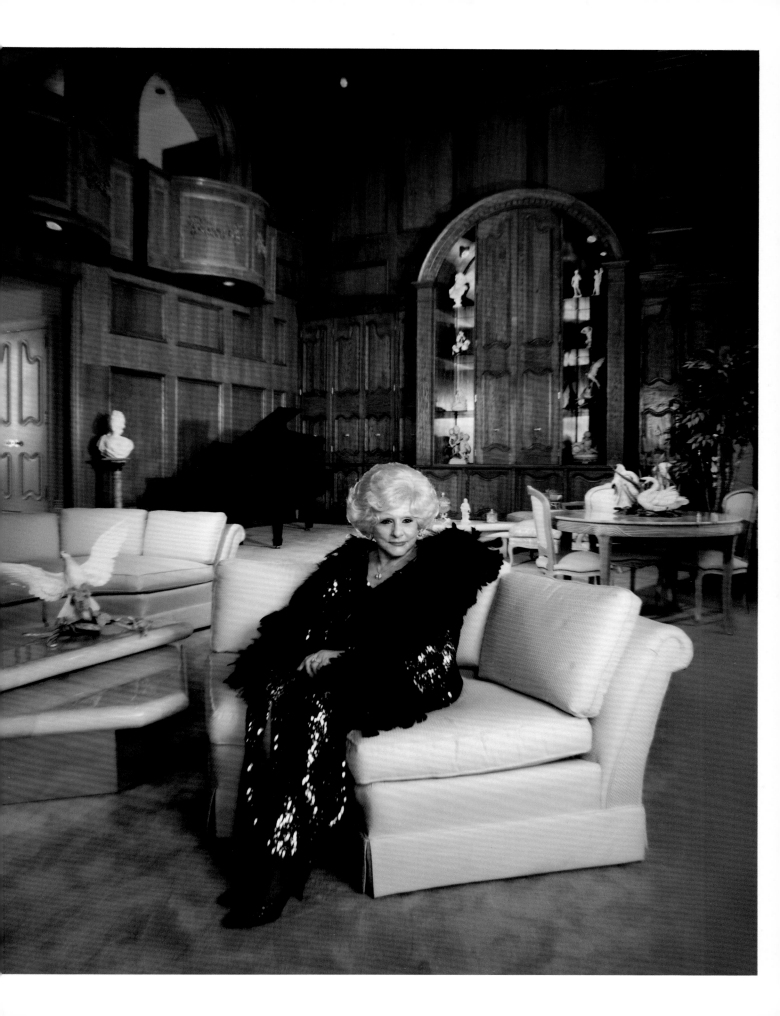

Mrs. Oscar Bryan

Nellie Bryan is one of those community-minded women who can be depended on to run a successful charity bazaar, a hospital fund campaign, or to make herself available for almost any worthwhile cause that may fit her talents.

I photographed her in her home when she was President of the Board of Directors of the Virginia Symphony Pops Orchestra. The portrait was made for an exhibit of my work at the Symphony Hall.

Camera:	Mamiya RB67
Lens:	Mamiya Sekor 150mm f/4.5 variable soft focus
Exposure:	1/15 sec with f/5.6 disc
Lighting:	4 Flash units
Film:	Kodak Vericolor III ISO 160, exposed at ISO 100

Lighting Plan

Main light: 100 Ws in 7" reflector with barndoors and diffuser, to reduce the light output, set for f/5, placed at 45 degrees to the right of the subject.

Fill light: 100 Ws in 31" umbrella, set for f/2.8, directly behind the camera.

Back light: 100 Ws with 3" honeycomb and snoot, set for f/5.6.

Background light: 100 Ws with barndoors, set for f/4, at the right rear of the room.

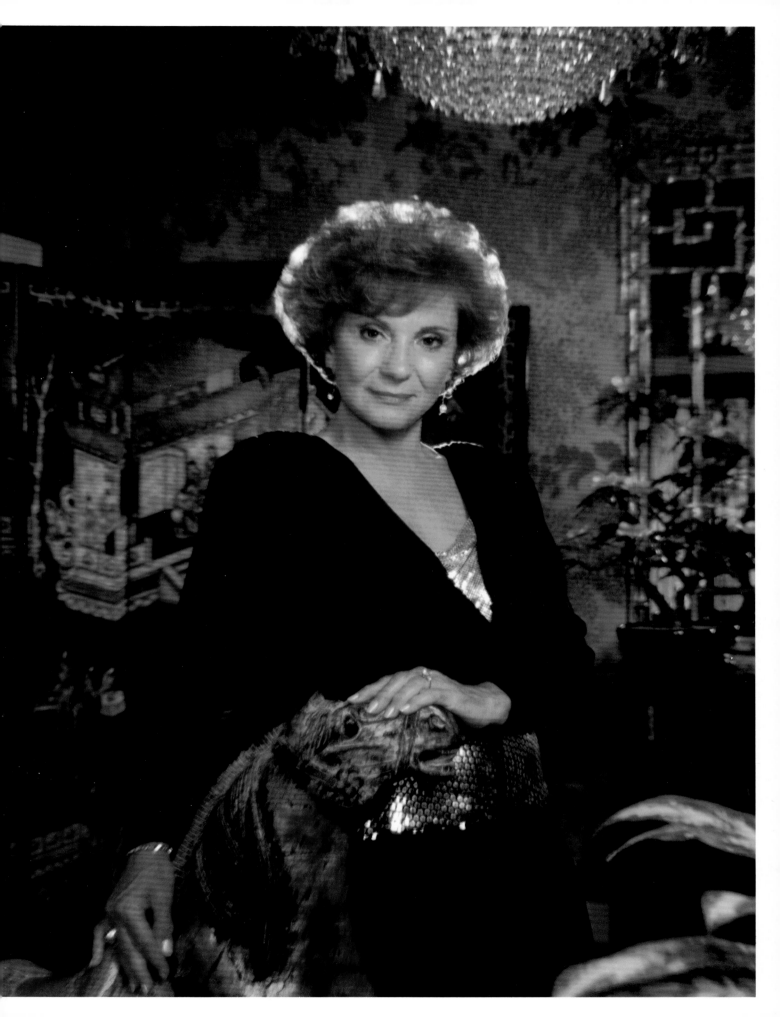

Mrs. Colin L. Powell

Alma Powell was photographed in her home in Fort Myers Virginia. The portrait was created for a travelling exhibit, sponsored by the Hampton Roads Chapter of the National Navy League.

Portraits of this type are designed rather than taken. A fire was lit in the fireplace. The flower arrangement and the bust statue were brought in from another room and placed to fill the space in the left corner. Tables, lamps and furniture were moved to make a more pleasing background. The plant in the lower right was also added to enhance the composition.

Alma Powell was once a model, so photographing her was not only easy, but a pleasure. I wanted a relaxed but sophisticated portrait of Alma, with a little mystery to it. I think I succeeded.

Camera:	Mamiya RZ67
Lens:	Mamiya Sekor 150mm f/4.5 variable soft focus with f/5.6 disc. This gave me the soft air of elegance I was looking for.
Exposure:	1/15 sec at f/5.6 to show fire in fireplace.
Lighting:	5 Flash units
Film:	Fuji Reala ISO 100

Lighting Plan

Main light: 100 Ws in 7" reflector with barndoors and diffuser to reduce the light output set for f/5, at 45 degrees to the right of subject.

Fill light: 100 Ws in 31" umbrella, set for f/2.8, placed directly behind camera.

Skim light: 7" reflector flash with barndoors, set for f/5.6, placed 135 degrees to right rear of the subject.

Background light: Similar unit, set for f/4, was placed outside the picture area to the left rear. Another, similar light was placed to the right rear, directed on the bust and flower arrangement on the coffee table.

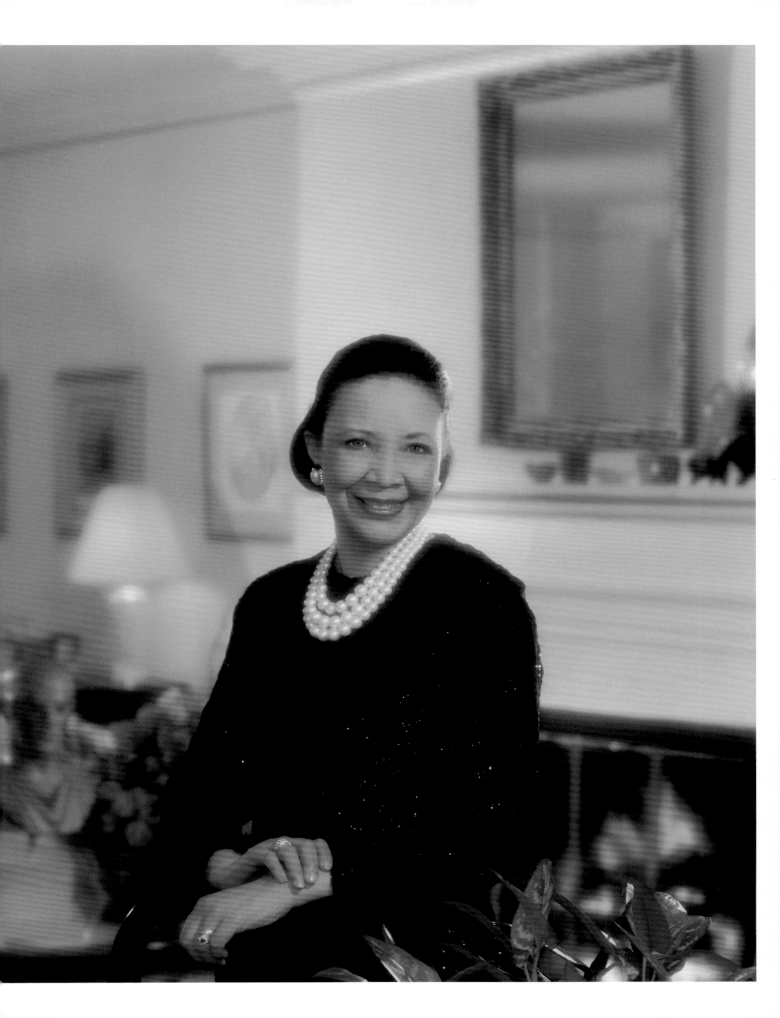

Tracey Robinson

Tracey is a friend of my daughter Lisa. When I first met her I thought she looked like a movie star. Not long thereafter the Fuji Film Company called me and was interested in obtaining some large display photos for a trade show.

I decided to use Tracey as a model for this job. She has high cheek bones and reminded me a little of Marlene Dietrich, as she appeared in the old movie "The Blue Angel", where she wears a tuxedo.

The idea occurred to me to photograph Tracey in a tuxedo, creating a black and white, slightly masculine, portrait of her. Then making a big, framed blow-up to serve as a background for a color portrait, showing her feminine side, with her hair down, looking straight into the camera. An orchid arrangement would further enhance this image and the composition.

I kept everything in black and white, the only color being in her face, jewelry, flowers and gold frame.

Camera:	Mamiya RZ67
Lens:	Mamiya Sekor 180mm f/4.5
Exposure:	1/125 sec at f/16
Lighting:	4 Flash units
Film:	Fuji NPS ISO 100

Lighting Plan

Main light: 100 Ws in 7" reflector with barndoors, set for f/11 - 16, at 45 degrees to the right of subject.

Fill light: White reflector to left of subject. (Reflector was used instead of flash to prevent a glare on the portrait behind her.)

Skim light: 100 Ws with 3" honeycomb and snoot behind her head, lighting her hair. A similar light was directed at the flowers.

Background light: 200 Ws in 7" reflector, with barndoors set for 100 Ws, was directed at the b&w portrait from the right rear of the room.

Comments: A concept portrait like this takes about three hours, not counting the time spent making the framed b&w portrait. The lighting plan is just a general idea of light placement and power. Each light, however, is adjusted and fine- tuned, making use of barndoors, snoots, honeycombs, gobos and reflectors. Polaroid exposures are made to check the lighting and pose, to accomplish the desired result. Then 20 to 40 exposures are made with 220 magazines to get the perfect expression, otherwise all the effort and time has been wasted.

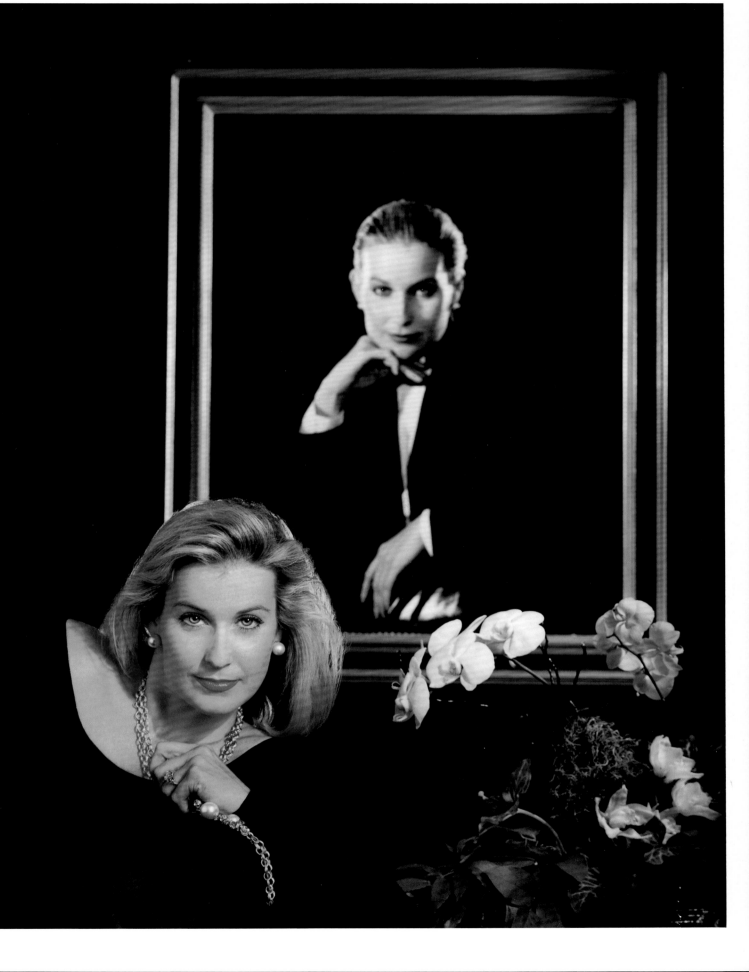

People of Prominence

There is a need for fine portraits of prominent people in all areas of human endeavor. Portraits are required for newspapers, annual reports, advertising, political campaigns, etc., etc. Large, framed portraits are a must for boardrooms, institutions, churches, libraries and hospital lobbies, to honor founders or significant donors. When beautifully framed color portraits resemble fine paintings, they will frequently grace walls in private homes.

Prominent people are always busy. They generally are too rushed to sit for a portrait painter. The perfect solution is high quality portrait photography.

With proper planning, cooperation from staff people and the aid of a volunteer assistant, I can consult with an executive for 20 to 30 minutes and learn his or her ideas of how to be photographed. A time can then be scheduled for the sitting which will have to take no longer than 30 minutes.

It may take me and my assistant one or two hours, or even more, to prepare for the sitting, but the executive's presence is not required until we are ready.

The Honorable John H. Dalton

John Dalton is Secretary of the United States Navy. I photographed him for a travelling exhibit, sponsored by the Hampton Roads Chapter of the National Navy League – a national organization of business executives – to acquaint the public with our senior military leaders.

Mr. Dalton was a busy man and it took several months before he could reserve the short time needed to be photographed. Finally an appointment was scheduled for me at his office at the Pentagon for a preliminary meeting.

The portrait session was set for the very next morning at 8:00. When the Secretary left his office in the afternoon, a member of his staff and and two of my assistants helped me to prepare the office for my portrait photography.

We moved several stuffed chairs, small tables and a number of chairs standing around the conference table out of the room. The conference table had to be pushed to one side, to make room for my camera and lights.

The Secretary, being a Naval Academy graduate and a former submariner, we moved a model of his submarine into the right rear of the room. We borrowed a sculpture from another room to fill the left corner.

My volunteer assistant, Jerry Kelly, was about the same height as my subject and I used him as a stand-in model and made Polaroids until all the lights were in balance and the design for the portrait was complete.

The next morning we arrived at 7:30 and tested the equipment. Mr. Dalton arrived punctually at 8:00 and offered us coffee. I casually directed him into the planned pose. We spent 30 minutes in light conversation and banter, while I surreptitiously made about 40 exposures. At 8:30 the sitting was finished. The Secretary was a very gracious host and an excellent subject and, together, we created a fine portrait.

Camera:	Mamiya RZ67
Lens:	Mamiya Sekor 65mm f/4 wide angle
Exposure:	1/125 sec at f/11
Lighting:	6 Flash units
Film:	Fuji Reala ISO 100

Lighting Plan

Main light: 200 Ws in a 31" umbrella at 45 degrees to the left of subject, set at f/8 - 11

Fill light: Similar unit, placed behind the camera and set at f/5.6 - 8.

Skim light: 200 Ws in a 7" reflector, set for f/11, placed at 135 degrees to the subject, at left rear of room, to backlight subject and separate him from background.

Background light: Three 100 Ws units in 7" reflectors with barndoors, all set at f/8. Two to light the back wall, one – behind the subject – to light the statue.

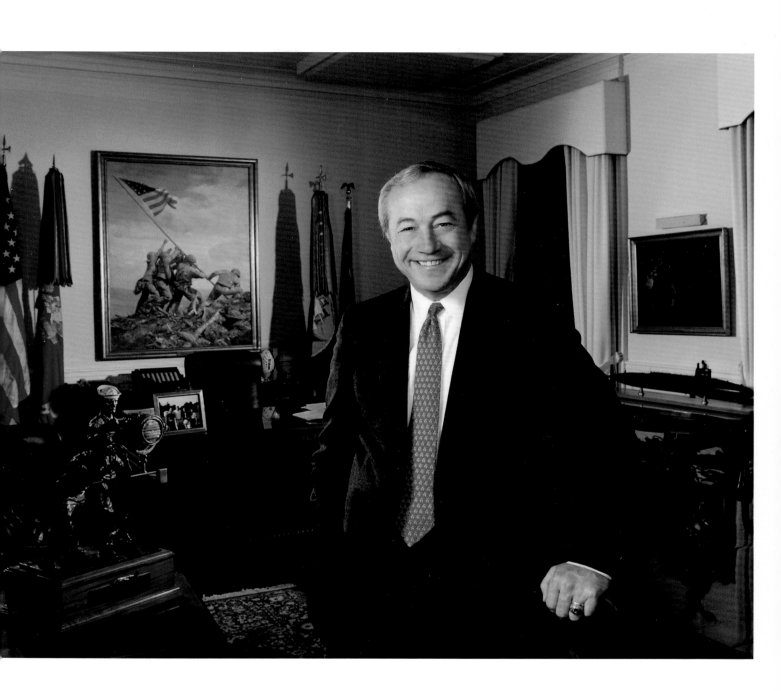

Frank Batten, Sr.

Frank Batten is Board Chairman of Landmark Communications, Inc., based in Norfolk, Virginia, a privately held communications company with interests in newspapers, broadcast and cable television , as well as special publications. The Weather Channel and Travel Channel are also part of the Landmark Company.

I have photographed Frank a number of times for his company's annual reports. He is amiable and easy to photograph. We chose the huge printing presses of one of his newspapers as the background for this portrait. The stack of "The Virginian Pilot," the newspaper that started his career, was used as a prop in the foreground.

The workers in the middle left and the man on the right of the picture were all lighted separately.

Camera:	Mamiya RZ67
Lens:	Mamiya Sekor 65mm f/4
Exposure:	1/2 sec at f/11 (to pick up the ambient light in the plant)
Lighting:	7 Flash units plus ambient light
Film:	Kodak Vericolor III ISO 160, exposed at ISO 100

Lighting Plan

Main light: 200 Ws in 31" umbrella set at f/8 - 11, 45 degrees to the right of subject.

Fill light: Similar unit, set between f/5.6 - 8, directly behind camera.

Skim light: 100 Ws in a 7" reflector with barndoors at 135 degrees to the right rear, lighting his left side to make him stand out from background.

Background light: The three workers were individually lighted by 200 Ws units, with 7" reflectors and barndoors, all set at f/11.

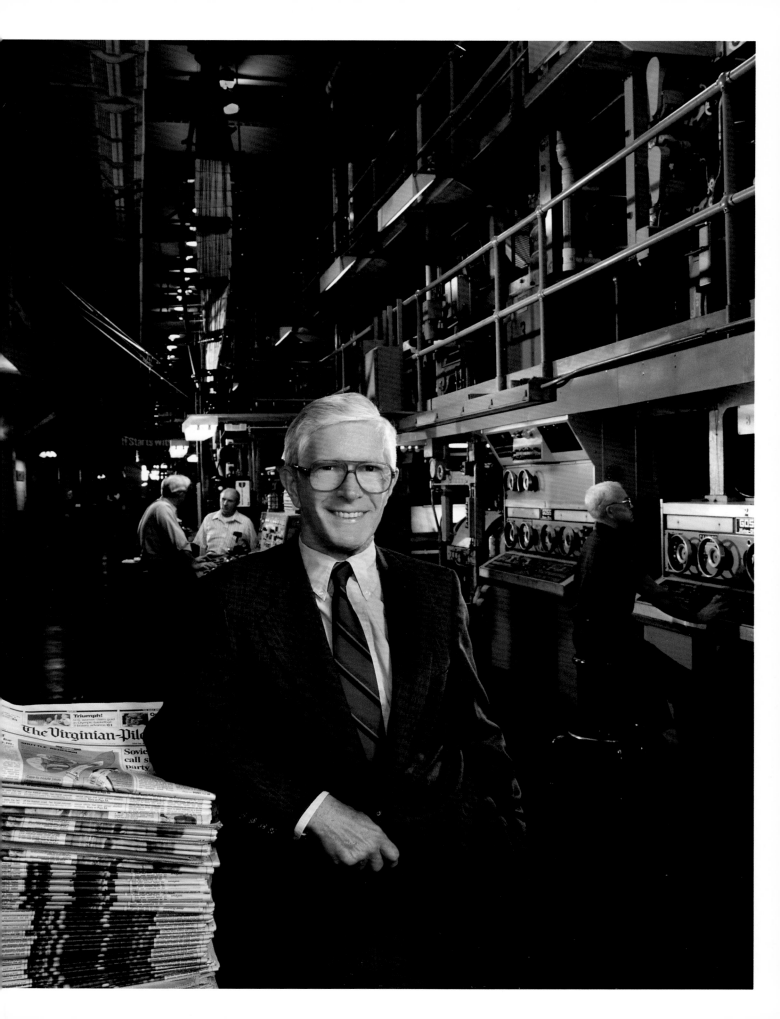

The Honorable Jan Graham

Jan Graham is the Attorney General of the State of Utah. I photographed her in the very impressive Utah State Capitol Building. Grand spaces with vast interiors require long exposures to utilize the ambient light. It would have taken many hours and a great number of flash units to light this enormous space and it still would not have achieved the beautiful effect of the building's ambient light.

Camera:	Mamiya RZ67
Lens:	Mamiya Sekor 65mm f/4
Exposure:	1 sec at f/16
Lighting:	3 Flash units to light subject only.
Film:	Fuji NH, ISO 400

Lighting Plan

The ambient light of the interior required an exposure of 1 sec at f/11.

Main light: 200 Ws in a 31" umbrella, placed at 45 degrees to the left of subject, set at f/11 - 16.

Fill light: Similar unit, placed behind the camera and set at f/8 - 11. This light added ½ stop to the mainlight, making the exposure for Ms. Graham f/16.

Skim light: 100 Ws in a 7" reflector with barndoors, aimed at subject, placed 135 degrees to the left rear of the room, set for f/16

Background light: Ambient

Comments: A 40x50" black cloth scrim , attached to two 12 ft light stands, was positioned above subject's head to prevent the building's ambient lights from overexposing her face during the 1 sec exposure.

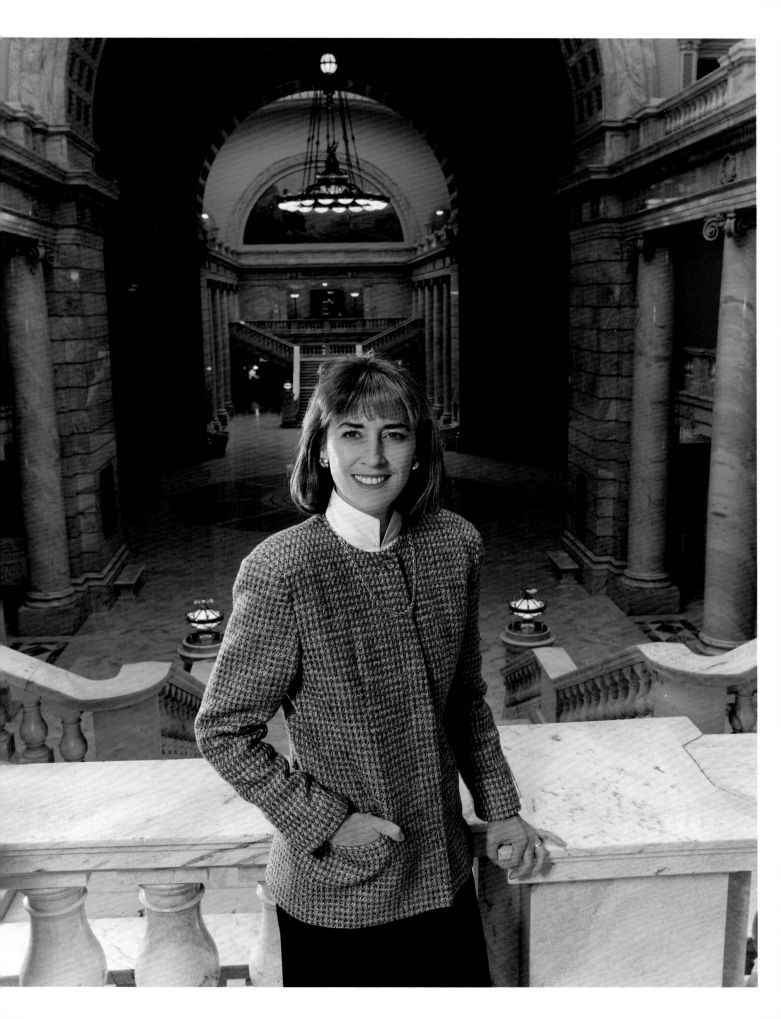

The Honorable George Nigh

George Nigh is a former Governor of the State of Oklahoma and is presently the President of the University of Central Oklahoma.

Mr. Nigh and I are the same age and share a liking for some of the old jokes of the forties and fifties. When I was ushered into his office I considered it too small for my style of portraiture. I suggested to the Governor that the official room for state functions, which I had just passed through, would better reflect his position as Governor of a great state and he agreed.

Under my direction, his staff moved his desk, two chairs, three flags and several artifacts that were meaningful to him. The result was a very spectacular portrait.

Camera:	Mamiya RZ67
Lens:	Mamiya Sekor 65mm f/4
Exposure:	1/8 sec at f/11 - 16 (to pick up lights of chandelier and lamps)
Lighting:	6 Flash units
Film:	Kodak Vericolor III ISO 160

Lighting Plan

Main light: 200 Ws with barndoors, set at f/11, placed at 45 degrees to subject's left.

Fill light: 200 Ws in a 31" umbrella, set for f/8, directly behind the camera.

Skim light: 200 Ws, set for f/8 at 135 degrees to the left rear of the room to light the subject's face and right hand set at f/11

Background light: 200Ws in a 31" umbrella, set for f/8, in the right rear and directed on the back wall. A similar light was placed in the left front of the room, to light the wall the governor is facing, which is reflected in the mirror.

Comments: A 200 Ws flash in a 7" reflector can only light about a 15 ft section of a wall evenly. The wall behind and in front of the governor, in this very large room, is over 30 ft wide. The walls were already brightened by ambient light but needed a little more light to keep the shadows from going too dark. The umbrella lights were a good choice because their soft light and very wide angle of coverage could spread the light evenly.

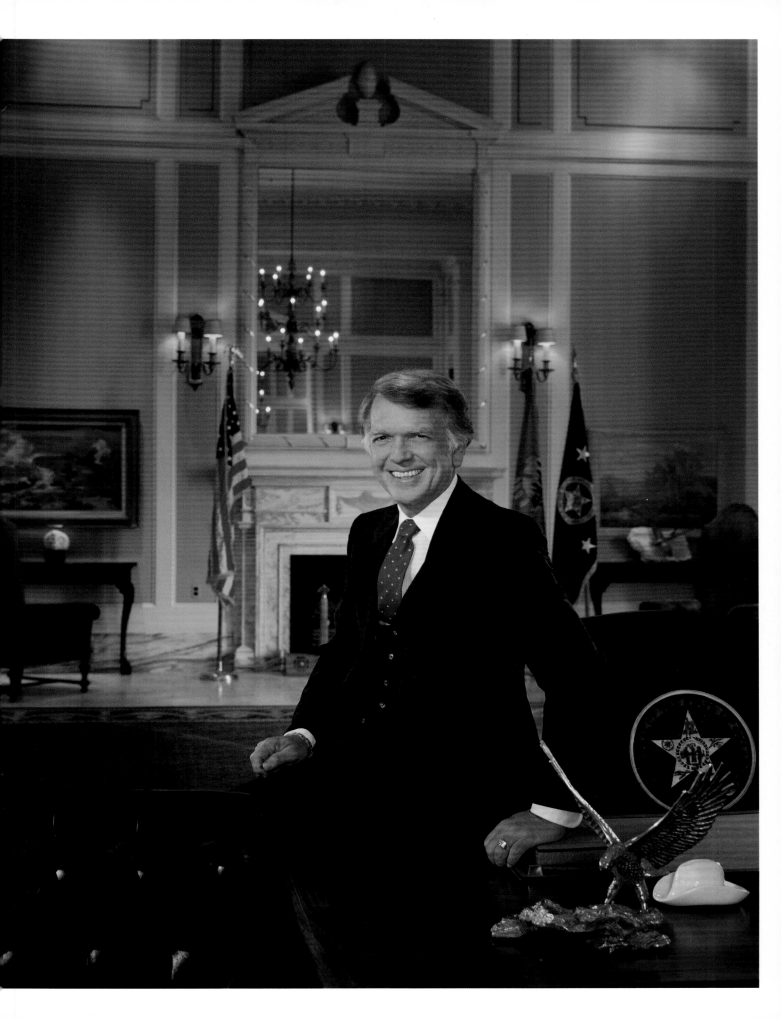

The Honorable Colgate Darden

Governor Darden is one of Virginia's outstanding leaders of the 20th century. He was a United States congressman, governor during the World War II years, and a former president of the University of Virginia.

I photographed the governor in his library in 1970 for one of my early exhibits of our cultural and civic leaders. We spent several hours one afternoon talking about Virginia history, philosophy, politics, and other interesting subjects. For once, I listened more than I talked. During this time, I set up my equipment and casually made exposures until I got what I thought was a warm and reflective portrait of one of our prominent leaders.

Camera:	Mamiya RB67
Lens:	Mamiya Sekor 90mm f/3.5
Exposure:	1/4 sec at f/11 (to pick up light in lamp)
Lighting:	3 Flash units
Film:	Kodak Vericolor I ISO 100

Lighting Plan:

Main Light: 200 Ws in 31" umbrellas, placed 45 degrees to the left, set at f/8 - 11

Fill Light: Similar unit behind camera set at f/5.6 - 8.

Background Light: Similar unit placed at 90 degrees to the left rear of the room, directed against library and set at f/5.6 - 8.

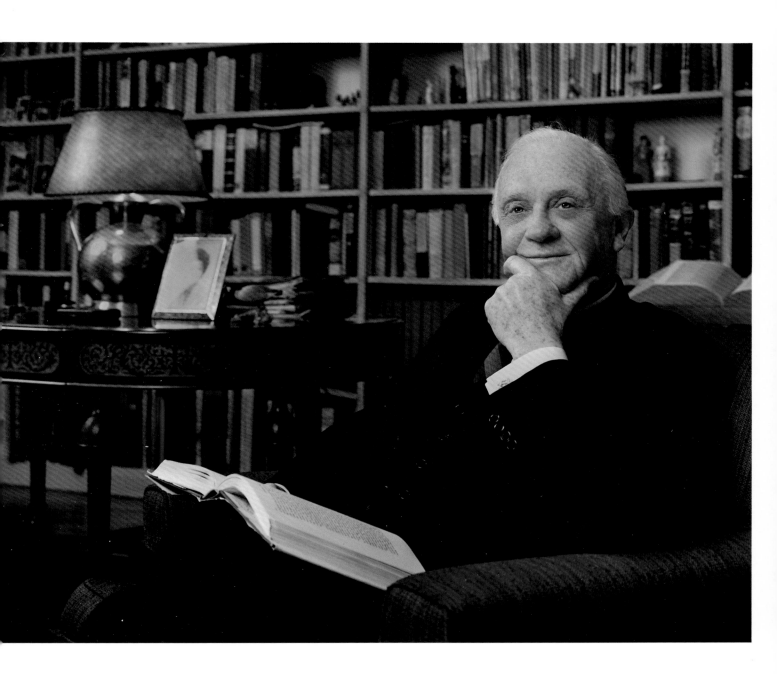

Drs. Howard and Georgeanna Jones

The Doctors Jones, a husband-and-wife team, pioneered the first invitro fertilization program in the United States. They do their research at the Jones Institute for Reproductive Medicine in Norfolk, Virginia. My double portrait honoring them is displayed in the lobby of the institute.

I visited the Joneses at their Norfolk home, and I also walked around the institute, looking for a location that would help me tell their story. Finally, we decided to create our own setting and to include a baby in the portrait. The chart on the wall, describing a part of the formula for their medical breakthrough, the medical books they have authored, the modernistic statue of mother and baby, and the real baby, all symbolically tell their story.

Camera:	Mamiya RZ67
Lens :	Mamiya Sekor 110mm f/2.5
Exposure:	1/125 sec at f/11
Lighting:	3 Flash units
Film:	Kodak Vericolor III ISO 160, exposed at ISO 100

Lighting Plan:

Main Light: 200Ws in 7" reflector with barndoors, set at f/11, placed at 90 degrees to the left of the physicians.

Fill Light: 200 Ws with 31" umbrella, set at f/8, at 45 degrees to left of subjects, spaced behind the camera.

Background Light: 100 Ws with barndoors on left, directed to the statue, microscope and large chart.

Dr. L. D. Britt

I first photographed Dr. Britt in a more traditional setting when he was rector of the Norfolk State University. His portrait was for display in the University's Board Room. Later in the year, when working on an exhibit of the area's outstanding citizens, I photographed Dr. Britt again.

Dr. Britt is the first African-American in the history of Virginia to be appointed Professor of Surgery. He currently is Program Director, General Surgery, Eastern Virginia School of Surgery.

This time we decided to photograph him in the operating room and we prepared the setting an hour in advance. The medical equipment as well as the operating lights are placed in the background to show the physician's environment and to enhance the design of the portrait. The green and red LEDs on the monitor screens are echoed in the color of the surgical gown and the red ribbons on the rack on the left. They add color harmony to the portrait.

Camera:	Mamiya RZ67
Lens:	Mamiya Sekor 140mm f/4.5 Macro
Exposure:	1/2 sec at f/8 - 11 (The slow shutter speed was chosen to register the colorful LEDs on the monitor screen. The surgical lights were dimmed by rheostat.)
Lighting:	5 Flash units
Film:	Fuji NPS ISO 160

Lighting Plan:

Main light: 200 Ws in a 31" umbrella, placed at 45 degrees to the right of subject, set at f/8.

Fill light: Similar unit, placed behind the camera and set at f/5.6

Skim light: 100 Ws in a 7" reflector with barndoors, set for f/8 - 11, placed 135 degrees to the right rear of the room and aimed at the subject.

Background light: Two additional similar lights, both set at f/5.6-8, were placed at the left rear of the room. One directed at the equipment in the background and one at the surgical lights.

John Thompson, Co-Vice President, The Southland Corporation

I photographed Mr. Thompson when he was board chairman of the Presbyterian Health Care Center in Dallas, Texas. His portrait now hangs in its boardroom.

Mr. Thompson's office is in the headquarters building of the Southland Corporation. In our walk-through, we decided to use the art work in the lobby as the portrait's background. The Southland custodians moved the large Plexiglass sculpture in front of the handsome wall hanging, so I could use the unusual design of two pieces of art to enhance Mr. Thompson's portrait.

Camera:	Mamiya RZ67
Lens:	Mamiya Sekor 65mm f/4
Exposure:	1/60 sec at f/16
Lighting:	5 Flash Units
Film:	Kodak Vericolor III ISO 160, exposed at ISO 100

Lighting Plan:

Main light: 200Ws with 7" reflector and barndoors, set at f/11 - 16, placed at 45 degrees to the right of subject.

Skim light: Similar unit, set at f/16, at 135 degrees to the right rear of subject.

Fill light: 200 Ws in 31" umbrella placed directly behind camera, set for f/8 - 11.

Background light: 200 Ws with 7" reflector and barndoors.

George Fix, Jr.

George Fix, the former chairman of the Board of of Trustees of the Presbyterian Hospital of Dallas, is presently a member of the Board of Trustees of the Presbyterian Healthcare System.

The portrait of Mr. Fix was made for the boardroom. I met with him in his home and we agreed that his library would give a warm, friendly feeling to the picture.

My meter showed that to record the fire in the fireplace and the dim light in the background, it would require a 1 sec exposure at the small aperture needed for depth of field. We had to turn off the modeling lights to avoid overexposing the subject.

Camera:	Mamiya RZ 67
Lens:	Mamiya Sekor 65mm f/4
Exposure:	1 sec at f/11 - 16
Lighting:	6 Flash units
Film:	Vericolor VPH ISO 400

Lighting Plan

Main light: 100 Ws in 7" reflector with barndoors, set at f/11, placed 45 degrees to left of subject.

Fill light: 200Ws in 31" umbrella, set at f/5.6 - 8, placed behind the camera.

Skim light: 100Ws in 7" reflector with barndoors, set at f/11 - 16, placed 135 degrees to left rear of subject and aimed at his face. A similar unit, in the same area, was placed 100 degrees to the subject, to light his hands.

Background light: 100 Ws in 7" reflector, set for f/8 - 11, was placed in the left rear of the room and directed on the right wall. A similar unit was placed in the right rear of the room and directed on the left wall.

Harry Blevins

Harry Blevins was named High School Principal of the Year and inducted into the Virginia High School League Hall of Fame.

I have known Harry and had made the senior portraits for his Great Bridge High School for 30 years. I was very proud to be asked to make his portrait in honor of the occasion.

We decided to include about 200 of his students in his portrait. We asked them to wear dark clothes so they would not detract from the subject. They took their seats in the gym and Mr. Blevins sat on top of a ten-foot ladder. The camera, main light, and fill light were similarly elevated on platform risers (used by the school chorus).

Camera:	Mamiya RZ 67
Lens :	Mamiya Sekor 65mm f/4
Exposure:	1/125 sec between f/16 and f/22
Lighting:	5 Flash units
Film:	Kodak Vericolor VPH 400 ISO 400

Lighting Plan

Main light: 200 Ws in 31" umbrella, set for f/16, placed 45 degrees to the right of subject.

Fill light: Similar unit, set for f/11, placed behind the camera.

Skim light: 200 Ws with 7" reflector, set for f/11 placed 135 degrees to the right rear of the subject.

Background light: Two 2,000 Ws in 54" umbrellas, set for f/11 - 16, placed just behind the subject and aimed evenly at the students.

Comments: The powerful umbrella units were needed to cover the distance from the subject to the students and to provide a soft, even light without creating dark shadows.

Lou Duva

Lou Duva is a promoter/manager with Main Events, an organization that represents world-class boxers.

Some of Lou's boxers train at Waring's Gym, in Virginia Beach, which is where I exercise. There I met Lou and it occurred to me that he would make a great subject for a portrait. I offered to photograph him with one of his boxers. He agreed and we set up the shot with Lou in the foreground and his boxer in a stance behind him. I included enough of the ring to get the dramatic effect I was looking for.

Camera:	Mamiya RZ 67
Lens:	Mamiya Sekor 65mm f/4
Exposure:	1/30 sec at f/16 - 22
Lighting:	7 Flash units
Film:	Fuji NHG 400 ISO

Lighting Plan

Main light: 200 Ws in 7" reflector with barndoors, set for f/16, placed 65 degrees to his left.

Fill light: 200 Ws in 31" umbrella, set at f/8 - 11.

Skim light: Four 200 Ws in 7" reflectors with barndoors, set at f/16 - 22. Two were placed in the right rear of the room, one directed at the boxer and one at Lou. Two were placed in the left rear of the room, again one directed on the boxer and one on Lou.

Background light: 200 Ws in 7" reflector with barndoors, set for f/11, placed behind and to the left of the boxer in the rear of the room.

Comments: The 7" reflectors with barndoors were used to control the lights and enhance the character and texture of Lou and highlight the boxer. The umbrella fill light was used to soften shadows on Lou.

Beautiful Painted Arrow (Joseph Rael)

Beautiful Painted Arrow is the Indian name of Joseph Rael. He is a native American shaman – a healer who lectures and raises funds for building lodges around the globe, dedicated to world peace.

I would say he is one of the most spiritual people I have ever met. He is humble, a philosopher, has a good sense of humor, and is dedicated to doing everything he can to further world peace.

Joseph needed a poster to help promote his lectures. In our consultation, he described the image and view he envisioned. He wanted the portrait to show a spiritual quality and to reflect the Indian philosophy of all humanity being connected to God, nature, the cosmos, and each other.

He suggested a portrait at sunrise for mood and being close to nature. We made the sunrise portrait, but I did not consider it dramatic enough because it did not bring out the strong colors and details of his headdress and face. I recommended having a large black-and-white painting made of the sunrise portrait and using it as a background, suggesting his spiritual self. The painting was done on 9-foot-wide black seamless paper, and I posed Joseph about seven feet in front of it.

Joseph's face is dark and had to be lighted by a flash unit with a snoot and honeycomb, so the light would not spill over onto the white feathers of his headdress. The frontal feathers of his headdress were lighted separately, with a weaker light. If I had used only one light for both his face and feathers, it would have overexposed the white feathers, and they would have lost their texture and tonal range.

This portrait was made in a studio because the idea I had in mind was better accomplished there. Studio portraiture gives you many advantages: You have complete control of the lighting, choice of background, and choice of props. You are familiar with your working space and, thus, can work much smoother and faster, and with a high degree of confidence, bred by familiarity.

Camera:	Mamiya RZ 67
Lens:	Mamiya Sekor 180mm f/4.5
Exposure:	1/125 sec at f/16
Lighting:	7 Flash units
Film:	Fuji Reala ISO 100

Lighting Plan

Main light: 200 Ws honeycomb with snoot, set for f/11 - 16, 45 degrees to the left, directed only on his face. Similar unit placed 90 degrees to the left, directed on his hands to bring out their texture. 200 Ws in 31" umbrella, set for f/8, and placed 50 degrees to the left to light the rest of the his body and headdress and keep texture in the feathers.

Fill light: A 40" x 40" white reflector was placed close to right of the subject to lighten the shadows.

Skim light: Two 200 Ws in 7" reflectors with barndoors, set for f/8, placed at the right and left rear of the room and directed on each side of the headdress.

Background light: Two similar units, set for f/11, were placed on the right and left side of the room to light the black and white print.

The Museum as a Portrait Background

A wonderful way to tell a visual story about my subjects is to include other elements. Painting, sculpture, and music have been used to to convey feelings since the beginning of civilization. Why not use art to enhance portraits of artists?

Recently, I offered to make portraits of some of the Virginia Symphony's leading musicians for an exhibit in the Chrysler Symphony Hall. I frequently photograph our cultural and civic leaders as my contribution to the community and as a showcase of my work. I had previously photographed musicians at the Symphony Hall, in a studio, or in the great outdoors. I wanted a different look for this exhibit and came up with idea of using some of the great paintings in the Walter Chrysler Museum as a background for my subjects. (Many museums will give you permission to photograph their art if it is for a not-for-profit, cultural purpose and creates favorable publicity for them.)

Before I go to such a location, I allow an hour or so for a walk-through in order to acquaint myself with background possibilities for my subjects. I don't believe a violinist's portrait would look right in front of a picture of a New Orleans brass jazz group. I was pleased to discover three paintings that would fit ideally into my plans, as some of the following portraits will show.

Jo Ann Fallata
Music Director of the Virginia Symphony, The Long Beach Symphony and San Francisco's Women's Philharmonic

I chose the Italian Renaissance painting by Donato Criti (1695) of young string players as background for the symphony conductor Jo Ann Fallata. Measuring about 5 x 6½ feet, the painting was large enough for this purpose. The 150mm lens was the perfect focal length for my composition. The 65mm wide angle lens would have made the subject too large and the painting too small. The 250mm tele lens would not have worked because Jo Ann would have to be too close to the painting to permit me to light it separately and to backlight her. The lens allowed me to position Jo Ann about 12 feet in front of the painting and to place two backlight flash units behind her – one on each side – to separate her from the background.

Camera:	Mamiya RZ67
Lens:	Mamiya Sekor 150mm f/3.5
Exposure:	1/125 sec at f/16 - 22
Lighting:	6 Flash units
Film:	Fuji NPS ISO 160

Lighting Plan

Main light: 200 Ws in 7" reflector with barndoors , set for f/16, placed 45 degrees to the right

Fill light: A 40"x40" white reflector. (Usually the fill light is directly behind the camera but at this position it would have caused a large glare on the painting.)

A 200 Ws umbrella flash, set at f/8, was positioned beside the main light to keep the glare off the background. Because of its wider and softer coverage, it helped the white reflector to fill in the shadows. (The 7" reflector of the main light covers too narrow an angle to bounce off the white reflector).

Skim light: Two 200 Ws in 7" reflectors with barndoors, set at f/16 - 22, placed 135 degrees in the back left and right of the subject and aimed at her.

Background light: Two similar units, set for f/11 - 16, placed behind and to the left and right of the subject, directed on the painting.

Scott McElroy

We chose the painting *Music* by Philip Evergood (1933-1959) as the background for the photograph of Scott McElroy, the first trombone player. The painting measures 5½ x 10 feet. My technique was similar to what I used for Jo Ann's portrait, except I placed the umbrella flash unit 90 degrees to his left, instead of 45 degrees, as I did on Jo Ann. This produced a more dramatic lighting on his profile.

Camera:	Mamiya RZ67
Lens:	Mamiya Sekor 110mm f/2.8
Exposure:	1/125 sec at f/16 - 22
Lighting:	5 Flash units
Film:	Fuji NPS 160

Lighting Plan:

Main light: 200 Ws in 31" umbrella, set at f/16, placed 90 degrees to the left.

Fill light: A 40"x40" white reflector was placed to the subject's right. (Usually the fill light is located directly behind the camera. At this position the flash would give a large glare on the background painting. The 200 Ws umbrella main light, with its wide coverage, caused the reflector to lighten the shadows.)

Skim light: Two 200 Ws in 7" reflectors with barndoors set at f/16 - 22, placed 135 degrees to the back left and right of the subject.

Background light: Two similar units set for f/11 - 16, placed just behind and to the left and right of the subject, directed on the painting.

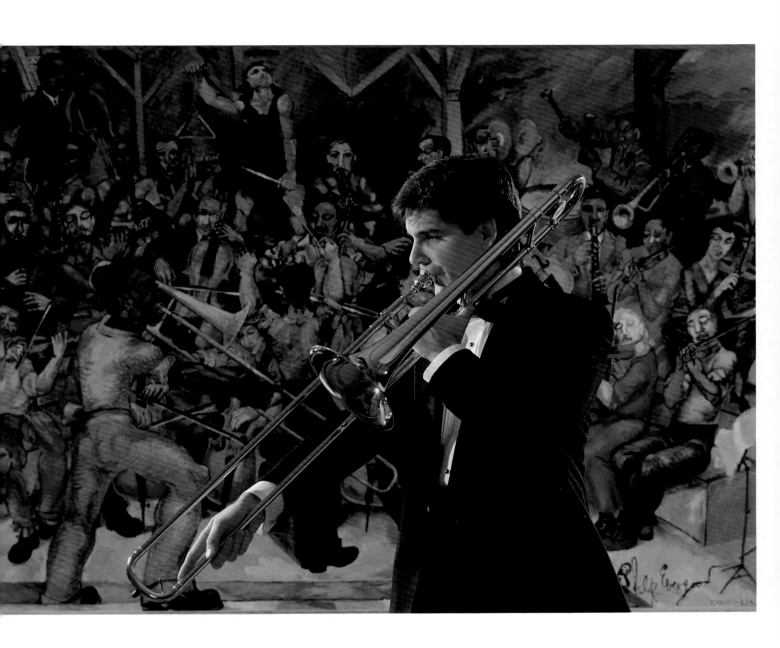

Steve Carlson

Steve, the Virginia Symphony's first trumpet player, was photographed in front of *Hot Jazz*, a 1940 painting by Franz Kline. The work measures 3½ x 3¾ feet. I used the same lighting technique on Steve as I did on Jo Ann, except there was no backlight on Steve's left side. I chose a 110mm lens because the size and design of the painting were more compatible with Steve's overlapping image.

Camera: Mamiya RZ67
Lens: Mamiya Sekor 110mm f/2.8
Exposure: 1/125 sec at f/16 - 22
Lighting: 4 Flash units
Film: Fuji NPS 160

Lighting Plan:

Main light: 200 Ws in 7" reflector, set for f/16, placed 45 degrees to the right.

Fill light: A 40"x40" white reflector. (Usually the fill light is directly behind the camera. However in this position the flash would cause a glare effect on the painting behind the subject.) A 200 Ws umbrella unit, set at f/8, was placed beside the main light. Because of its wider and softer coverage, it helped the reflector to fill in the shadows, without creating glare. The 7" reflector main light covers too narrow an angle to bounce light off the 40"x40" reflector.

Skim light: 200 Ws in 7" reflector with barndoors, set at f/16 - 22, placed at 135 degrees to the right.

Background light: A similar unit, set for f/11 - 16, placed just behind and to the right of the subject, directed on the painting.

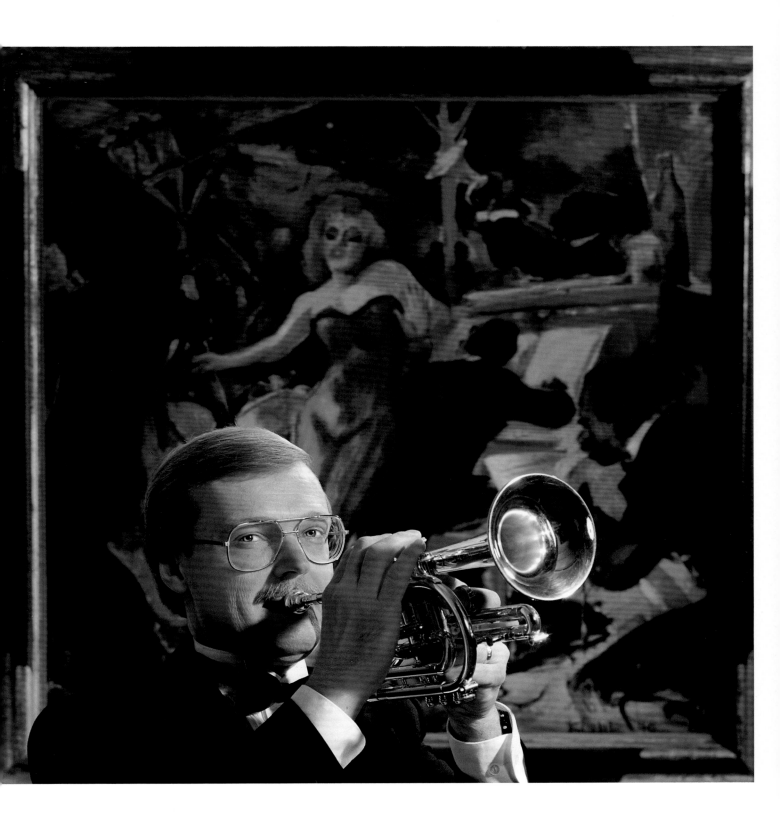

Walter Noona

Walter Noona is a nationally known pianist, conductor, master teacher, and composer of young people's music for the piano. We made this portrait in the music room of a beautiful old English Tudor style mansion, The Hermitage Foundation Museum, in Norfolk, Virginia.

Most of my portraits are designed. They tell a story about my subject. I use the background and, when available, the middle ground and foreground to enhance the subjects and make them look their best. One definition of design is to fill space in a pleasing way. That's why I rarely go into a room and photograph my subject without moving furniture, plants, artifacts, paintings, lamps, or whatever it takes to create the finest portrait possible.

For Walter's portrait, I borrowed the chair he is sitting on, the table in the lower right, his music sheets, and the sculpture of the horse, from another room. We moved lamps from other parts of the room into the spaces on the left and right. We did this because lights in the middle ground and background add a feeling of depth to a portrait.

Expanding the limited range of tones in a color portrait, to make it compare favorably with a painting, requires extensive lighting.

Camera:	Mamiya RZ67
Lens:	Mamiya Sekor 65mm f/4
Exposure:	1/8 sec at f/16
Lighting:	7 Flash units
Film:	Kodak Vericolor III ISO 160, exposed at ISO 100

Lighting Plan:

Main light: 200 Ws in 31" umbrella, set for f/11 - 16, placed 90 degrees to the right.

Fill light: Similar unit set for f/8, placed behind the camera.

Skim light: 200 Ws in 7" reflectors with barndoors, set at f/11 - 16, placed 135 degrees to right and left rear of subject. An additional similar unit, placed to the right rear, was directed only on his hands.

Accent light: 200 Ws with honeycomb and snoot, set for f/11, was directed at horse sculpture in lower right.

Background lights: Two 200 Ws in 7" reflectors with barndoors, set at f/8 - 11, placed at right and left rear, to light back wall.

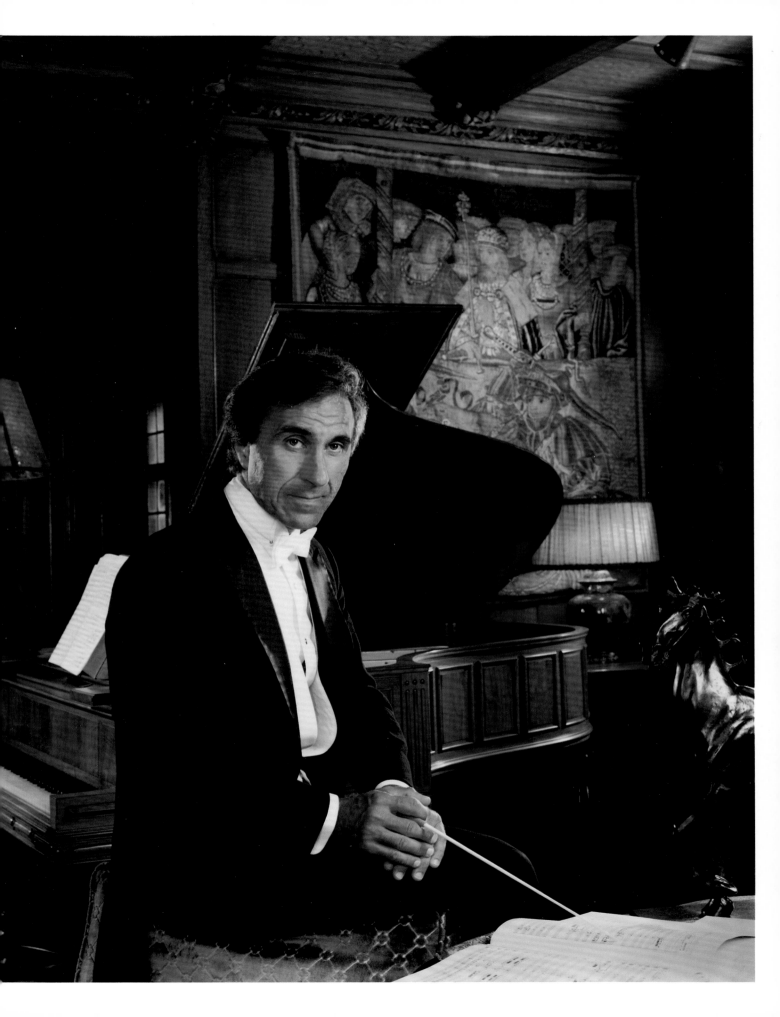

Thomas Lane Stokes, M.D.

Dr. Stokes, board member and later chairman of the Board of Trustees of the Walter Chrysler Museum, was involved in the museum's expansion from 1971 to 1984. I thought it appropriate to make his portrait in the impressive and handsome new lobby entrance of the building.

Large public spaces are usually lighted evenly, but I needed a 1 second exposure to allow a small enough aperture to get the doctor in focus and the back of the room in reasonable focus. Because the room lights would combine with my portrait lights in the long exposure, the doctors face would be overexposed. To prevent this, I placed a 40"x60" black cloth scrim above his head. This kept the direct room light off his face, permitting only my flash units to light him.

I designed the portrait to cause the column, the stairs, and the lines in the floor to lead the viewer's eye around the room and always come back to the subject.

Camera:	Mamiya RZ67
Lens:	Mamiya Sekor 65mm f/4
Exposure:	1 sec at f/16 (to utilize the ambient light in the lobby)
Lighting:	3 Flash Units
Film:	Fuji Reala ISO 100

Lighting Plan:

Main Light: 200 Ws with 7" reflector and barndoors, set at f/11 - 16, placed at 45 degrees to the left of subject.

Skim Light: Similar unit, set for f/11, at 135 degrees to the left rear of the subject.

Fill Light: 200 Ws in 31" umbrella, set for f/5.6 - 8, directly behind camera

Background Light: Ambient illumination.

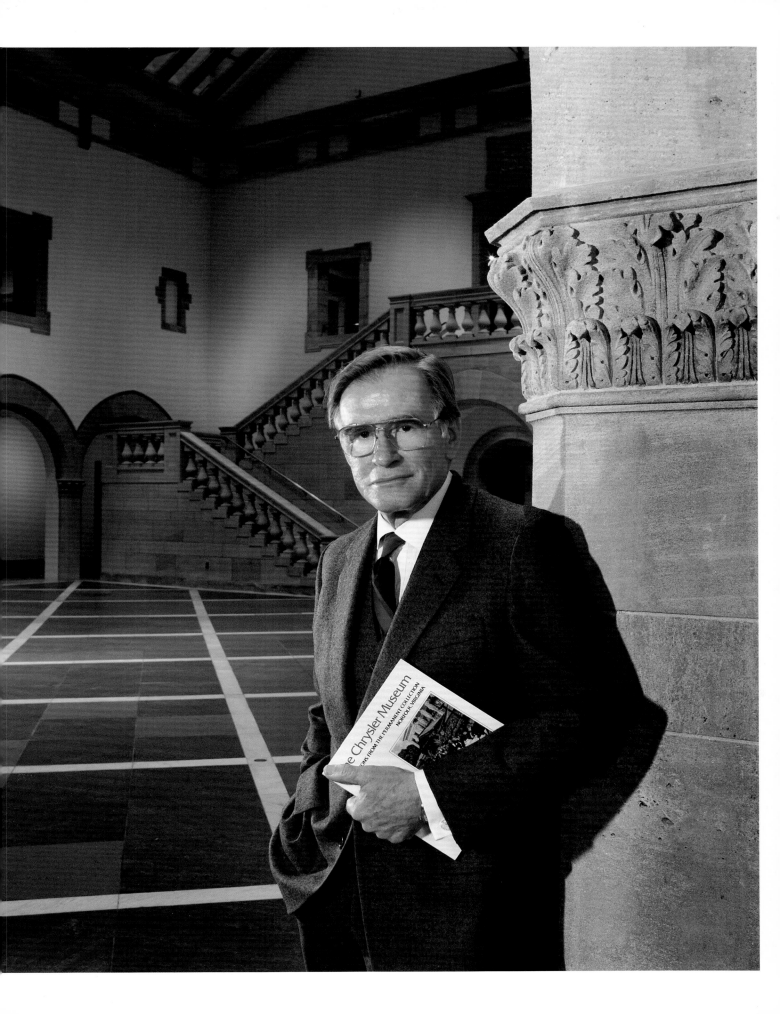

Mario Amaya

Mario was director of the Walter Chrysler Museum from 1974 to 1976. When I photographed him about 1976, I was impressed by his vast knowledge of art. He was a very well-educated, cultured, and impeccably groomed young man. One of his fields of interest is Art Deco, a subject about which he has written many articles and given many lectures.

During our walk-through and discussion of how to photograph him, we agreed to use the handsome Art Deco bas relief *Woman with a Deer* by Adolph Block, as an impressive background, and a small statue from another gallery, *Woman with a Musical Instrument* by Jan Martel, to fill the left foreground.

I wanted everything in the portrait to be black and white, except Mario's flesh tones and the gold in the bas relief. I accomplished this by placing nine-foot black seamless paper in the background and by covering the table, which held the small statue, with black velvet.

Camera:	Mamiya RB67
Lens:	Mamiya Sekor 127mm f/3.5
Exposure:	1/125 sec at f/11
Lighting:	5 Flash units
Film:	Kodak Vericolor I ISO 100

Lighting Plan:

Main light: 200 Ws in 7" reflector with barndoors, set for f/8 - 11.

Fill light: 200 Ws in 31" umbrella, set for f/5.6.

Skim light: 200 Ws in 7" reflector with barndoors, set for f/8.

Accent light: 200 Ws with honeycomb and snoot, set for f/5.6, directed on the white statue on subject's right.

Background light: 200 Ws in 7" reflector with barndoors, set for f/8, placed 90 degrees to the left of the gold statue in the background.

Men of the Cloth

It has always been a challenge for me to photograph religious leaders and to make portraits that tell something about the person as well as show the trappings of their religions. I find that showing the interior of a beautiful church, temple, or mosque is necessary to make a meaningful portrait, but I am careful not to detract from my subject. I am constantly looking for a blend that conveys the sincerity and spirituality of the subjects in the environment they represent.

Father Claude L. O'Brian

A photographer friend of mine, Walter Roob, arranged for me to photograph Father O'Brian as part of a workshop I was giving in Milwaukee. We met with Father O'Brian at his church and consulted on the best way to photograph him. Together, we looked at his robes and took a walk through the church.

I was impressed by the sanctuary's old-world beauty, and particularly by the stained-glass windows. One of Father O'Brian's robes echoed the colors in the windows, but the windows were about 15 feet too high to use as a background if we were on the main floor of the church. I therefore chose to use the choir loft, with the pipes of the organ and a stained glass window as a background.

Father O'Brian fit my idea of a genial Irish priest with a great sense of humor and a twinkle in his eyes. The church was well represented in the portrait and served as a fine background for my subject.

Camera:	Mamiya RZ67
Lens:	Mamiya Sekor 65mm f/4
Exposure:	1/15 sec at f/11
Lighting:	4 Flash units
Film:	Kodak Vericolor III ISO 160, exposed at ISO 100

Lighting Plan:

Main light: 200 Ws in 7" reflector and barndoors, set at f/8 -11, placed 45 degrees to the right.

Fill light: 200 Ws in 31" umbrella, set at f/5.6 - 8, placed behind the camera.

Skim light: 200 Ws in 7" reflector with barndoors, set at f/11, placed 135 degrees to the right rear.

Background light: 200 Ws in 7" reflector with barndoors, set at f/8, placed behind the subject, 65 degrees to the left, lighting the background.

Rabbi Lawrence R. Foreman

Rabbi Foreman is a friend I have known for 25 years. This is the third time I've photographed him over the years, and I think this time I got it right. The temple's altar is an off-color white, which looks cold in a photograph. I was never pleased with my previous portraits of the rabbi, and I believe this was the reason.

For this portrait, I placed an 85cc (orange) filter on the flash lighting the background, which gave it a rich, warm, amber color. I photographed the rabbi at night so the light coming through the stained glass windows would not overexpose his face during the one-second exposure necessary to record the lighted bulbs in the menorah (candelabra) in the background. When an exposure is one second or longer, the modeling lamps in the strobe units must be turned off, otherwise they will overexpose the subject's face.

Camera:	Mamiya RZ67
Lens:	Mamiya Sekor 65mm f/4
Exposure:	1 sec at f/16
Lighting:	4 Flash units
Film:	Fuji NPS ISO 160

Lighting Plan:

Main light: 200 Ws in 7" reflector with barndoors, set at f/11 - 16, placed 45 degrees to the left of subject.

Fill light: 200 Ws in 31" umbrella, set at f/8, placed behind camera.

Skim light: 200 Ws in 7" reflector with barndoors, set at f/16.

Background light: 200 Ws in 7" reflector, set at f/11, placed at the left rear of the Temple.

Pat Robertson

Pat Robertson is not only a religious broadcaster and a former presidential candidate, but he has also created one of the largest congregations in the world with his international program "The 700 Club." Pat and I agreed that his portrait should reflect the area of his ministry where he reaches the most people and where he is best known.

"The 700 Club" background in his television studio is familiar to millions of his viewers, so that was an easy choice. I wanted Pat standing in front of the set, with a microphone in his hand and a large TV camera in each corner of the room.

The studio set is dramatically illuminated by tungsten lights. I could not improve on this lighting with my flash equipment, so I decided to use tungsten film and place 85cc filters over the three flash units I still would have to use. The filters changed the color temperature of the flash from 5400K daylight, to 3200K tungsten.

The exposure reading was one second at f/8 for the background. I wanted the light on the background to be one stop less than the light on Pat. The main light read between f/8 and f/11; the fill light read f/6.3. Adding the fill light to the main light gave me an exposure of fill on Pat. Exposing at f/11 would give me the exposure difference I wanted, making Pat stand out from the background.

Camera:	Mamiya RZ67
Lens:	Mamiya Sekor 65mm f/4
Exposure:	1 sec at f/11
Lighting:	3 flash Units
Film:	Vericolor Tungsten ISO 100

Lighting Plan:

Main light: 200 Ws in 31" umbrella, set at f/8 - 11, placed 45 degrees to the left.

Fill light: Similar unit, set for f/5.6, placed behind camera. 85cc filters used on all units. Model light turned off on all units to prevent overexposing subject's face.

Skim light: 200 Ws in 7" reflector, placed 135 degrees to the left of subject.

Artists and Writers

Artists and writers are interesting subjects to photograph because the environment they work in usually has many eclectic items and artifacts that reflect their personalities and work. Artists' studios have models, paintings, sculptures, still-life arrangements; writers' studies have computers, books, papers, magazines. Both can also be photographed at the locations where they are painting or the places they are writing about, or, of course, in their homes.

The Artist and The Model

Renata Keep, a prominent local painter and sculptor, is shown with her model Bryan Feldman, an award winning body builder and owner of a gourmet restaurant.

The portrait is one of the most complicated in this book, as far as lighting, composition, use of background space and most important, blending two people into a meaningful image, is concerned. My original idea was to illustrate the intimate and sometimes spiritual relationship between artist and model. I did not intend it to be an individual portrait of the artist, using the model as just an anonymous subject for a painting. If that would have been my intention, I would have made the artist much more prominent than the model.

The portrait location was Renata's 21x21 ft studio. It has a 10 ft high beamed ceiling and a peaked roof with a skylight above the beams, adding another 7 ft in height. To include as much of the studio as possible, I used my Mamiya RZ67 camera with a 65mm lens and backed into the doorway for maximum coverage. I knew I needed to stop the lens down to at least f/16 to obtain the desired depth of field.

I positioned Renata in the lower left foreground, close enough to get a threequarter view of her with a sketch pad. I seated a stand-in for for the model on an antique couch on the right side.

To light the portrait I began with a flash unit on a 9 ft stand, placed 135 degrees to the left rear of the room, directed on my stand-in and to separate him from the background. Another flash, attached to a 12 ft boom stand, was placed between the beams, directed right over him, giving a sculpted look to his body. A third, 6 ft high unit was placed at 90 degrees to the right of Renata to light her profile. A 31 inch umbrella flash was located behind my camera as a fill light.

I then took a meter reading of the back wall, which was lit by the skylight. It showed 1/30 sec at f/8. I exposed a Polacolor Pro ISO 100 film to give me my first test. The equivalent exposure for the ISO 400 film in my camera would mean closing the lens down two stops, from f/8 to f/16.

Studying my Polaroid test film "A", I noticed that the background was insufficiently illuminated by the skylight. I therefore decided to expose at 1/60 sec, to get just a little ambient light in the ceiling, but to light the background with two more flash units. Another test shot showed the light on the stand-in to be okay, but Renata needed more light.

Most important, however, it revealed that the composition was unsatisfactory. The couch was too low and too bright, upsetting the balance between artist and model.

With the help of my assistants, I promptly made the needed corrections. We removed the couch and replaced it with the hard case in which my lights were stored. We placed a kitchen stool on top of it, draped it with a maroon velvet cloth and seated the real model on it. We also added a large coffee table, covered with art books, in the lower right corner. I lightened the background with two more barndoor-equipped flash units, standing right and left, outside the picture area. I also added more fill light on Renata, which in combination with the main light, turned out to be too much for her face, as test print "B" proved.

Some more changes were added before we were ready to make our next Polaroid test print. I brought the table, loaded with tubes of paint and a palette, closer to the left of Renata and moved a large painting to the lower right corner, behind the model. Now we checked all the lights.

The main light on Renata's face was 1/3 stop less than f/8. I set the fill light at f/4.5, just enough to render some detail in the shadow, but not enough to diminish the strength and character in her face. The light directed on the model from above was f/8 with no fill light; his back light was set for f/8. I made another Polaroid test print "C,' and it looked good. I closed the lens to f/16 and exposed two rolls of 220 film, having the complete assurance that I got exactly what I wanted.

Camera:	Mamiya RZ 67
Lens:	Mamiya Sekor 65mm f/4
Exposure:	160 sec at f/16
Lighting:	9 Flash units
Film:	Fuji NHP ISO 400

Lighting Plan: See story above.

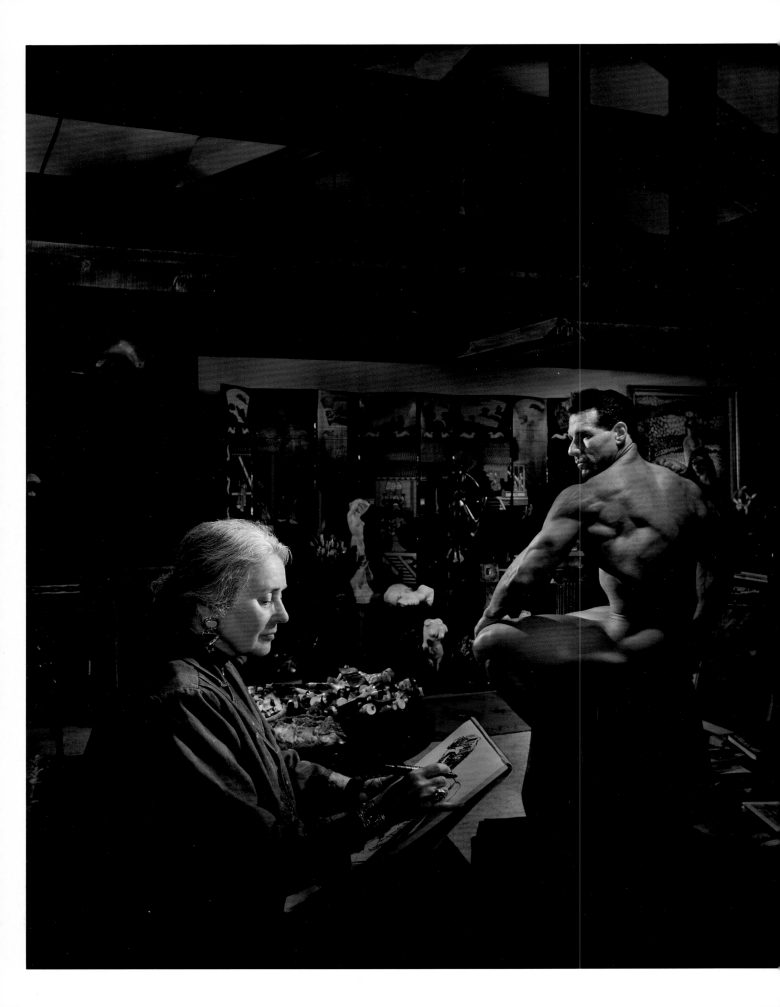

Vonnie Wentworth

Vonnie Wentworth is a beautiful young woman as well as one of the area's outstanding painters. I wanted to photograph her for one of my ongoing exhibits. In addition to telling a usual story about Vonnie as an artist with her work, I wanted to take advantage of her good looks to make an elegant portrait.

I visited Vonnie at her studio to plan the portrait. While it was adequate for her needs, the studio did not lend itself to the type of portrait I had in mind. Vonnie is noted for her fine figure studies, and my idea was to place a model in an opulent room, converting it to a studio as the setting for the photograph. Therefore, I rented a room at the Hermitage Museum for a morning session the following week.

We went to the museum in advance to determine what furniture and props we would need for the portrait. A week later we met at the museum for the shoot.

Vonnie brought her easel with sketch pad, palette, table of paints, and brushes. I had hired a model, and brought a large plant and a small table. Among other things, we also decided to place a still-life painting of a vase with flowers under the easel and a bouquet of flowers on a table behind the painting.

Camera:	Mamiya RZ67
Lens:	Mamiya Sekor 65mm f/4
Exposure:	1/30 sec at f/16 - 22
Lighting:	8 Flash units
Film:	Kodak Vericolor III ISO 160, exposed at ISO 100

Lighting Plan

Main light: 200 Ws in 31" umbrella set at f/16, placed 45 degrees to the left of subject.

Fill light: Similar unit, set for f/8 - 11, placed behind the camera. (The wide coverage of both units were adequate to also light the charcoal drawing of the model and the watercolor picture beneath it.)

Skim light: Two 200 Ws units in 7" reflectors with barndoors, set for f/16 - 22, placed 135 degrees to left and right of subject.

Background lights: Two similar units, set for f/11, one placed in the right rear, directed on the left rear wall and one to the left of the easel, directed on the right rear wall.

Light on model: Similar unit set for f/16 - 22, placed in the right rear.

Accent light on flowers: 200Ws with honeycomb, set for f/16 - 22, placed behind the easel.

Vonnie Wentworth

Charles Sibley

Charles Sibley is a retired head of the Art Department of Old Dominion University and is one of Virginia's finest artists. The first time I photographed him was for an exhibit of 22 artists, to be shown in a local art gallery. This exhibit eventually moved to the Norfolk Museum (now the Chrysler Museum). I have photographed Charles repeatedly over the past several years, and this is the most recent portrait.

When Charles viewed this photograph, he remarked that the design is rectangles within rectangles, anchored by his triangular pose.

Camera:	Mamiya RZ67
Lens:	Mamiya Sekor 65mm f/4
Exposure:	1/15 sec at f/16
Lighting:	Combination of 7 flash units, ambient light, and window light
Film:	Kodak Vericolor III ISO 160, exposed at ISO 100

Lighting Plan:

Main light: 200 Ws in 31" umbrella set for f/11 - 16, placed 45 degrees to the right.

Fill light: Similar unit, set for f/8, placed behind the camera

Skim light: Two 200 Ws units in 7" reflectors with barndoors, set for f/16

Background lights: Three similar units, set for f/8 - 11. One placed in the right rear corner, directed on the painting on the easel. One to the left, between subject and painting, directed on the bookcase. One behind the painting to light the far left corner and wall.

Comments: Shutter speed was set for 1/15 sec to expose for the cloudy daylight coming through the window and the room spotlights directed on the book cases and painting. Backlights were purposely weaker to brighten the shadows without over-lighting the existing ambient light.

Peter Mark

Peter Mark has been the artistic director of the Virginia Opera since 1975. During his tenure, he has staged over fifty productions, including world premieres of Thea Musgrave's *Harriet, The Woman Called Moses* (1985) and *Simon Bolivar* (1995).

I wanted the portrait to show Peter with an opera scene behind him, illustrating that he is an opera conductor. Normally the conductor, in the orchestra pit in front of and below the level of the stage, is barely visible. I elevated his podium by placing two banquet tables on top of each other, bringing him almost to stage level. The key flash light is also elevated on two tables to the right, and I, the camera, and the fill light are standing on another two tables. Ambient light from the podium lamp reflects off his cummerbund and gives his face a slightly reddish glow.

It required several stage hands plus three assistants about one hour to set up for the portrait, and it took me about seven minutes to make ten exposures.

Camera:	Mamiya RZ67
Lens:	Mamiya Sekor 65mm f/4
Exposure:	1 sec at f/11 - 16
Lighting:	5 Flash units
Film:	Kodak Vericolor VPH ISO 400

Lighting Plan:

Main light: 200 Ws in 31" umbrella, set for f/11, placed 60 degrees to the right.

Fill light: Similar unit, set for f/8, directly behind camera.

Skim light: Two 200 Ws in 7" reflectors with barndoors, placed 135 degrees to the right and left of the subject.

Background light: One similar unit, set for f/11 - 16, directed on the opera singer from a 90 degree angle at her left.

Comments: The 1 sec exposure was required to properly expose for the stage lights with red filters, the singer and the artificial smoke.

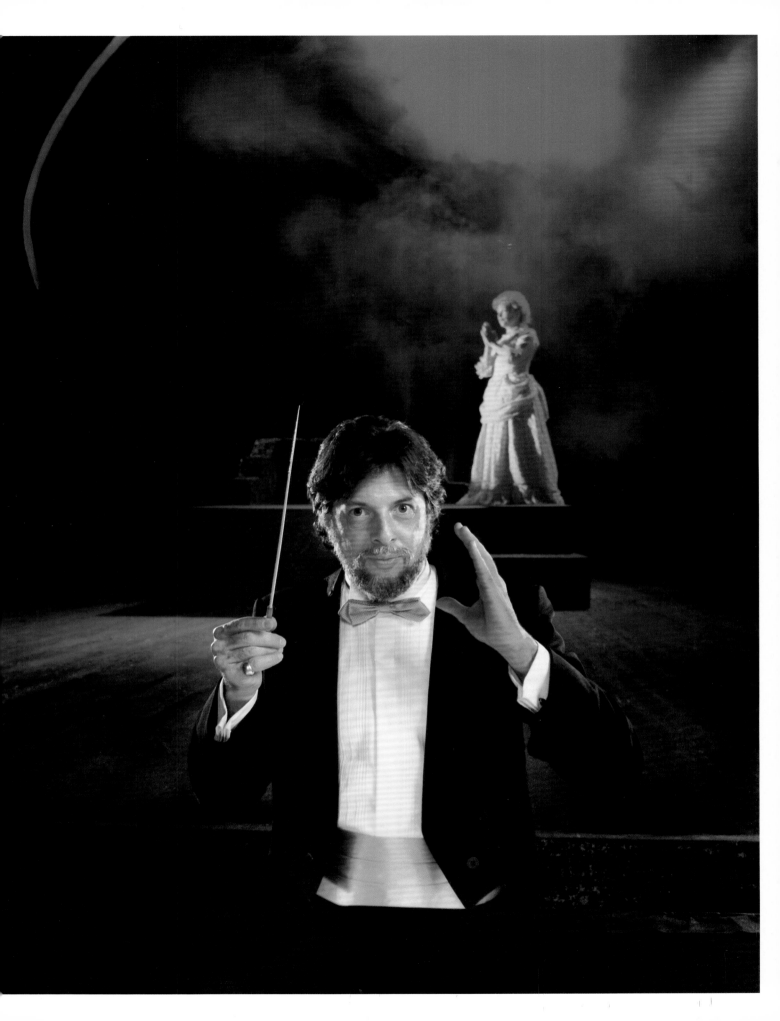

Lenoir Chambers, Writer, Newspaper Editor

Lenoir Chambers won the Pulitzer Prize in 1960 for a series of editorials for the Virginian Pilot. In describing Mr. Chambers' editorials, Frank Batten, the publisher, said, "His voice was a lonely but steadfast opposition to state policy that closed public schools in order to avoid integration."

I made the portrait of Mr. Chambers for an exhibit of the cultural leaders of Hampton Roads in 1970, photographing him in his elegant town house in the historical section of Norfolk. I felt that the living room with its high ceiling, books, and portrait of one of his ancestors over the fireplace would tell a better story about him than his small study on the third floor. I moved his desk, books, and writing materials to give the portrait a better design.

Camera:	Mamiya RB67
Lens:	Mamiya Sekor 90mm f/3.5
Exposure:	1/125 sec at f/11 - 16
Lighting:	3 Flash units
Film:	Kodak Vericolor I ISO 100

Lighting Plan:

Main light: 200 Ws in 31" umbrella, set for f/11, placed 90 degrees to the subject's left.

Fill light: Similar unit set for f/5.6 - 8, placed behind the camera.

Background light: 200 Ws in 7" reflector with barndoors, set for f/8 - 16, placed at left rear of room.

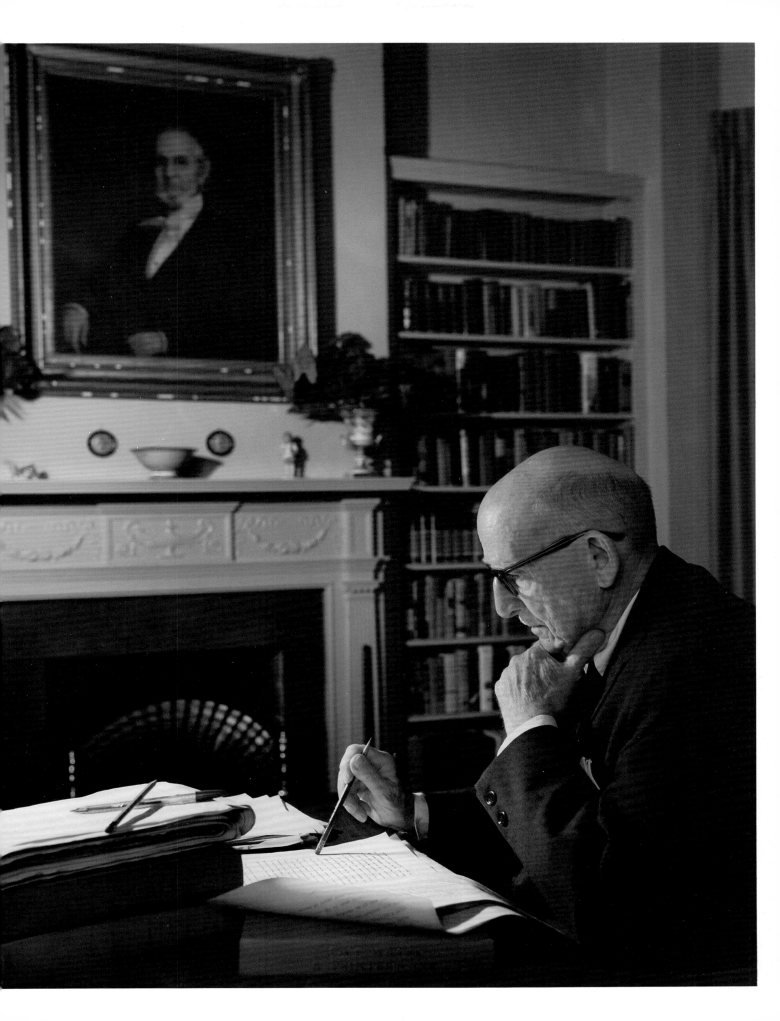

Alf Mapp, Jr., Old Dominion University
Eminent Scholar Emeritus, Author and Historian

Alf Mapp was photographed for an exhibit honoring outstanding writers of the area. The portrait was displayed in a large bookstore in the public area of our most prestigious mall.

Mapp's most recent and best-known work is his two-volume biography of Thomas Jefferson: *A Strange Case of Mistaken Identity* and *The Passionate Pilgrim*. Mr. Mapp and I decided that Jefferson's home, Monticello, would be an appropriate place to make the photograph. I wanted to put Jefferson's environment into the portrait, trying to capture some of the spirit of Mr. Mapp's feelings and perceptions about the man.

When we arrived at Monticello late in the afternoon, I noticed an attractive background. The sun was going down and we could see it through the double doors leading to the gardens. It gave a nice mood to the room and doorway.

We had to work fast to capture it. I quickly moved a period chair into the space in front of the doorway. This gave Mr. Mapp a place to rest his arm and where he could get as comfortable as possible. The sun had already gone down, so I exposed for the afterglow in the sky.

Camera:	Mamiya RZ67
Lens:	Mamiya Sekor 65mm f/4
Exposure:	1/8 sec at f/8 - 11
Lighting:	5 Flash units
Film:	Fuji NPS ISO 160

Lighting Plan:

Main light: 200 Ws in 31" umbrella, set at f/8 - 11, placed 45 degrees to the left.

Fill light: Similar unit set for f/5.6 and placed behind camera.

Skim light: 200 Ws in 7" reflector with barndoors, set for f/8 - 11, placed 135 degrees to the subject's left.

Background light: Two similar units, set for f/5.6 - 8, placed at the right and left rear of the room and directed on each side of the doorway.

Comments: Permission was granted to make the portrait at the entrance as a courtesy, because Mr. Mapp wrote a biography of Jefferson.

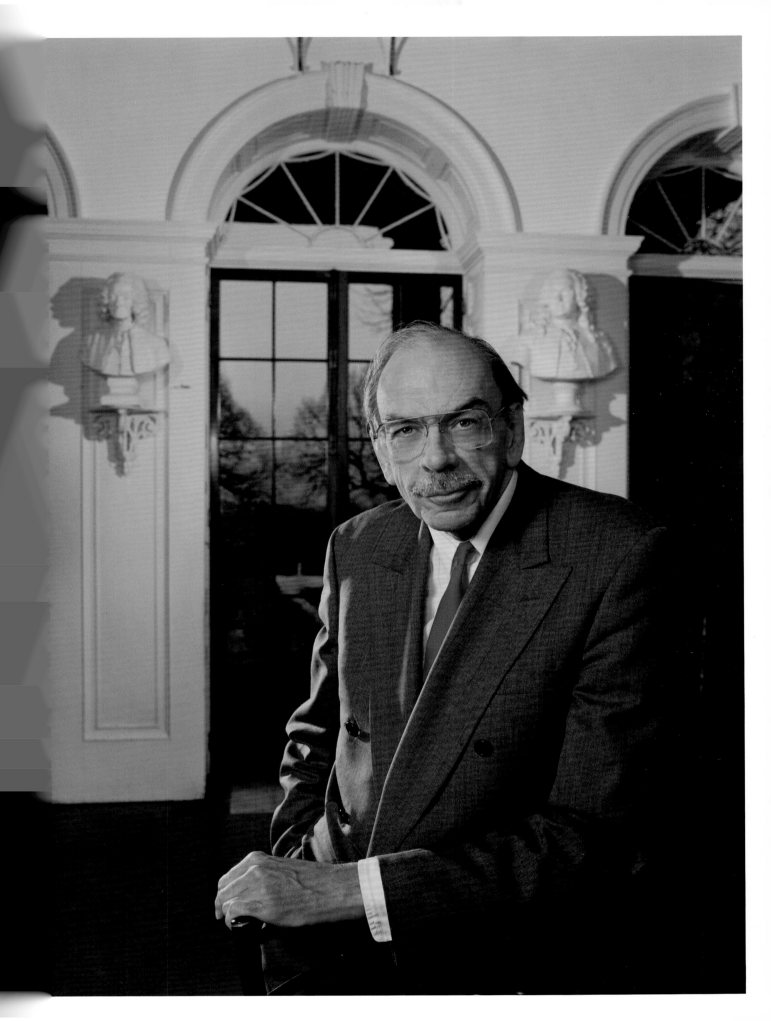

Photographing the Photographers

In 1984 I went on a nation-wide lecture tour, giving one day seminars on portrait photography. Having many photographer friends around the country, I began photographing them as part of these workshops. It also gave me a chance to spend time with my friends.

Within two years I had a good portrait collection of some of America's outstanding photographers. Fred Quellmaltz, executive director of the International Photography Hall of Fame, saw a number of these portraits at a trade show and invited me to present a special "Photographing the Photographers" exhibit at the International Photography Hall of Fame in Oklahoma City.

The exhibit was a huge success. Four magazines ran articles featuring the collection, and there was a special exhibit of the work at the 1987 convention of the Professional Photographers of America.

Beaumont Newhall

Beaumont Newhall was the first curator of the Department of Photography of the Museum of Modern Art in New York. He wrote the *History of Photography* and also was the founding curator of the International Museum of Photography at the George Eastman House in Rochester, New York.

I met Beaumont there in the late fifties. Being a good Kodak customer, I wanted to meet Beaumont on one of my annual trips to Rochester. Introductions were arranged and Beaumont and I discovered that we had a lot in common. We both love photography, and our conversation and tour of George Eastman House lasted the rest of the afternoon. Regrettably our paths did not cross again until 1985, when I photographed him for my museum exhibit.

I was giving a seminar in Albuquerque, New Mexico, when I learned that Beaumont was living in Santa Fe. I promptly made an appointment to photograph him at his home. My local friends went with me to assist me in setting up the lights and to observe my technique.

It is interesting to note that I have photographed thousands of people, yet more unusual things happened to me when I photographed fellow photographers than when photographing all those other subjects. Here is an example:

When we were ready for the Polaroid tests, I approached Beaumont and bent over to take a reading with my flash meter, closely watched by his black labrador, sitting behind me. I pushed the button, the flashes fired, and the dog ran over and bit me in the rear end. Fortunately, it was not serious, and getting Beaumont to smile was a fringe benefit.

Camera:	Mamiya RZ67
Lens:	Mamiya Sekor 65mm f/4
Exposure:	1/30 sec at f/11
Lighting:	3 Flash units
Film:	Kodak Vericolor III ISO 160 exposed at ISO 125

Lighting Plan:

Main Light: 200 WS in 31" reflector, set at f/8 - 11, placed at 45 degrees to right of the subject.

Fill Light: Similar unit behind camera set for f/5.6 - 8.

Skim Light: 100 WS in 7" reflector with barndoors, set at f/11, placed 135 degrees to the right rear of subject

Background Light: Skylight in the ceiling reading f/8 at 1/30 sec

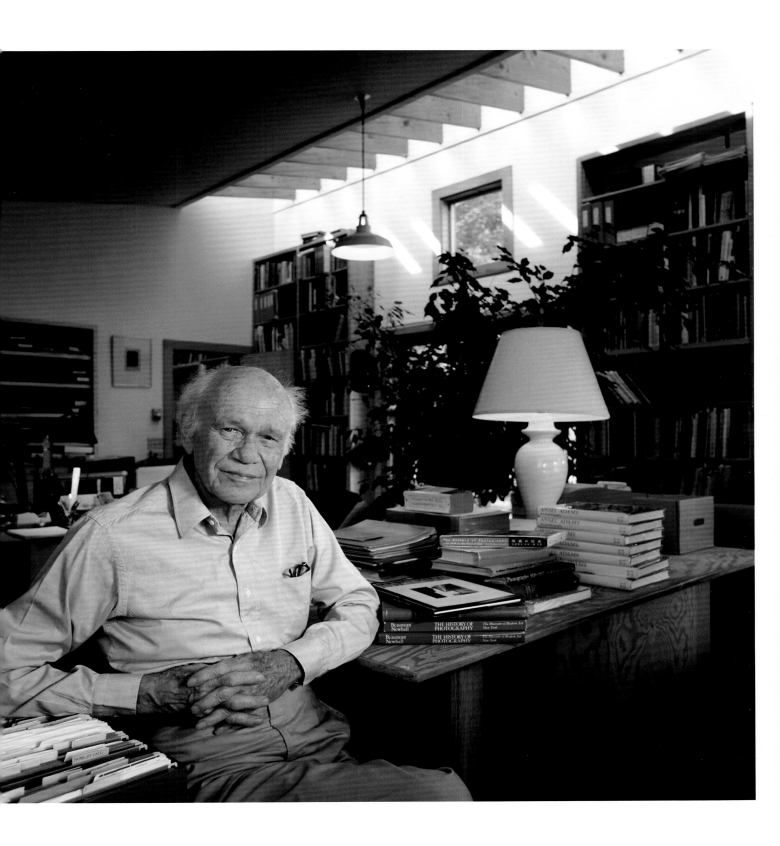

Don Blair

Don Blair is a great photographer and one of the most popular lecturers on portrait photography. In 1987, we both were teaching at the Winona School of Photography in Chicago. As a class project, I thought it would be a good idea to photograph Don as an instructor. I wanted the portrait to include the students of both our classes, as they watched Don demonstrate his posing and lighting techniques.

The inspiration for this idea came to me from a painting by Thomas Eakins I had seen at the Philadelphia Museum of Art, many years ago. It was an 1875 portrait of Dr. Samuel D. Gross, an eminent Philadelphia surgeon. In the foreground is the doctor operating on a patient, with several doctors assisting. In the background, a group of interns observe the procedure, and each face is a portrait in itself.

The image stuck with me over the years, and I finally found a situation where I could put the idea to work. Don and I arranged for our students and several of the school staff to sit in the amphitheater behind Don and his two models. I asked the students to strike poses that were natural to them. Like Eakins, I wasn't just making a portrait of Don, but showed him also as a teacher, with his students in the background.

The project took most of the afternoon. We needed nearly all the flash equipment in the school to provide enough illumination to be able to shoot at f/32. This gave me sufficient depth of field to obtain pleasing focus on Don in the foreground and the students in the background.

Camera: Mamiya RZ67
Lens: Mamiya Sekor 65mm f/4
Exposure: 1/15 sec at f/32
Lighting: 7 Flash units
Film: Kodak Vericolor III exposed at ISO 100
Lighting Plan:

Main light: 400 Ws in 48" umbrella set for f/22 - 32, placed 45 degrees to the right of subject.

Fill light: Similar unit, set for f/16, placed behind the camera.

Background light: Five 2400 Ws units in 54" umbrellas, set for f/22, were strategically placed around the room, just outside the picture area and high enough to illuminate the students without creating deep shadows.

Marvel Nelson

Marvel is the second woman president of the Professional Photographers of America and one of the first women to receive the degree of Fellow, American Society of Photography. We have been friends for over 25 years, and I was very pleased and honored to make her official president's portrait.

I had previously visited the lobby of the Professional Photographers of America headquarters building and had some thoughts on how I wanted to photograph Marvel. The building featured Gothic architecture and a rotunda on the main floor with several two-story arches. We used these arches to frame the portrait. The column on the left was balanced by the large plant on the right.

Camera:	Mamiya RZ67
Lens:	Mamiya Sekor 65mm f/4
Exposure:	1/15 sec at f/11
Lighting:	5 Flash units and window light
Film:	Fuji NHG ISO 160

Lighting Plan:

Main light: 200 Ws in 31" umbrella set for f/8 - 11, placed 45 degrees to the right.

Fill light: Similar unit set for f/5.6 - 8, placed behind camera.

Skim light: 200 Ws in 7" reflector with barndoors, set at f/11, placed 135 degrees to right rear.

Background light: Two similar units set for f/8. One placed 90 degrees to the left rear, to light the archway, framing the subject, the other inside the archway to light the interior.

Van P. Moore

Van Moore and I have known each other since the early fifties, and his portrait was the first one I ever made of a photographer. Van was with Wendell Powell in Richmond, Virginia, then and was probably the finest bridal photographer in the country.

I photographed Van in Greenville, South Carolina. I thought it appropriate to include a bride in the portrait, which meant I had to set up two sets of lights - one for each subject.

I frequently use a lot of exaggerated and outrageous flattery when I photograph people. This generally gets them to relax and to forget they are being photographed, producing a natural smile or expression. Needless to say, Van and most other photographers are on to my tricks. I had to come up with some brand new lines and jokes to work on them.

Camera: Mamiya RZ67
Lens: Mamiya Sekor 65mm f/4
Exposure: 1/30 sec at f/16
Lighting: 9 Flash units
Film: Kodak Vericolor III ISO 160, exposed at ISO 100
Lighting Plan:
> Main light: 200 Ws in 7" reflector with barndoors, set for f/11 - 16, at 45 degrees to the right of subject
>
> Fill Light: 200 Ws in 31" umbrella behind camera, set for f/8.
>
> Skim Light: 200 Ws at 110 degrees to the right rear of subject, set for f/11. Similar unit at the left rear, to separate him from background.
>
> Background Lights: Similar unit nearby, but directed on the wall and staircase to keep it from going too dark. Another, similar unit was upstairs to light the wall behind the bride. All units were set for f/11.

Lighting Plan for Bride:
> Main Light: 200 Ws in 7" reflector with barndoors on a 12 ft stand, set for f/11 - 16, 45 degrees to her right.
>
> Fill Light: 200 Ws in 31" umbrella on 12 ft stand, set for f/8, about 10 ft in front.
>
> Back Light: 50 Ws with barndoors, to light her veil.

David La Claire

David's father, Maurice La Claire, was the pioneer who brought color portraiture to local professional photography studios. He had been making color portraits for his customers in Grand Rapids, Michigan, since the late 1930s. David has carried on this tradition and is recognized as one of the nation's foremost portrait photographers.

I made David's portrait in his studio, and I included his old view camera and a picture of his father to show his heritage. David and I are the same age and have been in photography the same length of time. Both of us enjoyed the sitting and produced one of my nicest portraits.

Camera:	Mamiya RZ67
Lens:	Mamiya Sekor 65mm f/4
Exposure:	1/4 sec f/11 (to pick up ambient light).
Lighting:	5 Flash units
Film:	Kodak Vericolor III ISO 160, exposed at ISO 100

Lighting Plan:

Main Light: 200 Ws in 7" reflector with barndoors, set for f/8 - 11, at 45 degrees to the left of the subject. A similar unit was placed 55 degrees to the left of the subject, to light the black view camera and his father's portrait.

Fill Light: 200 Ws with 31" umbrella, set at f/5.6 was placed a little to the left and behind the camera.

Background lights: Two 200 Ws with 7" reflectors and barndoors, set for f/5.6, one lighting the left wall, the other the right wall.

Marjorie Neikrug Raskin

Marjorie owns the Neikrug Photography Gallery, the second oldest photography gallery in New York City. I met her in the early seventies at her gallery and bought some books from her. We met again when we were speakers at a University of Maryland Visual Arts Seminar. We have been friends ever since.

Photographing Marjorie was a great experience. I told her that she looked so good that if the door to the gallery weren't closed, men passing by would see her sitting on the sofa and would rush in and knock over my camera and lights trying to get to her. She laughed and said she had that kind of trouble all the time. I responded that I was going to have my camera bronze plated and put her name on it so it would be displayed next to her portrait in the Photography Hall of Fame.

When the sitting was finished, she quipped, "Let me have that camera. I know just where to get it bronze plated." I replied that I wanted to keep it a little longer. Because her image had passed through its lens, its vibes would continue to inspire my art.

I photographed with the very wide 50mm lens to include as much of the gallery as possible. I used tungsten lights instead of strobes in order to more closely match the color temperature of the existing lights in the room.

Camera: Mamiya RZ67

Lens: Mamiya Sekor 50mm f/4

Exposure: 1/4 sec at f/16

Lighting: Two photoflood bulbs and existing room light

Film: Vericolor Type L tungsten, ISO 100

Lighting Plan:

Main light: 500 W tungsten bulb in a silver umbrella, set for f/11 - 16, placed 45 degrees to the right.

Fill light: Similar unit, set for f/8 - 11, placed behind camera. Background light: Ambient light, reading 1/4 sec between f/11 - 16.

Military Leaders

Having lived most of my life in and around Norfolk, Virginia, I've taken the presence of the largest United States Naval base in the world for granted. From the thousands of dedicated men and women who are stationed here, to the mighty armada of magnificent ships that frequently dock in Chesapeake Bay, the naval base is a tremendous source of pride to the area.

The Virginia chapter of the Navy League, a national organization of business executives devoted to strengthening the ties between the navy and civilian sector, asked me to photograph portraits of top military officers for a traveling exhibit that would introduce citizens across the country to the leaders of the armed forces. I was extremely honored to accept this assignment.

The exhibit features chief officers of the United States Air Force, Army, Marine Corps, and Navy, as well as the Chairman of the Joint Chiefs of Staff, John Shalikashvili.

This portrait collection, which took over one year to complete, was one of the most challenging and interesting projects of my career. I traveled across the country to create the portraits. I was also a passenger aboard a variety of naval vessels, both at sea and docked. To get the proper perspective for one image, I even climbed to the very top of an aircraft carrier.

I look forward to making many more innovative portraits of our military leaders in the years to come.

General John M. Shalikashvili, USA

The Chairman of the Joint Chiefs of Staff, General Shalikashvili, represents all the armed forces. In making his portrait, we had to decide on a background that would reflect all the services. The Command Center of the Joint Chiefs of Staff was selected, and members of his military staff from each of the services were placed in position around the table to show the activity of a working situation.

The ambient lighting in the room was a mixture of tungsten light, spotlights, and fluorescent lights. The world map on the back right wall was illuminated by fluorescent lights.

We stretched a 40"x60" black gobo over one-inch plastic tubing and positioned this with two ten-foot light stands above General Shalikashvili. This kept the ambient light off his face during the two-second exposure necessary to properly expose the room behind him. The general was lighted separately. I used Fuji Reala film because it is the only film that records fluorescent light naturally; all other color films record subjects under fluorescent light with a greenish tinge and require filters to correct it.

Camera: Mamiya RZ67
Lens: Mamiya Sekor 65mm f/4
Exposure: 2 sec at f/11
Lighting: 6 Flash units
Film: Fuji Reala ISO 100

Lighting Plan

Main light: 200 Ws in 7" reflector with barndoors, set at f/11, placed 45 degrees to the left.

Fill light: 200 Ws in 31" umbrella, set for f/5.6 - 8 placed behind camera.

Skim light: 200 Ws in 7" reflector with barndoors, set at f/11.

Background light: Three similar units, set for f/8. One at the rear right middle of the room, directed on the staff members behind the General's left shoulder, another at the right rear balcony covering the staff there, and the third at the right rear, covering the staff behind the General's right shoulder.

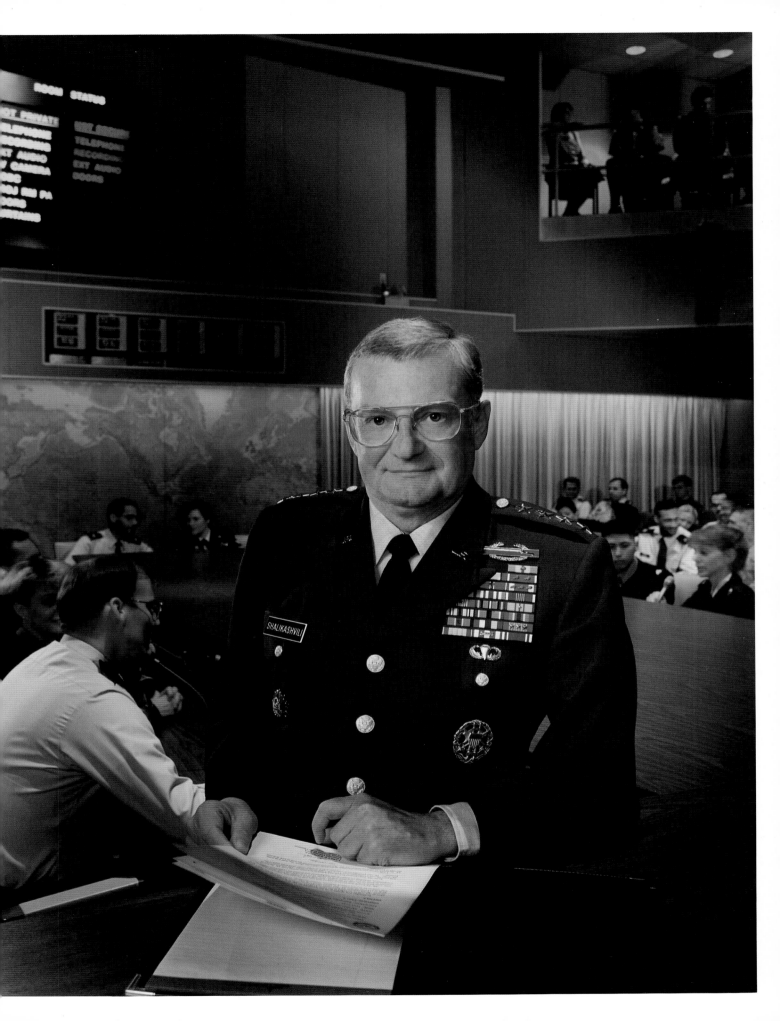

General Colin L. Powell, USA (Ret.)

I had an early morning appointment with General Powell, when he was Chairman of the Joint Chiefs of Staff, to photograph him on a hill in Fort Myer, Virginia, with the Lincoln Memorial, the Washington Monument and the Capitol in the background. Unfortunately the weather did not cooperate and we decided to use an alternate location, the Command Center, later that morning.

The Command Center in the Pentagon is a very large room with maps of the world and three big screens on which detailed information can be projected for strategy meetings.

Camera:	Mamiya RZ67
Lens:	Mamiya Sekor 65mm f/4
Exposure:	2 sec at f/11
Lighting:	3 Flash units
Film:	Fuji Reala ISO 100 (to record the fluorescent lights accurately)

Lighting Plan:

Main light: 200Ws in 31" umbrella, set at f/8 - 11, placed at 45 degrees to the left of the camera.

Fill light: 100 Ws in 31" umbrella, set for f/5.6, placed behind the camera.

Skim light: 200 Ws with a 7" reflector and barndoors, set for f/11, was placed 135 degrees to the left rear of the room, directed on the General to separate him from the background.

Background light: Ambient light on the staff people placed around the table, to simulate a typical work situation.

Comments: The ambient light in the room was a mixture of tungsten light, spot lights and fluorescent lights. The world map on the back right wall was illuminated by fluorescent bulbs; the screens showed rear projection images, selected to complement the portrait.

The 2 sec exposure was needed to permit an f/11 aperture for the required depth of field. To keep the ambient light off the General's face, a 40"x60" black cloth gobo was stretched between 10 ft light stands over the General.

It was a pleasure to photograph General Powell. It is easy to see why he is so popular and well liked. He puts the people around him at ease with his humor and by giving them his full attention.

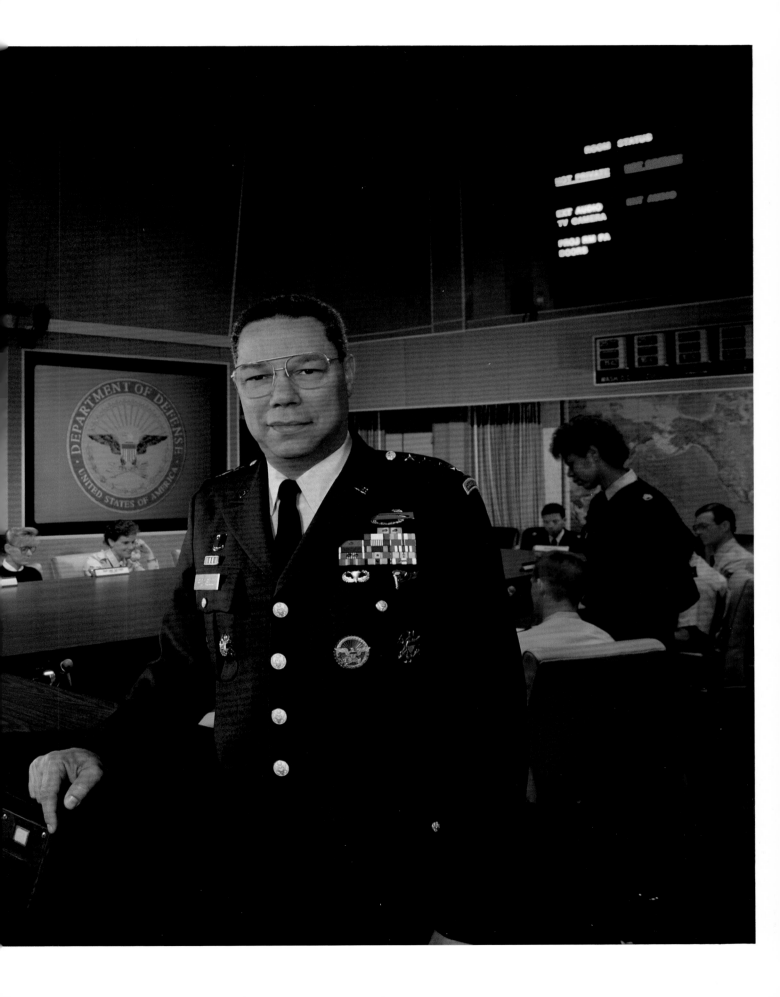

Admiral William A. Owens, USN

 Admiral William A. Owens is vice chairman of the Joint Chiefs of Staff. A graduate of the United States Naval Academy, he still has close ties with this institution. In our presitting consultation, we decided the academy would be a good place to make his portrait.

 I made an exploratory trip to Annapolis and was escorted around the academy by a public relations officer. I found historic Bancroft Hall to be just right for the portrait, which was scheduled to be taken one week later at 8 A.M.

 Admiral Owens' staff brought artifacts that would tell a little about his career: his flag, sword, and a model of one of the submarines he served on. We placed these on a table on a balcony overlooking Bancroft Hall.

Camera:	Mamiya RZ67
Lens:	Mamiya Sekor 65mm f/4
Exposure:	1 sec at f/22
Lighting:	7 Flash units
Film:	Fuji NHG ISO 400

Lighting Plan:

 Main light: 200 Ws in 7" reflector with barndoors, set for f/16 - 22, placed 45 degrees to the right.

 Fill light: 200 Ws in 31" umbrella, set at f/11, behind camera.

 Skim light: Similar unit, set at f/16 - 22, placed 135 degrees to subject's right

 Background light: Four similar units, set at f/11 - 16. Two placed in the middle left of the hall, one lighting the archway and middle wall to the right, the other lighting the room to the right rear of the archway, a third placed to light the left wall behind the admiral and a fourth to light the dome behind the admiral.

Comments: The ambient light was inadequate to light the background properly. This is why it required four flash units to fill the shadow areas and give tone and depth to the large space. The modeling lights in the reflectors lighting the Admiral were turned off, to prevent overexposing his face during the 1 sec exposure necessary to pick up some of the ambient light.

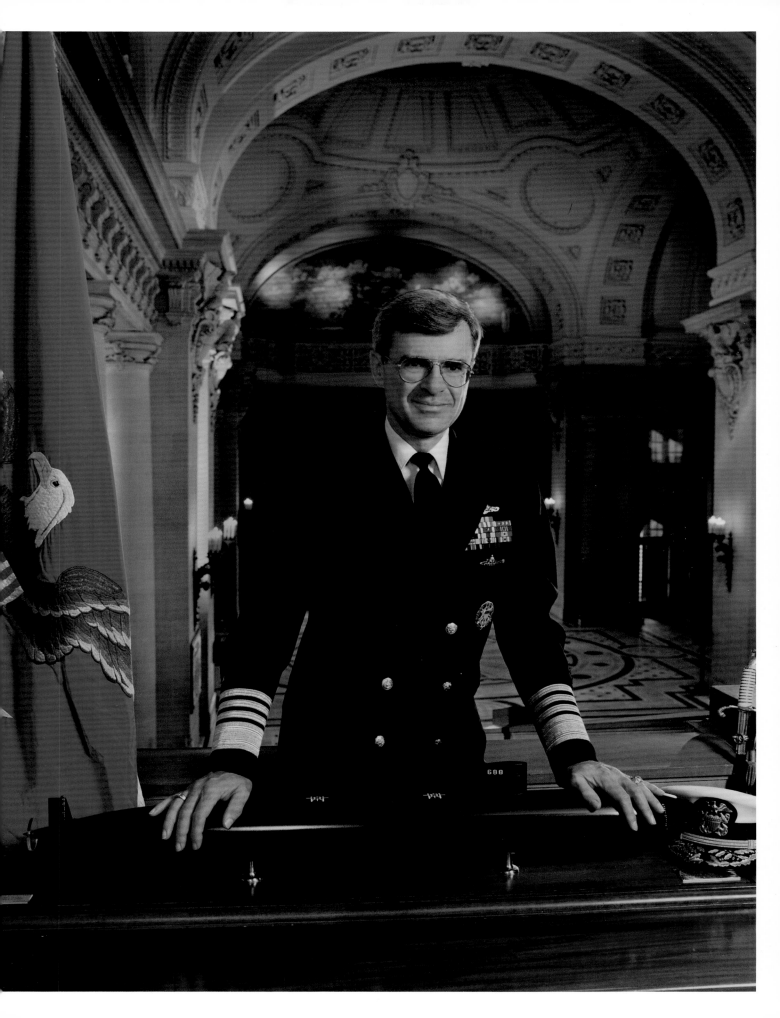

General Carl E. Mundy, Jr., USMC (Ret.)

For the portrait of General Carl E. Mundy, Jr., Commandant, U.S. Marine Corps, I wanted to make a powerful statement about the leader of this elite military group. When people view this image, I want them to exclaim, "This is the Marines!" Therefore, I portrayed a fully decorated General Mundy in front of the one hundred men of a platoon.

Technically, this portrait was the most complicated and demanding one to plan and photograph in the entire series. On some Fridays, the Marine Silent Drill Team gives a review at its Washington barracks. We scheduled a time before this review and staked out an area that would hold one hundred men, ten across by ten deep. Using a truckload of equipment, it took six hours to set up for the picture, but only forty minutes to get the men and General Mundy in place and complete the shoot.

General Mundy stood on a table, three feet off the ground. I perched on a ladder, with my camera on a ten-foot tripod, to get the perspective I wanted. We placed three banquet tables lengthwise along each side of the platoon, with a strobe on a 12-foot stand on each table.

Camera:	Mamiya RZ67
Lens:	Mamiya Sekor 110mm f/2.5
Exposure:	1/125 sec at f/22
Lighting:	10 Flash units
Film:	Fuji NHG ISO 400

Lighting Plan:
Main light: 200 Ws in 31" umbrella, set at f/16 - 22, placed 45 degrees to the right.
Fill light: Similar unit, set at f/11 - 16, behind the camera.
Skim light: Two 200 Ws in 7" reflectors, set at f/22, placed 135 degrees to the right and left of the subject.
Background light: Six 600 Ws in each light, the total was 1800 Ws in 48" umbrellas, set for f/16. Three umbrella units were 15 ft from each other on each side, lighting all the men evenly.

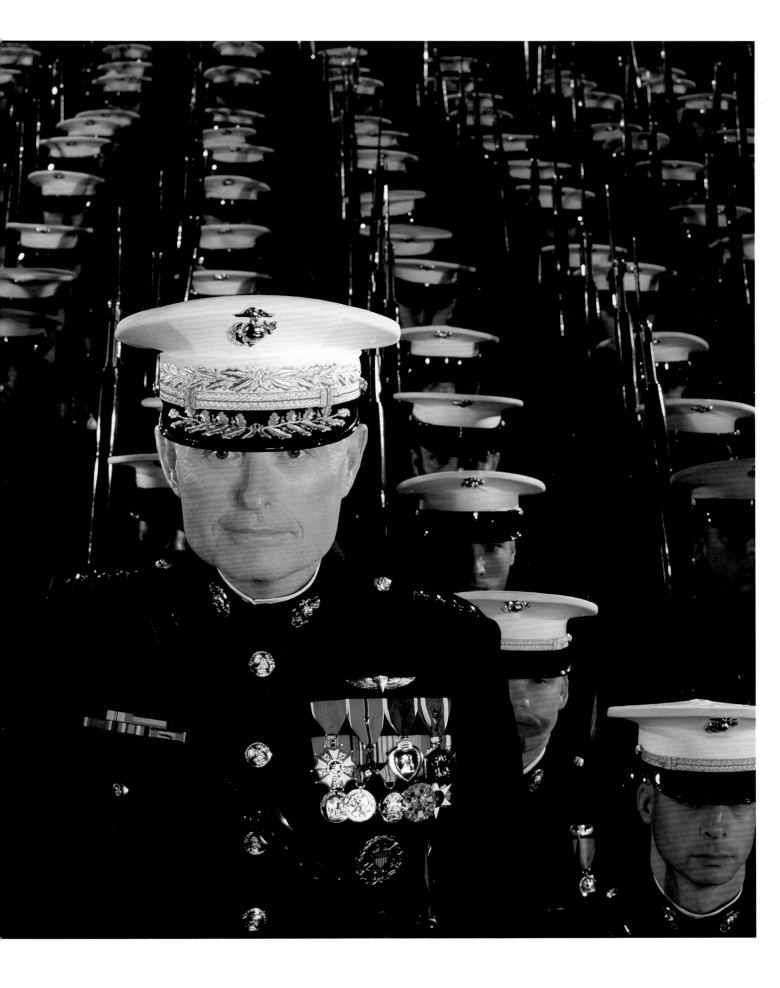

General Gordon R. Sullivan, USA (Ret.)

General Gordon R. Sullivan was chief of staff of the United States Army when this portrait was made. He expressed a desire to be photographed in front of the statue of General Grant near the United States Capitol building. I jokingly mentioned that I was a Virginian and my wife's maiden name was Lee, and couldn't we use General Lee's statue in Richmond instead? General Sullivan insisted that it must be Grant, and I had to agree, since we lost the war.

There is nothing more important to me than creating the finest portrait of my subject that I am capable of. My approach, however, is to make it fun for everyone involved. The general, some of his staff, my assistants, and I had a good time bantering light humor back and forth during the session.

The challenge in using the equestrian statue of General Grant was that it is on a 30-foot-high pedestal. I felt the only way for me to make the portrait impressive was to make three photographs on separate negatives and have them combined digitally.

We chose a sunny day, just before sundown, and we used a cherry picker to lift me high enough to take a picture of General Grant's statue. Then I returned to ground level and photographed General Sullivan at the base of the statue from the same angle. I made a third negative of a blue sky with some clouds.

I sketched a scale layout on a sheet of 16"x20" paper. I had the photographs of General Grant and General Sullivan enlarged to the size I had drawn, and I cut out both photos and positioned them the way I wanted them to appear in the finished print. Then Miller's Imaging Service took the negatives of the generals and the sky, digitized them, and combined them on the computer. Result: A portrait that placed General Sullivan in front of General Grant's statue, both apparently at ground level, with a beautiful blue sky and no distracting buildings or tree limbs behind them. If I can move furniture, why not statues?

Camera:	Mamiya RZ67
Lens:	Mamiya Sekor 180mm f/4.5 (for Sullivan)
	Mamiya Sekor 110mm f/2.5 (for Grant)
Exposure:	1/60 sec at f/11 for statue
	1/60 sec at f/8 for Sullivan (light decreased between shots)
Lighting:	Natural outdoor lighting at sundown
Film:	Fuji Reala ISO 100

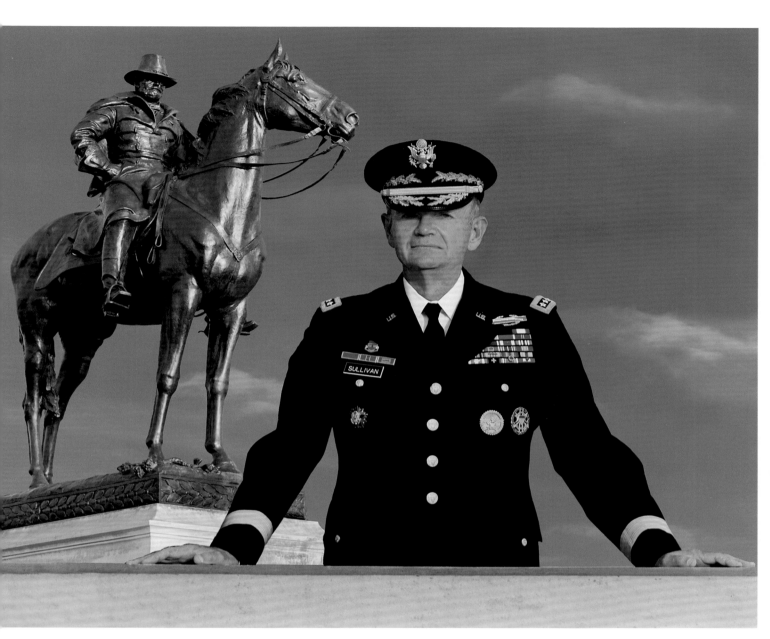

General Merrill A. McPeak, USAF (Ret.)

General Merrill A. McPeak was chief of staff of the United States Air Force.

Earlier in General McPeak's career, he was a solo pilot for the elite aerial demonstration team "The Thunderbirds." I thought a portrait of the general on an airfield with planes would make a better statement about him than an office portrait. He had spent a good part of his military life flying war planes, and a portrait including planes could not help but be successful.

I arrived at Andrews Air Force Base about 2 o'clock the afternoon of the session, to plan the portrait and to decide where to place the two jets I wanted behind the general. The ground crew chief was with me, and at my direction, he ordered the jets to be positioned in the right place for the light at sunset, when I would make the photograph. Using a stand-in who was the same height as General McPeak, we made test pictures on Polaroid film.

General McPeak arrived about forty minutes before the sun went down, and we made exposures at 10 minute intervals before the sun set. The window for the best exposure was about five minutes before the sun touched the horizon. I made about 20 exposures during this period. (This time can be different every day, and could be any time from thirty minutes before to ten minutes after the sun has passed below the horizon.)

Camera:	Mamiya RZ67
Lens:	Mamiya Sekor 65mm f/4
Exposure:	1/15 sec at f/16
Lighting:	Natural outdoor lighting at sunset
Film:	Fuji NHG ISO 400

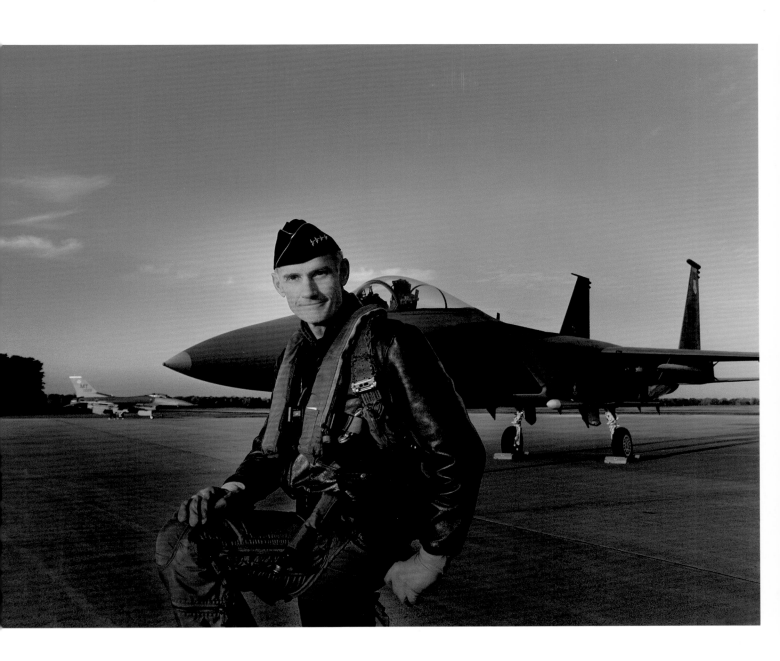

Admiral Paul D. Miller, USN (Ret.)

Admiral Paul D. Miller was supreme allied commander, Atlantic, and Commander in Chief, United States Atlantic Command, when this portrait was made.

Admiral Miller liked the idea of a somewhat informal portrait made outdoors with ships in the background. I did not want to feature any one type of ship but preferred to have several different ones in the background. One of the admiral's officers and I drove up and down the pier and climbed to the top of several ships, looking for a good location. When we went to the top of the aircraft carrier John F. Kennedy, I spotted just the right place.

Several weeks later, we scheduled the appointment for one hour before sunset. We met at the area, and I made photographs as long as the light lasted. I was standing on a six-foot ladder (it was cold up there!) with the camera mounted on a ten-foot tripod, looking down at my subject with a panorama of the fleet behind him. As the winter sun was setting, the admiral was lighted by the last rays of the sun from behind his left side. One of my two assistants held a Lumedyne battery flash with softbox to the right of the camera to light the shadow side of his face.

Camera:	Mamiya RZ67
Lens:	Mamiya Sekor 110mm f/2.5
Exposure:	1/15 sec at f/8
Lighting:	Natural outdoor lighting at sunset; 50 Ws with softbox, set at f/5.6 - 8, to light the face
Film:	Fuji NGH ISO 400

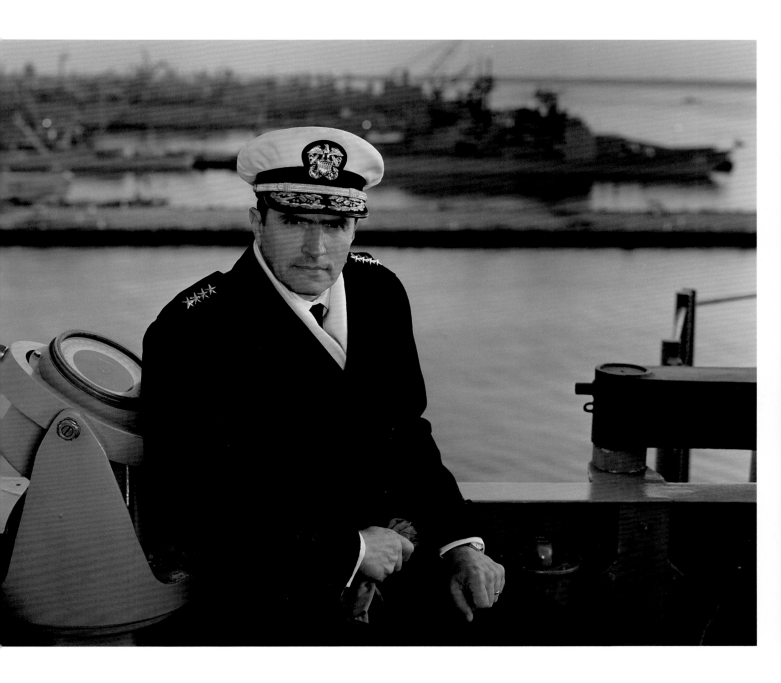

Vice Admiral Anthony Less, USN (Ret.)

One of the more exciting backgrounds for my series of military portraits was the new nuclear aircraft carrier USS George Washington. I could think of no better location to picture the commander of all the planes in the United States Atlantic Fleet.

Vice Admiral Less was Commander, Naval Air Force, U.S. Atlantic Fleet, and a former leader of the Blue Angels. In discussions on how he should be photographed, I suggested we photograph him in his flight suit, out at sea on the carrier flight deck, at sunset, with an F/A-18 Hornet fighter plane directly behind him. The bridge tower and flight deck with planes in the background added depth and authenticity to the portrait.

Camera:	Mamiya RZ67
Lens:	Mamiya Sekor 65mm f/4
Exposure:	1/15 sec at f/6.3
Lighting:	Natural outdoor lighting at sunset, the sun 45 degrees to the left of the subject
Film:	Fuji NPS ISO 160

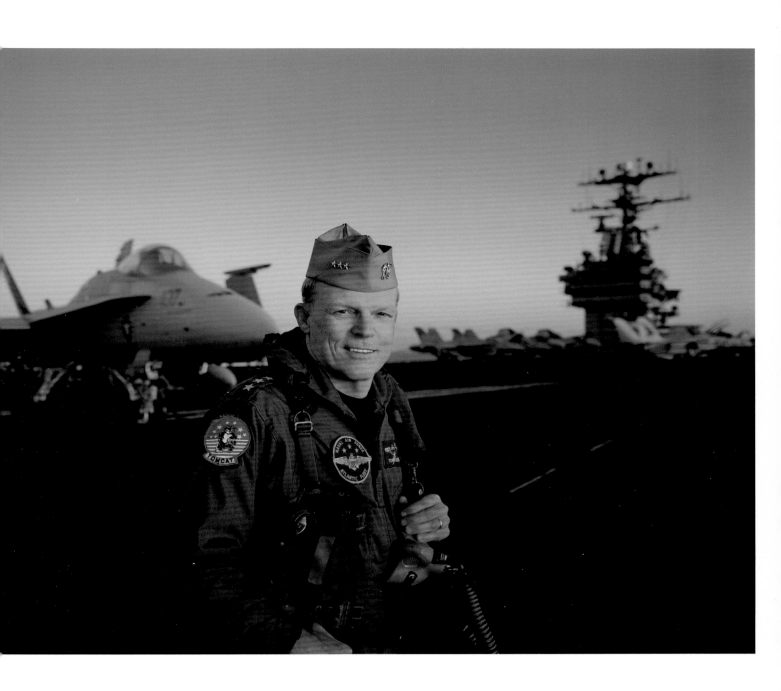

Admiral Henry H. Mauz, Jr., USN (Ret.)

Admiral Mauz was commander in chief of the Atlantic Fleet when this portrait was made.

The command centers of the newest navy ships have capabilities undreamed of a few years ago. The latest destroyer, the USS Arleigh Burke, offered a background that gave us a different look for Admiral Mauz's portrait.

The light level in the command center was low and not directed on the men; therefore, each man had to be lighted separately. No ambient light was on the admiral.

Camera:	Mamiya RZ67
Lens:	Mamiya Sekor 65mm f/4
Exposure:	2 sec at f/22
Lighting:	9 Flash units
Film:	Fuji NGH, ISO 400

Lighting Plan:

 Main light: 200 Ws in 31" umbrella, set at f/16 - 22, placed 45 degrees to the left.

 Fill light: Similar unit, set for f/11 - 16, behind the camera. Skim light: 200 Ws in 7" reflector with barndoors, 135 degrees to the left, directed on the subject.

 Lighting the four men behind the Admiral: Four 200 Ws in 7" reflectors with barndoors, set for f/11 - 22. One light directed on each man.

 Background light: Two similar units, set for f/16, one in the right and one in the left.

Comments:	A two second exposure was necessary to record the images on the computer screens and instrument panels. The nine flash units were required to get sufficient detail in the rest of the command center. All modeling lights were turned off to prevent overexposing the men's faces and showing possible movement.

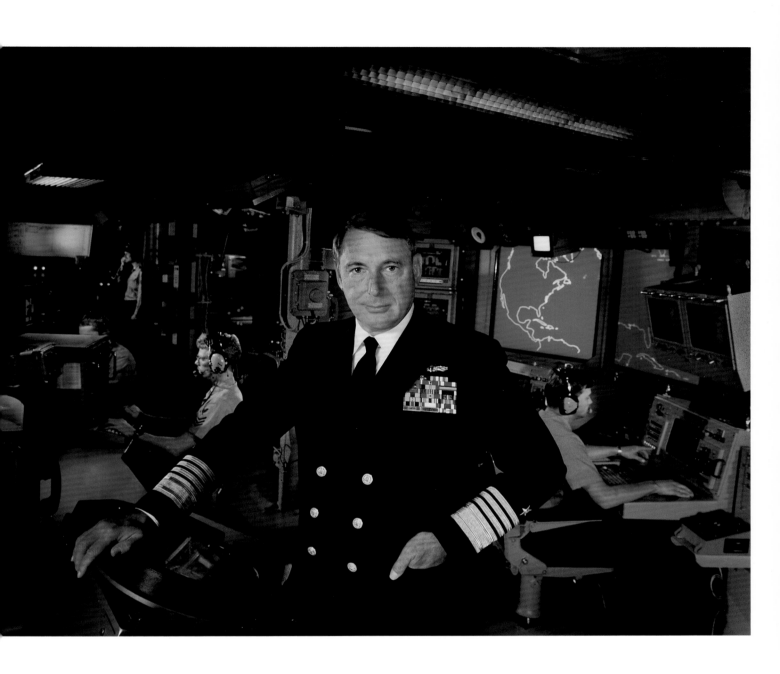

Photographing British Nobility

Camelot International Limited, a United States marketing company, hired me to photograph the Lord Mayor of London and six members of British nobility who have made their castles, manor houses, and stately homes available to the public for corporate meetings, formal dinners, overnight stays, and vacation weekends. These estates are part of over forty homes called The Heritage Circle. The portraits were to be used for advertising and brochures in the United States, and the assignment was one of the most interesting ones of my entire career.

Many of these magnificent estates have all the amenities of a luxury resort hotel. All of them are well over one hundred years old, are surrounded by formal gardens, and have a fascinating ancestral history. They are filled with priceless antiques and art works. Many have the facilities to seat forty people or more for dinner at one table.

My job was to personalize the "lord of the manor" and show the spaciousness, elegance, and tasteful luxury of each home. My pictures were to include as much of the interior of these homes as possible, with their owners posed prominently in the foreground.

I used the 65mm, 50mm, and 37mm fisheye wide-angle lenses on the Mamiya RZ67 camera. I lighted the rooms as if I were making the picture for *Architectural Digest.* Then I placed my subjects in the foreground and lighted them separately, using portrait lighting techniques.

The Duke of Roxburghe

I photographed the Duke of Roxburghe in his ancestral home, Floors Castle, Kelso, Roxburghshire, Scotland, in January 1992.

I admired the elegant beauty of this drawing room and believed it to be a wonderful space in which to photograph the duke. My assistants and I moved a handsome antique desk close to the room's entrance in order to let me include as much of the room as possible. With the help of the duke, I placed some of his favorite personal artifacts on the desk. We moved some other furniture into the background to balance the space in relation to his pose.

Camera: Mamiya RZ67
Lens: Mamiya Sekor 65mm f/4
Exposure: 1/15 sec at f/16
Lighting: 6 Flash units plus windowlight
Film: Fuji NHG ISO 400
Lighting Plan:
 Main light: 200 Ws in 31" umbrella, set for f/11 - 16, placed 45 degrees to the left.
 Fill light: Similar unit, set for f/8 - 11 behind the camera.
 Skim light: 200 Ws in 7" reflector with barndoors, set for f/16, 135 degrees to the left rear.
 Background light: Three similar units, set for f/8 - 11, were strategically placed to light the side and rear walls.
Comments: The existing light in the room was not evenly balanced. The added flash light gave the room more sparkle and depth and also filled the darker areas. It was easy to hide the flash units around the alcoves.

Sir James and Lady Scott

I photographed Sir James and Lady Scott at their home Rotherfield Park, Alton, Hants, England, in January 1992.

The spacious entrance hall to Rotherfield Park presented me with an enormous challenge. I needed the 180 degree angle of the fisheye lens to be able to include the entire two-story height of the room.

The most interesting view of the room was from the staircase, looking toward the entrance. This area held many art objects from the world travels and previous duty stations of Sir James, a retired British Army officer. I wanted these in the picture, but not in sharp focus in order not to detract from my subjects. I used an ISO 100 film and exposed at f/8 to lessen the depth of field. A smaller aperture would have recorded everything in sharp focus because of the great depth of field of the fisheye lens.

Posing people with the fisheye lens is critical because the camera is so close to the subjects. I was only about three feet from their faces. If I had included their hands, Lady Scott's would have been too large and Sir James' would have been too small. The stair railing also helped to eliminate visible distortion by masking their legs. Without the railing, their legs would have appeared foreshortened.

Camera:	Mamiya RZ67
Lens:	Mamiya Sekor 37mm f/4.5 fisheye
Exposure:	1/8 sec at f/8 (to record the lamps in the room).
Lighting:	5 Flash units
Film:	Fuji Reala ISO 100

Lighting Plan:

Main Light: 200 Ws in 31" umbrella, set for f/5.6 - 8, placed 45 degrees to the left of the subjects.

Fill Light: Similar unit, placed behind the camera, set for f/4.5 - 5.6.

Background Light: Three 200Ws flash units, with 7" reflectors and barndoors, set for f/5.6, were used. One directed from behind the staircase to the right, to light the back wall. Another, in the same area, to light the left back wall. The third on the balcony at the left rear, lighting its right wall.

The Lord Rowallan

I made this photograph of Lord Rowallan at the front entrance Blairquhan, Maybole, Ayrshire, Scotland, in January 1992.

The impressive entrance hall is a tower that rises above the two stories of the rest of the house. I used the 37mm fisheye lens to show the full height of the room and the ancestral paintings – dating back several hundred years – of previous owners of the home. The most impressive feature, however, was Lord Rowallan himself. We had a great time making his portrait. I joked that I could not put his portrait in the window of my studio back home because women would break the glass, steal his portrait, and my insurance rate would go up. I believe his good nature and sense of humor show in his portrait.

I was fortunate to be at Blairquhan on a day when a hunting party was in progress. Showing the pheasant and rifle added a nice touch.

Camera:	Mamiya RZ67
Lens:	Mamiya Sekor 37mm f/4.5 fisheye
Exposure:	1/15 sec at f/16
Lighting:	4 Flash units and window light
Film:	Fuji NHG ISO 400

Lighting Plan:

Main light: 200 Ws in 31" umbrella, set for f/16, placed 45 degrees to the right.

Fill light: Similar unit, set for f/11, behind the camera.

Background light: Two 200 Ws units, in 7" reflectors with barndoors, set for f/11. They were placed in doorways behind the subject, one directed on the right back wall and corner, the other on the left back wall and corner.

Comments: You will notice that I did not use a skim light because there is no place to hide it from the extreme wide angle view of the fisheye lens. It was not necessary to light the second floor and the tower, because there was enough ambient light for a proper exposure.

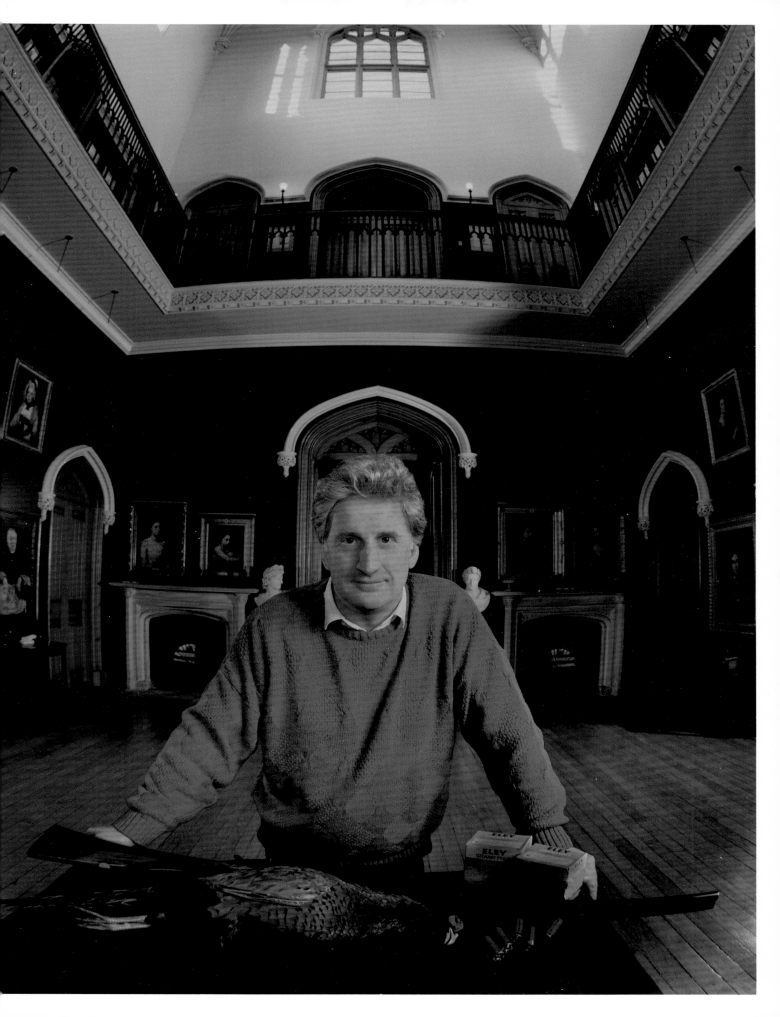

Sir Francis McWilliams

Sir Francis McWilliams was the Lord Mayor of London when I photographed him at the Mansion House in London in October 1993. I chose as background the room where diplomats and heads of state are received. It would be difficult not to be awed by the pomp and circumstance of his office and the magnificent surroundings of the Mansion House. The chairs in the room were impressive, but I preferred the beautiful throne-like chair I had noticed in another room, because I thought it would add an even more regal look to the portrait. It was so heavy that it took two men to bring it downstairs.

I adjusted the lights on the background to be one stop less than the light on the Lord Mayor, to make him stand out in the portrait.

As with most people in high places, such as the British nobility, Sir Francis had no need to try to impress anyone. I found everyone I met to be gracious, warm, friendly, and easy to joke with, which, of course, is a portrait photographer's stock in trade.

It is a good feeling when you leave after completing a sitting with a lord or knight, to have him and his wife see you to the door and walk outside with you to say goodbye.

Camera:	Mamiya RZ67
Lens:	Mamiya Sekor 65mm f/4
Exposure:	1/4 sec at f/16 - 22
Lighting:	5 Flash units
Film:	Fuji NHG ISO 400

Lighting Plan

Main light: 200 Ws with 31" umbrella , set at f/16, placed at 45 degrees to the left of subject.

Fill light: Similar unit behind the camera, set at f/11.

Skim light: 200 Ws in a 7" reflector with barndoors, set at f/16 - 22, to the left rear, to skim the subject's right face.

Background lights: Similar unit, set at f/11 - 16 in left rear of the room to light right wall at subject's left. Another similar unit, at same setting, to light the other wall.

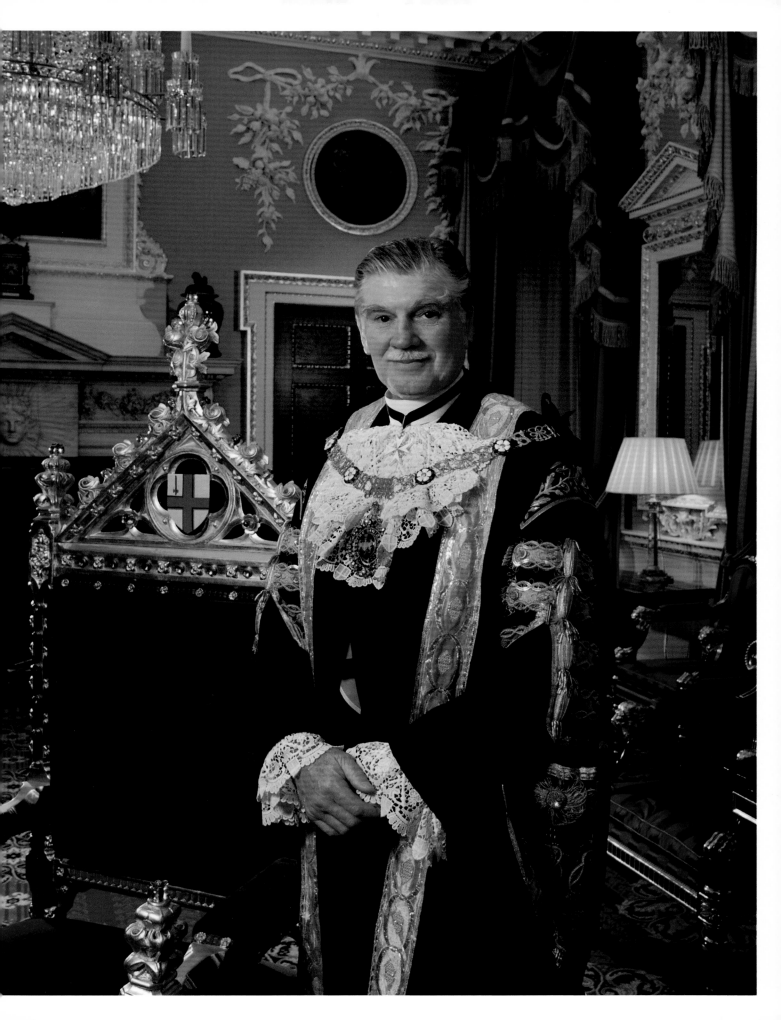

The Frame Makes the Picture

Artistic Portraits Require an Artistic Frame

Just like the saying, "Clothes make a man," a beautiful, handcrafted frame makes a fine portrait come alive. Conversely, an outstanding portrait will be diminished and lose much of its luster and quality when placed in a mass-produced, undistinguished frame, purchased for the sake of economy. A fine frame that is right for the portrait and complements the decor of the room where it will grace a wall will make the photograph sing and sparkle.

I have purposely presented a few of the portraits in this book both in frames and without frames to permit you to compare. But you must realize that you are looking at 8x10 inch pictures. My framed portraits are generally 24x30 inches and larger showpieces.

A frame of museum quality is a work of art in itself and requires highly skilled craftsmen to create it.

My preferred frames are Newcomb-Macklin Frames, manufactured by the Thanhardt-Burger Corporation, LaPorte, Indiana (1-800-826-4375). Newcomb-Macklin began making frames in 1871 and their frames have been been the choice of America's best museums and top painters. I urge you to request their free catalog. You will see a large selection of frame styles, shapes and finishes in any desired size. All frames are handmade – that is carved by hand, ornamented by hand, sanded by hand, gold-leafed by hand and toned by hand.

Photographic portraits, being a modern art form, will probably be appropriate in modern style frames, of which Newcomb-Macklin has a large selection. But you must also consider the decor of the room as well as the subject itself.

My large canvas-mounted portraits sell for a substantial price. I generally figure the retail value of the frame, which includes my markup, to be about 25 percent of the total. It is a good investment and your client will enjoy it for years to come.

General John M. Shalikashvili

The portrait of General Shalikashvili, Chairman of the Joint Chiefs of Staff, was made for the Navy League Travelling Exhibit. The technical details of this portrait are explained on page 186 and this framed version is shown for comparison.

The Frame:

 Dimensions: 24"x30", 3¾" wide
 Style : 10150, finish 254 PD, FS

Because this portrait was to be placed in a prominent position on a spacious wall, it required a wide frame. I also chose a frame that was appropriately solidly masculine, with slightly antiqued gold metal leaf, which is not too bright. The hand-tooled black panel matches the predominant color of the picture. The pleasing, rounded corners add elegance to this impressive frame.

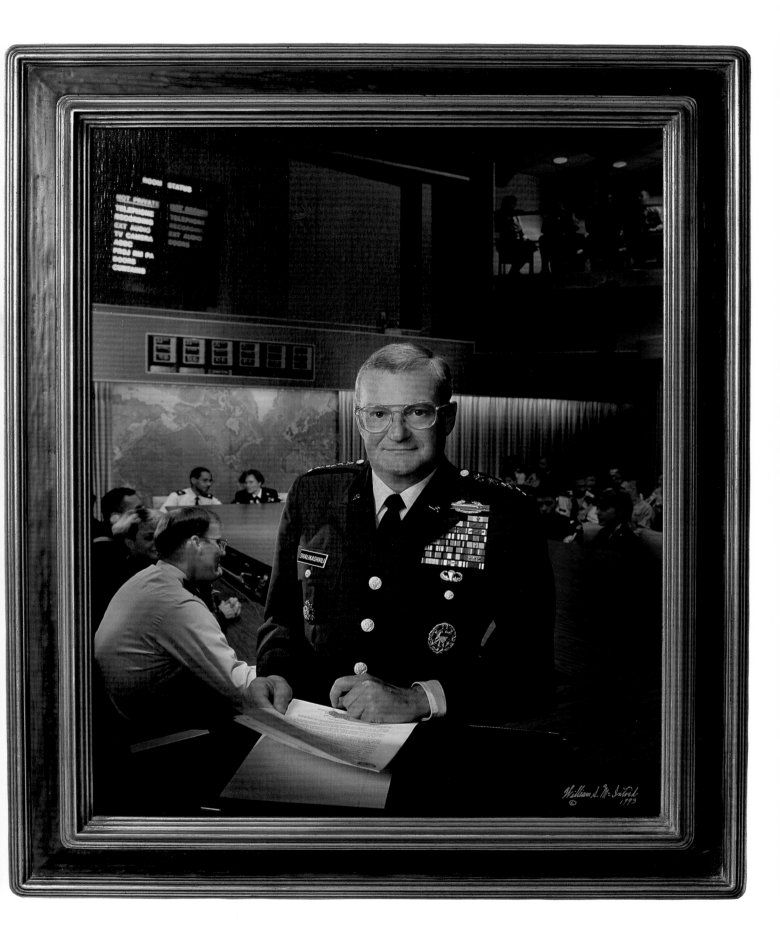

Carissa Reading by the Canal

Carissa was photographed just before the sun went below the horizon.

The white dress, the book and the softness of the late sun reflected enough light into her face, so a fill light was not required.

Camera:	Mamiya RZ67
Lens:	150mm f/4 variable soft focus, without disc
Exposure:	1/30 sec at f/6.3
Film:	Fuji NPS ISO 160

The Frame:

Dimensions:	Size 20"x24", 2" wide
Style:	#7528, #585 finish

The delicate leaf scrolls in the corners echo the foliage behind Carissa. The scalloped hem of her dress and her sleeves are repeated in the carvings of the frame. The all-gold frame reflects the sunlit water of the canal and complements the blond hair of the lovely young miss.

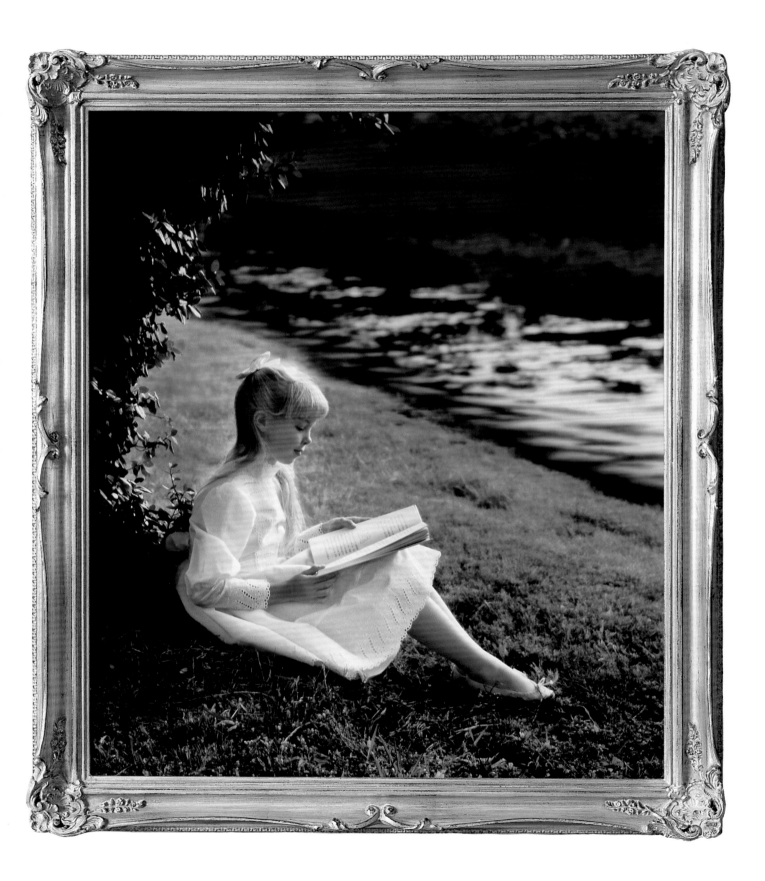

Lori Bateman, A Study in Red

Lori is a model I have photographed on a number of different assignments. She has a distinctive beauty and warm personality. When Fuji Film Company hired me to test their new NPS color negative film, I knew I wanted to use her as one of the models.

An impressive ad for a see-through screen material gave me the idea for this portrait. There was a flower arrangement behind the screen, looking soft and impressionistic. A few colorful petals placed in front of it were in sharp focus.

This caused me to buy the screen material and a 9 ft. red, seamless paper background. I also ordered a large, beautiful flower arrangement. I placed it behind the screen and photographed Lori in front of it.

Camera:	Mamiya RZ67
Lens:	Mamiya Sekor APO 210mm f/4.5
Lighting:	4 Flash units plus white reflector
Exposure:	1/250 sec at f/11
Film:	Fuji NPS ISO 160

Lighting Plan:

Main light: 200 Ws with 7" reflector and barndoors, closed down to keep the light off the screen, set for f/11. It was positioned directly above Lori's face to emphasize her high cheek bones.

Fill light: A 30" round white reflector was used instead of a f/11 flash to get a little detail in the shadow side of her face. Two 200 Ws units, with 7" reflectors and barndoors, closed down to keep stray light from the screen set for f/8 - 11, at 90 degrees to each side, were directed at the flower arrangement. (Any light spilling over on the screen would blot out the flowers behind it.)

Background light: Another similar unit, set for f/8 - 11, was directed on the background to emphasize the red theme.

The Frame:

Dimensions:	24"x30", 3" wide
Style:	7305 PL, finish 46

I wanted Lori's portrait to emphasize her beauty and to make a strong graphic statement. The simplicity of the Whistler style gold metal leaf frame, with a red rub showing through the gold leaf, makes it an ideal choice.